F.V.

The Photographer As Designer

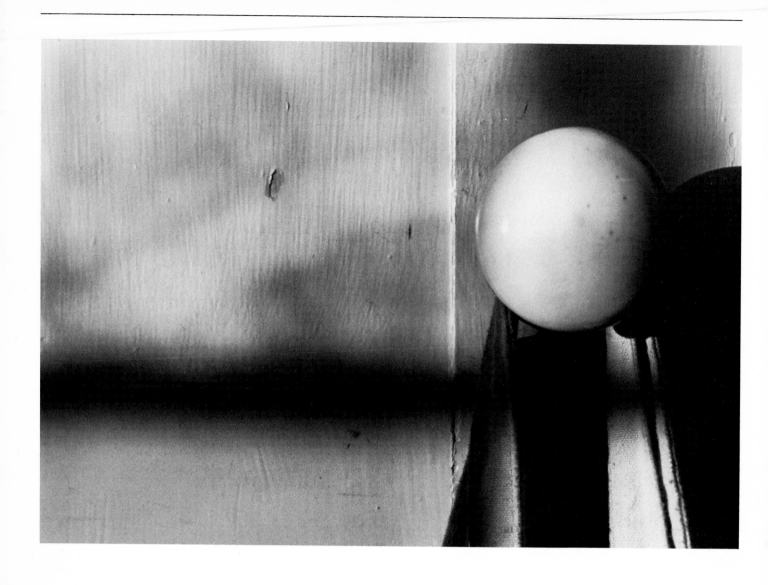

THE PHOTOGRAPHER AS DESIGNER

Vivian Varney

Davis Publications, Inc.
Worcester, Massachusetts

To Amanda

Printed in the United States of America
Library of Congress Catalog Card Number: 76-19943
ISBN: 0-87192-078-6

Composition: Davis Press, Inc.
Printing: Halliday Lithograph
Type: Palatino
Design: Jane Pitts

10 9 8 7 6 5 4 3 2 1

Contents

Introduction

This book is for the student, teacher, amateur, or professional camera enthusiast who knows the parts of a camera, has some darkroom experience or intends to acquire it, and wants to explore further the aesthetics of photography. Exploration of the visual world with the camera can be fun, can sharpen our awareness of and our appreciation of the world, and can serve as a source of great personal satisfaction, joy, and creative expression. The book does not pretend to exhaust the subject and the presentation has been kept simple and direct intentionally.

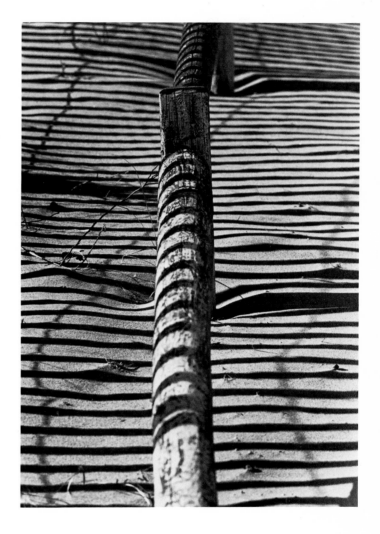

Most introductory books on photography are concerned mainly with techniques: the how-to's of camera use and of print making. Potentially good photographers are often turned away from the medium because of this emphasis on technical data. They are deterred by such considerations as ƒ stop, time exposure, and depth of field calculations, or feel that the presence of the sets of numbers on the camera body or lenses requires from the operator some special mathematical capabilities. Aesthetic qualities of the image are often little discussed. Although more sophisticated equipment holds greater potential for photographic expression, good photographs can be made with a simple camera with fixed focus and shutter speed. A number of the photographs in this book were taken with the Kodak Baby Brownie, a box camera which was a predecessor of the Kodak Instamatic, and other less complex cameras. Many professional photographers owe their beginnings in photography to rather simple equipment and point with pride to their early photographs.

This book clearly treats photography as an art form. Admittedly, photography is often used simply as a type of illustration or as a "snapshot" record of a family event or scene visited. However, here we will treat photography and judge photographs on the same plane as an accomplished critic would judge any work of fine art, whether it be a painting, a piece of sculpture, or a work of graphic art.

A few problems involved with any type of aesthetic judgment should be mentioned. What may be termed an excellent and meaningful print by one person may be considered a poor and meaningless print by another. Therefore, the author acknowleges that there is, necessarily, a good deal of subjective judgment throughout the text.

Many of the photographs in the book may be too abstract for some people. There is often controversy when the degree of abstraction is such that an object or area is not recognizable. However, many of the photographs were taken and chosen because of the degree of abstraction. When readily identifiable material is used, it is sometimes difficult, particularly for a beginner, to learn to observe visually in terms of the elements that compose art: line, shape and form, color and value, space and texture.

Finding an interesting subject or area is essential to a good photograph, but will not necessarily ensure one. Likewise, there is no formula which will guarantee a good print. Photography is an art form, not a science. Personal vision is essential to good photography. Thorough knowledge of the camera and of darkroom techniques does not make the good photographer, but can help the individual with vision to develop and grow through the medium. There are a number of intangibles that distinguish the good photographer from the fair or poor one, as is the case for any artist. The qualities of insight and sensitivity can be developed where the potential exists, but they cannot be created by any amount of technical competence.

It has often been said, but bears repeating here, that photography, if taken seriously, involves work by the photographer through the final print. There is no quick and easy way to obtain a good print. The print-making process involves the patience and know-how of picture taking, but also requires a knowledge of darkroom techniques and a willingness to work, sometimes for long periods, to achieve a personally satisfying print. Another element of successful photography is that of personal search. Although enthusiasm for photography can often be shared and a significant amount learned through exchange of ideas and critical dialogue, a good deal of the photographer's work must be done alone. One must be willing and able to accept this fact.

This book specifically treats photography in black and white. Most amateurs, even if they choose to work with color later, start with black and white. In many cases, the material we include will apply to both black and white and color photography.

One important consideration the author has tried to bear in mind throughout the book is the importance of photographic material to illustrate what is being discussed. We have used photographs liberally to make points clearer, and have included poor photographs along with the good ones to help the reader make distinctions.

The Photographer As Designer

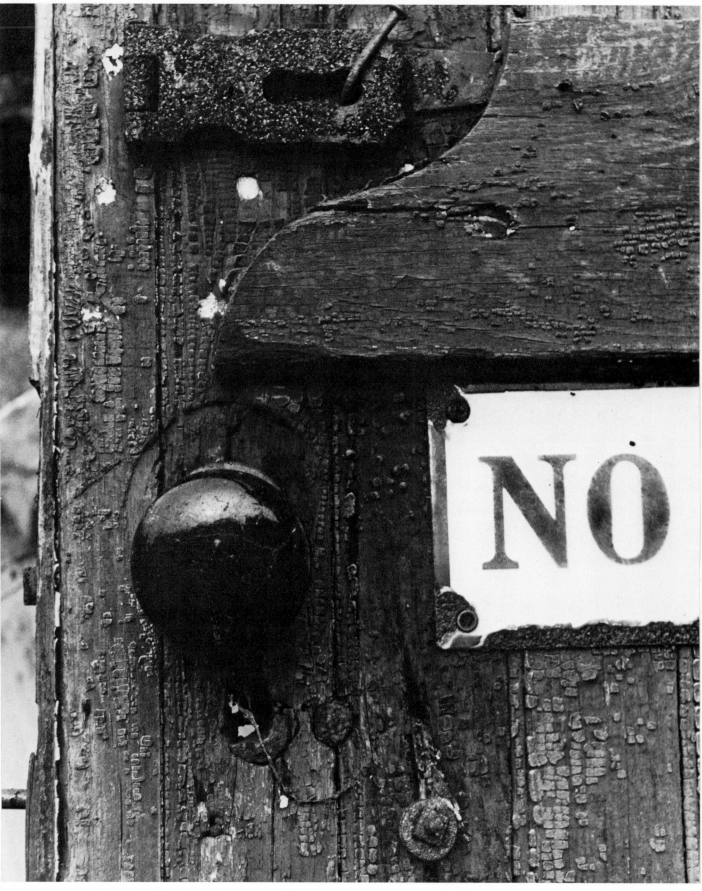

Chapter 1
THE CAMERA AND DESIGN

Of primary importance in using photography as an art form is the acknowledgment that in every aspect of activity from the selection of subject matter through the completion of the final print, the photographer be a designer. Before completing a final print, the photographer will have made, whether consciously or not, a number of choices having to do with picture design. In these choices lies the challenge one finds in photographic work.

In "designing," the photographer arranges certain elements of the visual world in a pattern. That pattern, or composition, is the photographer's selection, and a number of judgments must go into its making.

CONTENT

One of the first and most important judgments a photographer must make is the choice of subject matter or image. The possibilities are infinite, but the choice is an individual one and will be made on the basis of the photographer's own interests, values, sensitivity to picture potential, and a number of other factors. The content of the picture may be chosen for its power to reveal and often clarify a situation or a relationship, or it may be chosen for a certain type of beauty which the photographer sees in it. The reasons may be many or few. Indeed a photographer may, for certain reasons, wish to work with one particular type of photography. The validity of any visual statement may be judged by others and even criticized, but the statement remains uniquely that of the photographer.

In making the choice, the photographer may ask a number of questions: whether the object or area would make a stronger statement if seen from another angle, in a different light, closer, farther away, with a different background, or when combined with other objects or people. Such questions may be, and often should be, part of the thought process developed by the photographer in choosing an approach to picture making.

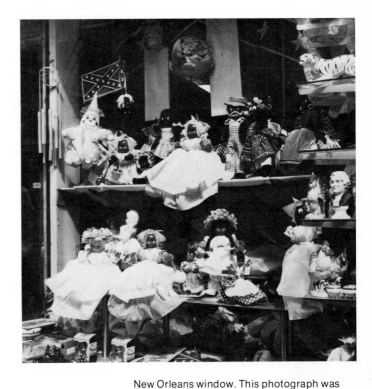

New Orleans window. This photograph was taken because of the interesting variety of objects and their arrangement on shelves in this shop window. Each of the dolls and pieces of bric-a-brac is unique, and together they make a delightful grouping. The presence of parts of Confederate flags, the Indian mask above, the black and white dolls, the clown, the rooster, the tiger, and the eighteenth-century head provide interesting contrast, whatever meaning one may wish to read into them.

This horse-drawn moving van in Italy was obviously of interest to its photographer. Often an object or experience which is unfamiliar and therefore fresh strikes one as a worthy visual statement. A person living where this sight is common might not find it interesting as photographic subject matter. The pile-up of belongings gives one a unique view of a human experience. The character of the belongings, their arrangement, the waiting horse, and the textures and shapes of the building in the background are also of interest. Even the fallen cloth adds another dimension.

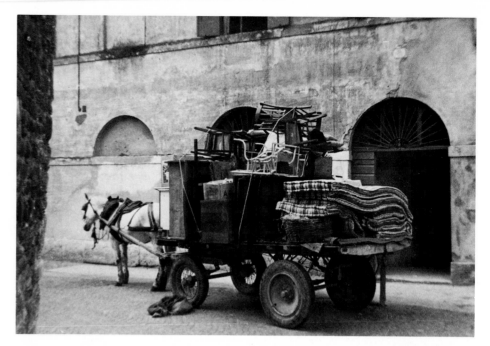

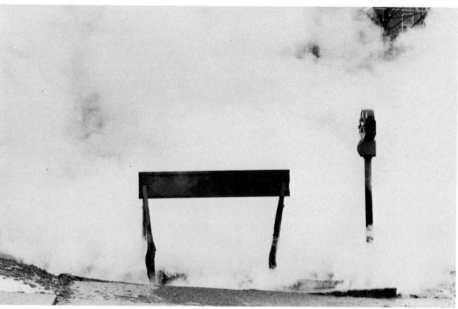

The atmosphere of fantasy created by a sidewalk cave-in above a broken steam pipe provided the motivation for this photograph. The white puffy clouds isolate the partially sunken barricade and parking meter and give the whole area a fascinatingly unreal quality.

THE FRAME

One of the fundamental characteristics of every photograph is that it has limits. There is a frame, there are top, bottom, and sides that end. The photographer determines the frame, and, in so doing, selects and designs. The frame is dependent on a number of factors. The nature of the camera and the type of lens are important determinants, for different cameras and lenses have varying fields of vision and different negative size.

Here are four photographs made with two different cameras. Lenses of four different focal lengths were used. All photographs were taken while standing in the same spot.

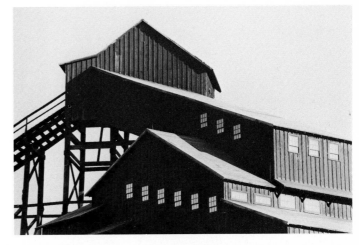

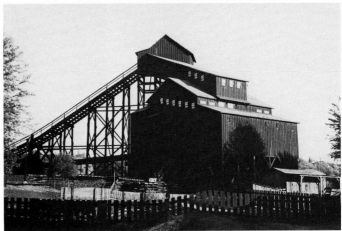

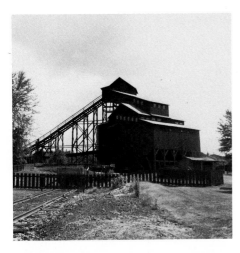

This photograph was taken with a Rolleiflex twin-lens reflex camera with normal 75 millimeter focal length lens. The format is a square, the negative size being 2¼" by 2¼".

The three photographs at the right were taken with a Pentax 35 mm single lens reflex camera, using three different focal length lenses. The format is rectangular; the negative size is 1½" by 1".

(top)
This detail was taken with a 135 mm moderate telephoto lens, a good lens for details of moderately distant objects or areas.

(middle)
This photograph was taken with a 50 mm focal length lens, a "normal" lens for the 35 mm single-lens reflex camera.

(bottom)
This photograph was taken with the standard wide-angle 35 mm lens. The area included is broader than in any of the other photographs.

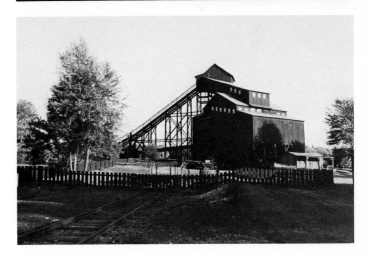

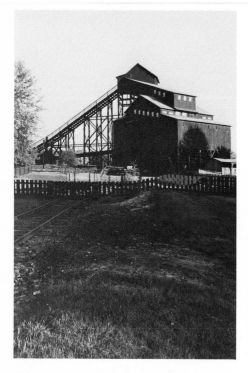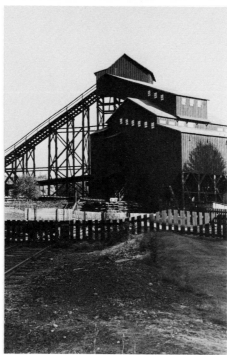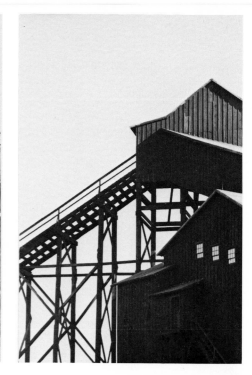

This photograph was taken with the wide-angle 35 mm lens.

This photograph was taken with the 50 mm lens.

Other variations within the same area can be made by turning the 35 mm camera for a vertical frame or by focusing at another area.

Both of the photographs above were taken with the 135 mm telephoto lens.

While it is to the advantage of the photographer to obtain at the time of exposure a frame which will be satisfactory as a final picture, this is not always essential. When the photographer obtains a negative which can be printed as a whole, further enlargement can be avoided. Enlarging may often involve a loss of sharpness and an unwanted grainy quality in the print, particularly in sizable enlargements.

The photographer may choose not to accept the frame as seen through the viewfinder, hence in the negative, as the final print. Part of the negative may be "cropped" for an image or a format which is more satisfying. Cropping may be done in the darkroom by selecting only sections of the negative for printing or by cutting off parts of the print after it is made.

Here are three photographs, all made from the same negative. The first print was obtained by using the whole negative. The others are prints made from certain sections of the negative. Both a vertical and a horizontal format have been used. Each photograph has its unique identity and is justified in its own right as a photographic image. With change of lens or vantage point, the photographer could have taken both the second and third photographs as separate photographs and thus avoided having to print them from the single negative.

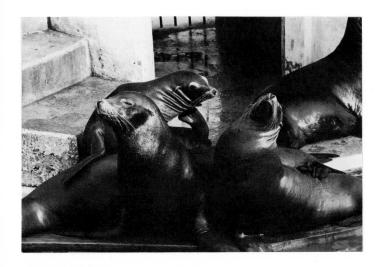

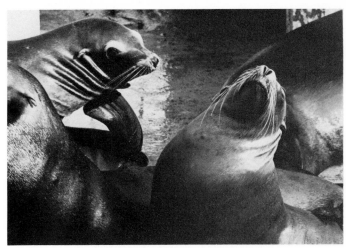

There may be times when the picture potential of a certain area of a single negative does not occur to the photographer until after a print of the whole negative is made. While viewing the original area, the photographer may have directed attention to a particular part. Rarely is it possible to study the qualities of all parts of a potential photograph and their placement before taking the picture, particularly if a "candid" quality is desired. To discover picture potential in another area of a negative can be an exciting experience.

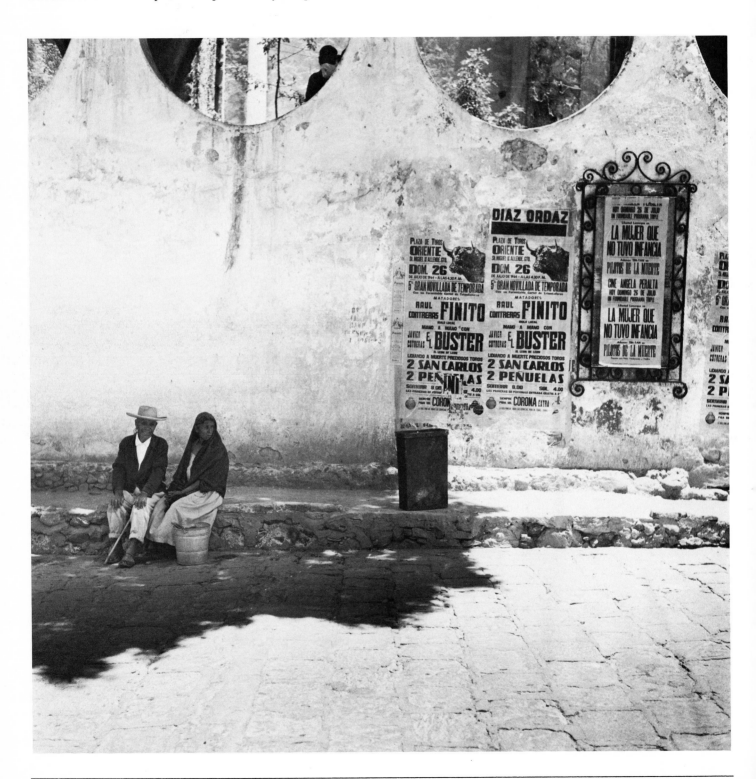

This photograph, made from only a small section of the negative, has a delicate oriental quality because of the unique combination of textures, lines, shapes, and white-gray-black relationships.

The photograph below is made particularly powerful by the rich blacks and geometric shapes of the letters contrasting with the play of grays and whites and irregular shapes that define the texture of the wall surface.

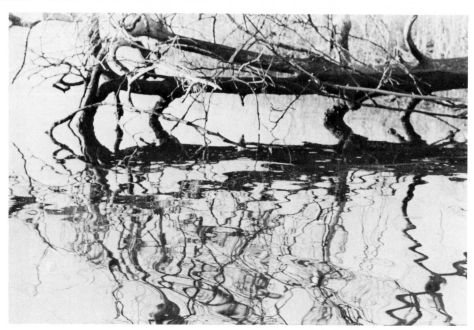

An important consideration in framing is whether the subject lends itself to a vertical or horizontal format. This consideration is very important with a camera whose negative is rectangular and thus requires that the photographer change the camera direction accordingly while shooting. In some cases the choice may be easy and, in fact, necessary to include the content or area desired. In other cases, there may be some question as to which format will make the more satisfying print. One may choose to photograph in both directions and then decide in favor of one or the other. The photographer may need to live with both formats for a while before making the decision. The decision may even be reached that both are equally successful as photographs, each valid in its own right.

These photographs of a fallen tree and its reflections in water were taken from the same spot and made use of essentially the same area for content. However, a change of camera position captured a vertical direction in one case, a horizontal one, in the other. Both presentations make interesting photographic statements. The weblike quality of the tree and its branches combined with their reflections is more boldly presented in the horizontal photograph. On the other hand, the inclusion of the interestingly curved end of the reflections and the larger area of unoccupied water makes for an interesting spatial contrast in the vertical format.

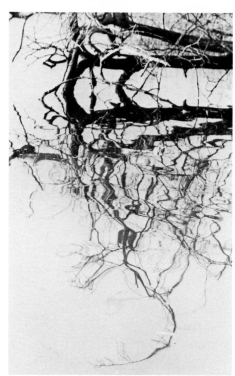

While the horizontal and vertical rectangular frames are the most common, the square format of the negative of the twin-lens reflex camera may be equally powerful for certain photographs. The photographer, of course, can always crop a rectangular format to make it square.

There are those who like to experiment with less common frames, such as the circle or triangle. While these less conventional frames will have their critics, a particular photographer may find the triangle and circle to be valid alternatives. In fact, certain subject matter may lend itself to impressive photographs in these less conventional frames. Even irregular shapes can serve as frames. Indeed, in some cases, they may be especially effective, and for this reason commercial advertisers often use them. Although irregular shapes are rarely seen in exhibitions, there is no reason why photography as fine art cannot employ them.

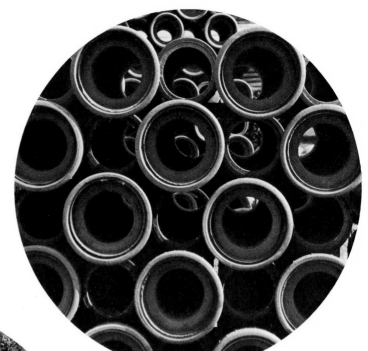

(above)
In this photograph of pipes waiting to be installed underground, the round frame helps to accent the play of round shapes. The choice of frame also heightens the sense of looking into space by suggesting the frame of a telescopic image.

(left)
This is a pothole, part of an extensive cryptozoon reef formed by prehistoric glaciers. The round frame accentuates the curvilinear shape, as well as the central emphasis, and contributes to a feeling of depth.

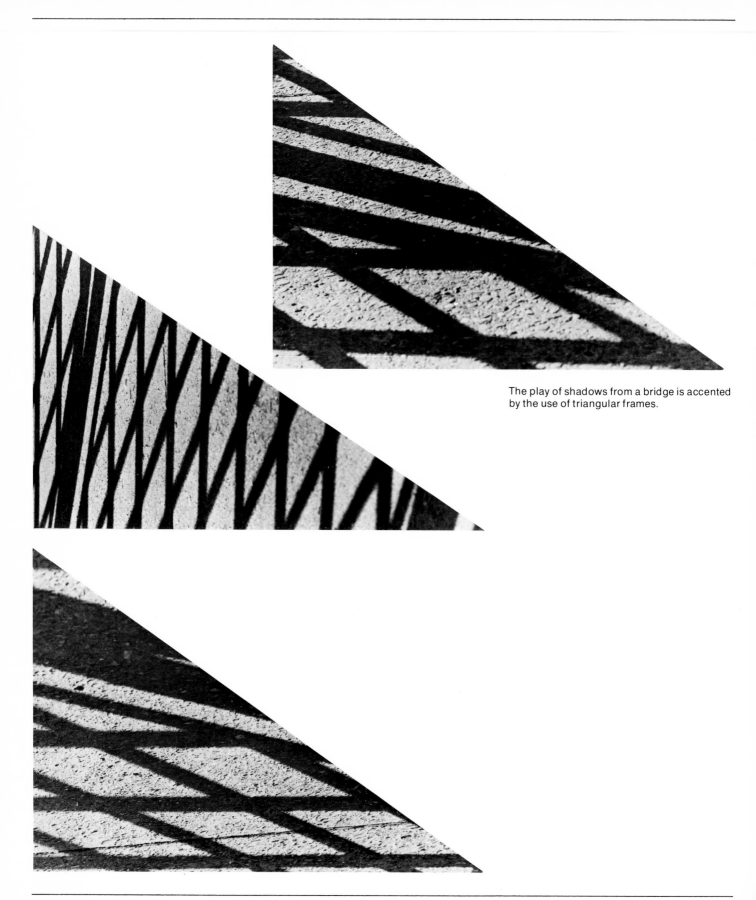

The play of shadows from a bridge is accented by the use of triangular frames.

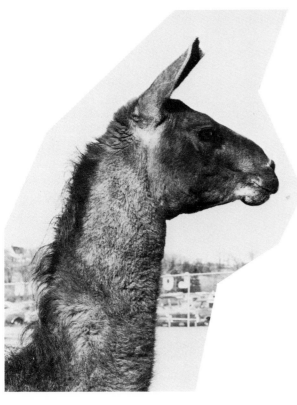

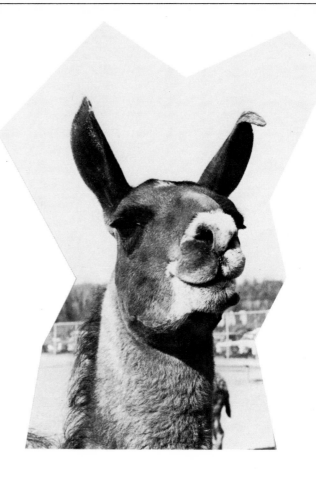

Llama — profile and three-quarter view.

Patterns of melting snow and ice.

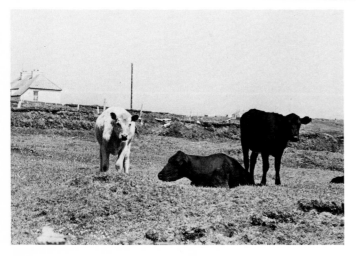 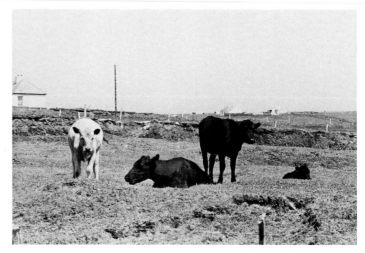

Here are two photographs of the same landscape with cows. Both have rectangular frames, but the photograph at the left is poorly balanced with too much visual weight on the right side of the imaginary vertical center line. The lack of balance is caused by framing the photograph so that most of the black cows are to the right of this imaginary line. Visually, black is much heavier than white, and this fact must be recognized when arranging the elements. Also the horizon line is slightly diagonal in direction with its lower extremity pointing to the right, thus causing the eye of the viewer to move in that direction. The photograph at the right is taken from a position slightly behind that at which the other was photographed. In this case, the total field of vision moves to the right and in so doing brings the heavier black cows closer to the left side. The horizon line is more nearly horizontal, and hence does not direct the eye to one particular side of the picture. The photograph demonstrates good balance.

THE PRINCIPLES OF DESIGN

When the content has been selected and the frame defined, the photographer may wonder whether the photograph actually holds the desired amount of interest or whether it contains the qualities that will make it truly fine. Being able to qualitatively measure the selected image at this point would be extremely valuable. In making an evaluation a great deal of subjectivity is involved, but there are certain characteristics exhibited by all good photographs. Even if these characteristics are present, however, a print may not be good. As mentioned earlier, personal vision is of great importance. The characteristics which all photographers should be aware of and which help to make for photographic excellence are: balance, variety and contrast, repetition and rhythm, emphasis or focus, and unity or cohesion, known as the principles of design.

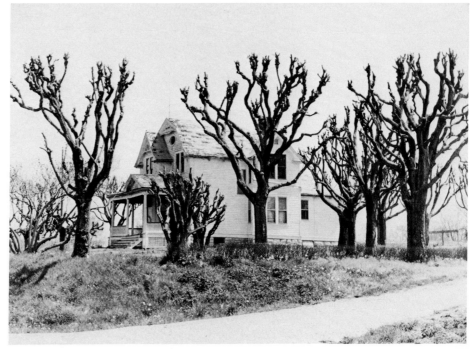

This is a very poor photograph taken with a twin-lens reflex camera. The use of a square format as the frame detracts from what is actually a rather fascinating area with an abandoned late Victorian house and a group of pruned catalpa trees. To achieve the effect of the trees and house and yet retain the effect of sloping ground, the photograph had to be taken from an angle and from across the street. The sky area and driveway swallow up the house and the trees, and there is too much weight on the right side of the print so that it actually seems to be tipping to the right.

A better photograph results after the format is changed to a rectangle, parts of all sides are selectively eliminated, and the printing exposure time is slightly reduced to attain better intermediate shades of gray.

BALANCE

Balance is essential to all good works of art. We find it disturbing to look at an unbalanced composition. Balance in photography is achieved by an arrangement of the elements within the chosen frame. It is a quality sensed by the viewer, and reflects the viewer's inherent need both for an equalization of visual weights on each side of an imaginary vertical center line and for the presence of the heavier weight in the lower half of an imaginary horizontal center line. The balance requirement should be a concern of the photographer from the beginning of the photographic process. The search for balance begins with the selection of the area and the framing of that area within the viewfinder.

Developing an ability to balance the elements within a frame is important to all photographers. Some find it easy and quite natural; for others it is more of a problem. This ability involves the arrangement of visual weights, which include such factors as the lightness and darkness of color, the size and character of shapes, and the direction of the elements. Actually all visual qualities affect weight.

Sometimes balance may not be possible while framing and taking a picture and may have to be achieved in the darkroom. There are many ways this can be done: tipping the baseboard to change a certain direction; making certain areas darker by burning-in, or giving them more exposure to the enlarger light; making some areas lighter than others by dodging, or withholding light from them while giving the full exposure time to the other areas; and cropping.

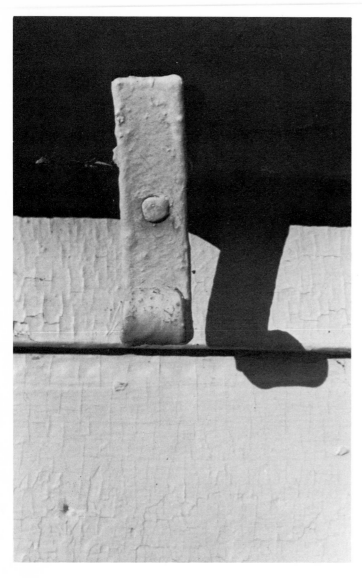

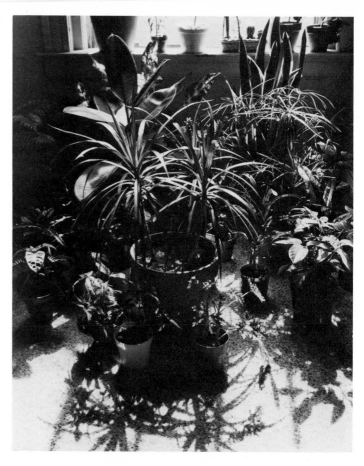

This photograph of a group of plants is filled with variety and contrast provided by: shapes, heights and direction of leaves and their shadows, size and placement of pots, and the interesting values of blacks, grays, and whites.

In this photograph a single contrast, the shape of the shutter hook with that of its shadow, is highlighted. The fact that the hook extends outward from the building and the higher clapboard overlaps the one below has made an interesting bent quality in the shadow.

VARIETY AND CONTRAST

Variety and contrast are also essential aspects of good design. Lack of variety and contrast can mean monotony and sameness. The world abounds in variety and contrast. The photographer may choose an area with few, often striking, contrasts or one abundant in contrast.

It may be that an area has too much variety and the photographer will have to isolate a section to make a good photograph. A change of lens or getting closer may be all that is needed to achieve isolation. When insufficient time, physical limitations, or the lack of a suitable lens will not permit the photographer to get closer, good cropping (the elimination of part of the negative) when printing may be sufficient. Often what one leaves out in art makes the difference between a good and a poor design as well as what one includes.

The photograph above is too busy. There are too many things competing for one's interest. By eliminating most of the car and a good part of the grass in the photograph at the right attention is concentrated on the caterpillar and leaves relationship, the area of principal interest to the photographer. The direction of the easel with printing paper was also changed to stress vertical direction and make for better balance.

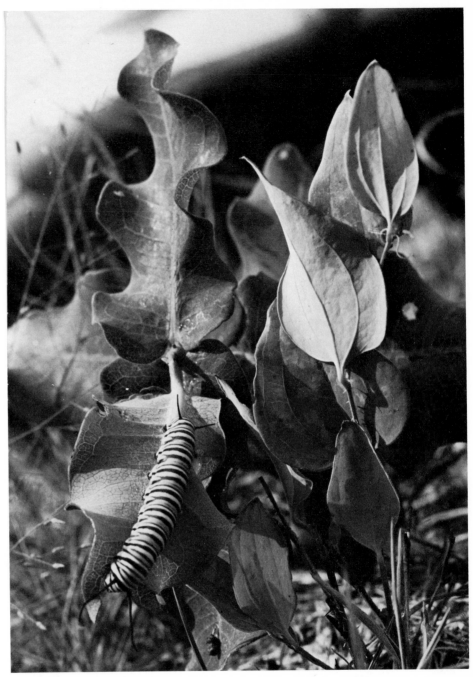

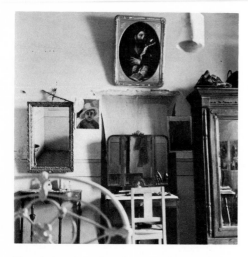

The cluttered quality of a student painter's room in Mexico creates an interesting play of shapes, mirror reflections, and space. Repetition with a variety of rectangular shapes helps tie the whole together. The spirit and atmosphere of the room is captured effectively.

It is important to be able to distinguish the difference between an area which is too "busy" and confusing to make a good photograph and an area which is filled with variety in order to bring out a certain mood or significant aspects of the area or object.

In these photographs complexity plays an important role. The many objects are so arranged that there is order in complexity. The photographs are well designed.

Not to be confused with a chaotic photograph is one in which the photographer has chosen repetition itself as being worthy subject matter. Although often complex in organization, repetition can help tie a photograph together visually.

This Mexican couple has covered up the vegetables they sell in a busy market and have found a moment to enjoy their simple meal, neatly arranged on a lace-edged doily. The busy background of the market with stands, crates, people, and goods contrasts nicely with the old couple at their makeshift table and makes more powerful and beautiful the sense of dignity and peace one feels in this human situation.

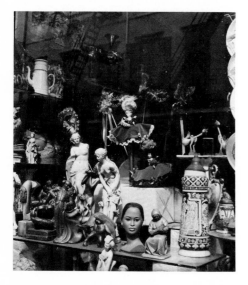

This shop window is a great collection of "objets d'art" for the viewer to discover. Imagine leaving one out! The reflection of the windows and stairways from the building across the street adds an interesting subordinate theme. The areas of black which surround the objects and which one finds throughout the picture help unify the numerous and varied pieces.

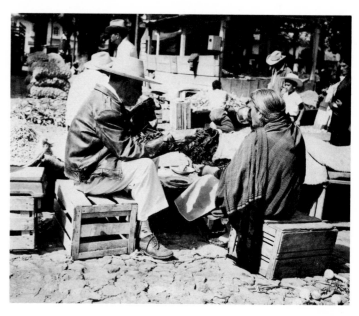

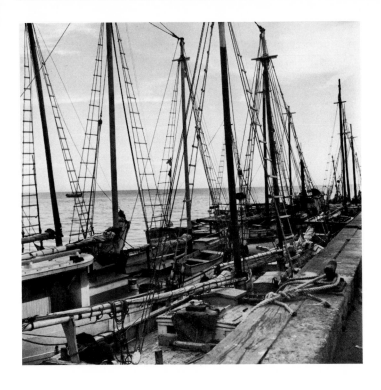

(above)
Fishing boats, Mexico.

(below)
Ante-bellum ruin, Mississippi.

(right)
Birches, upstate New York.

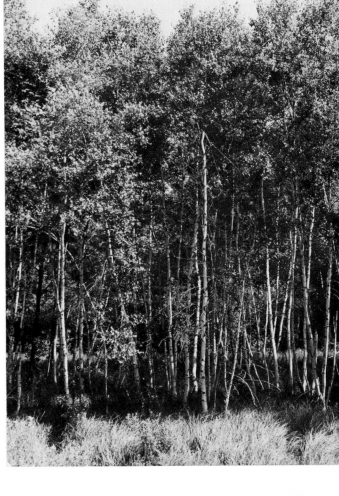

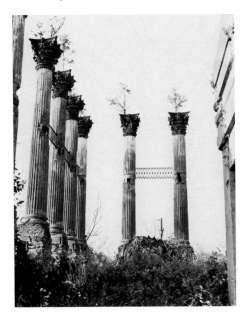

CONTRASTS IN SIZE

There are many types of contrast, and often these contrasts in themselves make for interesting photographs. Although the types of contrast are interrelated, they can be divided, for purposes of analysis, into those relating to the formal elements in a photograph (for example, contrasts of size, light and dark, textures and shapes) and those relating to the content or subject matter of a photograph.

Here is an interesting interplay of size contrasts, between those of the asparagus stalks themselves and between the asparagus in the foregound and the seemingly smaller trees in the background. The contrasts in direction and in the in-and out-of-focus textures also add interest.

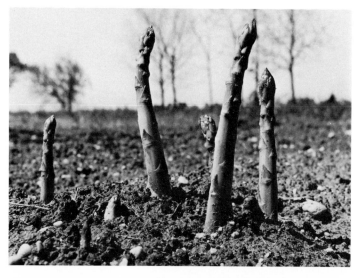

The larger pigeon is outnumbered by the smaller sparrows. The arrangement and contrast in size project a note of humor.

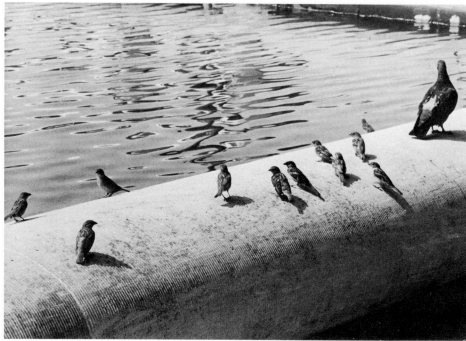

CONTRASTS IN LIGHT AND DARK

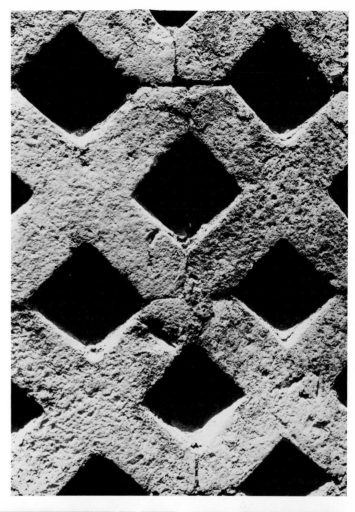

(top)
Pre-Columbian temple detail, Mexico.

(right)
Covered bridge detail, Vermont.

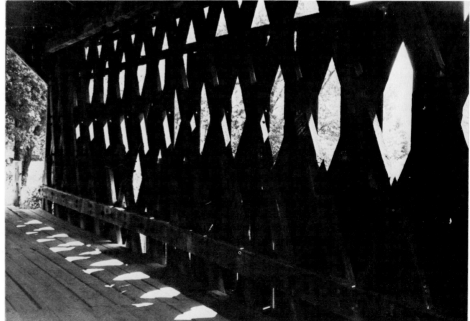

CONTRASTS IN TEXTURE

(below)
Grass and melting snow.

(right)
Girl inside nineteenth-century ruined house,
Achill Island, Ireland.

(below, right)
Donkey and grasses.

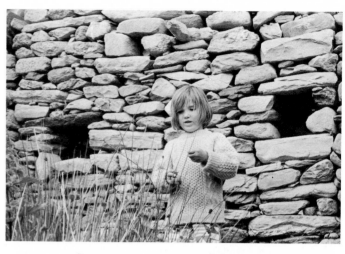

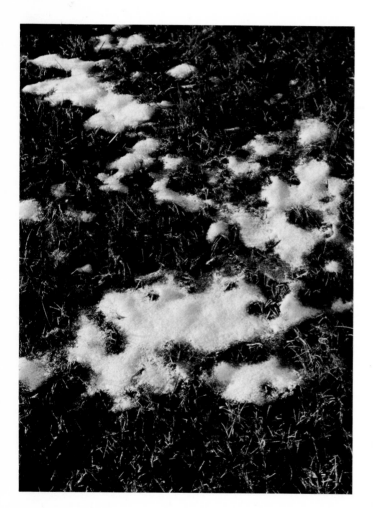

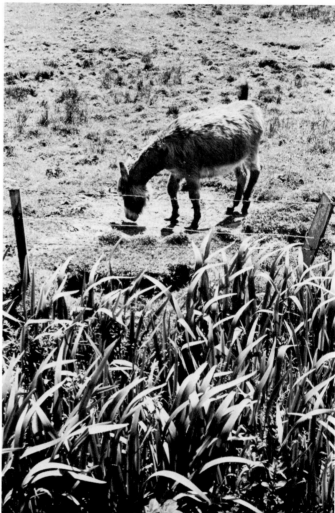

CONTRASTS IN SHAPE

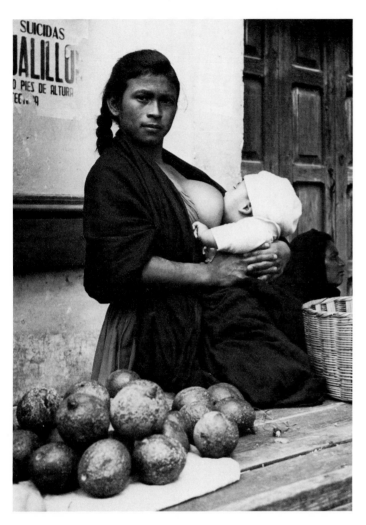

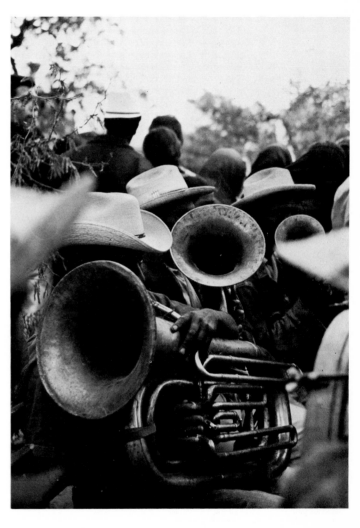

(above)
Nursing mother, San Cristobal de las Casas, Mexico. This is one of those photographs whose full visual power remains unknown until after development. The wonderful surprise was in the repetition of round shapes; the fruit, the breast, and the heads of the mother and baby. The roundness is in contrast to the rectangular panels in the floor, the door itself, the section of the building, and the section of sign.

(right)
Mexican band. There is a striking contrast in the shapes of the horns and their hollows and the hat shapes. The contrasts in the shapes of fingers and the tubes of the horn are also of note.

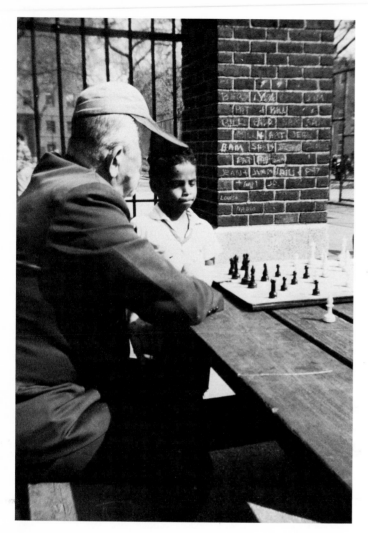

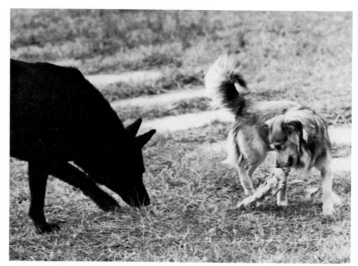

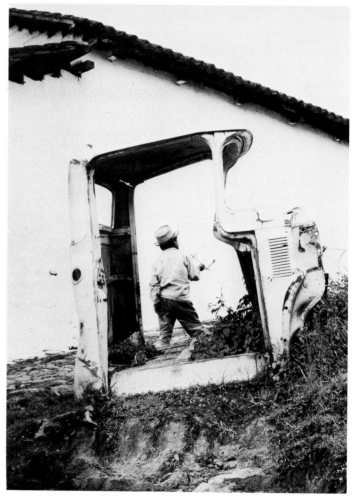

The contrasts and content of subject matter in these photographs are between the attitude of the interested observer and the involved participant, between the behavior of the haves and that of the have nots, and between the animate and inanimate of the young and creative, and the wrecked and discarded.

(above)
Chess player and audience, Tompkins Square Park, New York City. The varying attitudes of the different ages of people often exhibit great contrast and provide an extensive source of subject matter for interesting photographs.

(top, right)
Adam and Poncho.

(right)
Boy with handmade plane and ruined truck chassis, Guatemala.

CONTRASTS IN DIRECTION

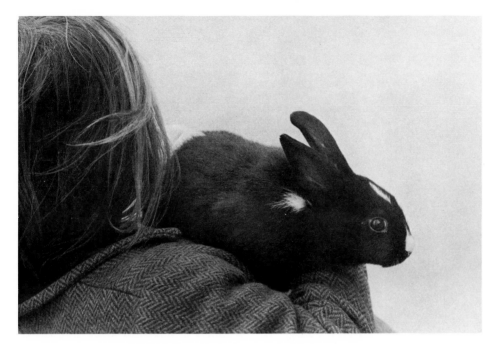

(left)
Child with bunny.

(below, left)
Caught unaware, the Mexican gentleman relaxing in front of the church moves to avoid the camera and his head and hands move in a rhythm and direction counter to those of the religious figure in the niche above.

(below, right)
English flea market. A fascinating interplay of direction of figures and heads is caught.

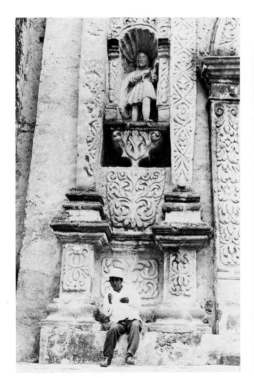

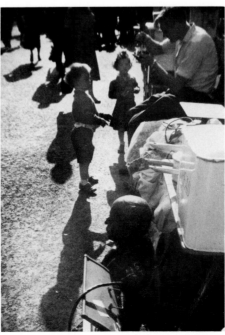

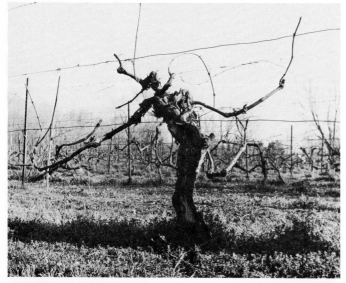

In this photograph of a grape orchard, aged trunks and extending arms appear throughout. This repetition creates a rhythm which helps unite the picture. The quality of the rhythm is dependent on the qualities of the shapes, particularly the zig-zag character or changing direction which resembles human forms in dancelike movement in this case. Although this rhythm is dominant in the picture, other rhythms are established by the repetition of the vertical poles, horizontal wires, and shadow patterns.

REPETITION AND RHYTHM

A degree of repetition of the elements within a photograph is essential to a good design. Repetition adds interest and unites the various parts of a composition. When certain elements, patterns, or visual units within a photograph are repeated, rhythms are established. These rhythms help move the viewer's eye through the picture and encourage exploration of the total unit. Most photographs will have a number of rhythms, some dominant, others essential but subordinate.

Repetition and the rhythms established by repetition are important to both photographs on this page. Note that even with repetition there is still variety and contrast of the elements, variety in size, height, width, position, gesture, lights and darks.

An interest in the presentation of repetition for its own sake may motivate the choice of subject for a photograph. Often the more powerful photographs are those derived from an area where repetition is an important component.

Repetition means movement in a photograph. The rhythms created have direction, which helps establish the picture's mood or spirit and develops a certain type of picture space. Most photographs have one dominant rhythm with a number of secondary rhythms that contrast with it.

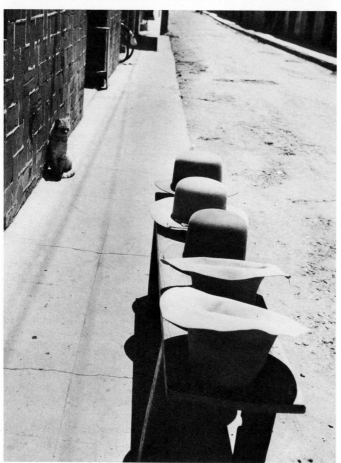

Here there is repetition of the hats, building stones, pavement blocks, textured street shapes, doorways, and shadow patterns—each creating its unique rhythm to enhance interest in this photograph.

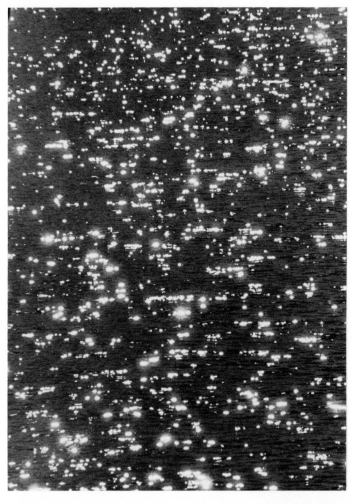

(above)
A design of repeated tiny reflections of light on water, with some rays that are visible and diamondlike in appearance.

(right)
Carpet of clouds above the Atlantic.

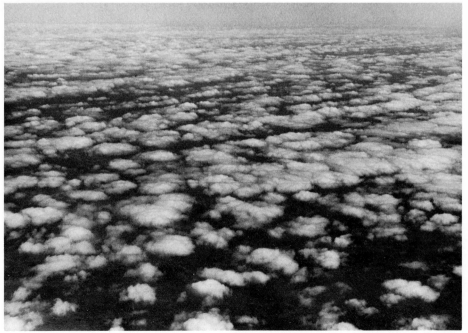

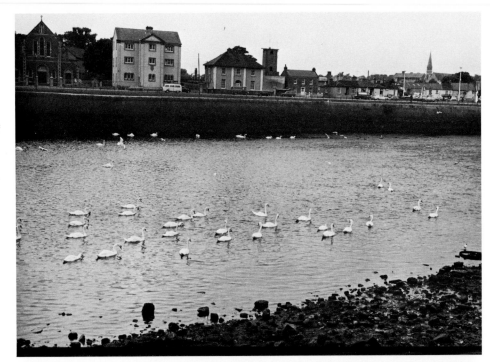

The swans comprise the only interesting part of this gray day view on the River Corrib in Galway, Ireland. A change in lens resulted in a series of subsequent photographs where the interesting repetition and rhythm of the swans were highlighted.

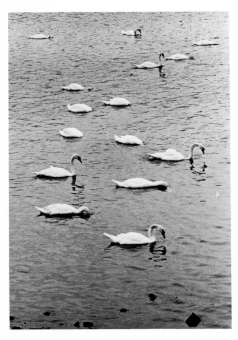

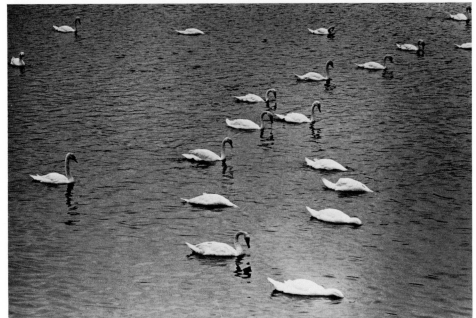

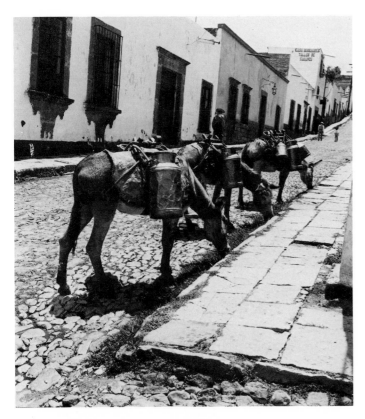

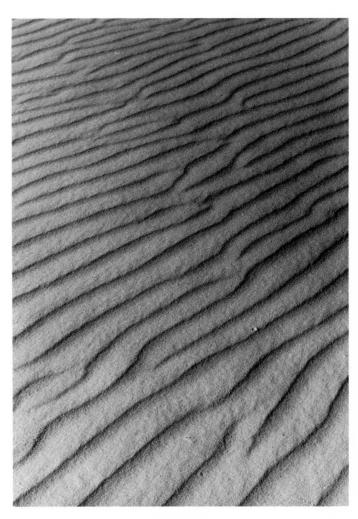

This photograph has a number of rhythms established by the repetition of the donkeys, their milk cans, the pavement slabs, street stones, windows, houses, pipes protruding from the houses, and walking figures. All of these rhythms move up and into space, becoming gradually smaller as they rise on the picture plane. The presence of so many rhythms moving in the same direction makes the upward movement even more emphatic.

In this photograph of sand patterns formed by the force of wind, there is an overwhelming rhythmic movement from lower right corner to upper left corner or the other way around, depending on one's perspective. The movement is gentle because of the nature of the lines created and the even, gradually changing amount of space between them. This movement results in an interesting spatial play within the photograph.

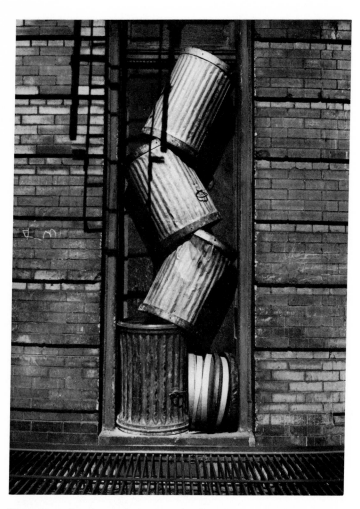

The group of trash cans is the most dominant rhythm, but the presence and repetition of the bricks, the grating, and the ladder add considerably to the spirit of the photograph.

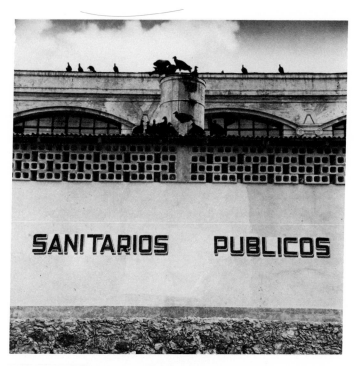

The rhythm of separated cement blocks is dominant because of the rich blacks and because of their central placement. The rhythms of vultures, words, clouds, and windows are no less important to the idea and spirit of a public sanitation plant.

EMPHASIS OR FOCUS

Good photographs need emphasis. Some characteristics, objects, or areas need to be subordinate to others. The emphasis or focus which one desires in a composition may be found to exist naturally or may have to be arbitrarily created by intentional placement.

Size is an important factor in emphasis. Larger areas and objects will almost always dominate, particularly when other similar but smaller areas or objects are present. Smaller objects can be made to dominate if they are placed or found in a setting where they stand out because of their uniqueness. The eye directs itself to that which is different.

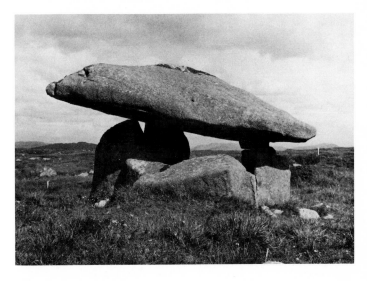

Prehistoric dolmen in Ireland.

Sheep on a Navajo Indian reservation, Utah.

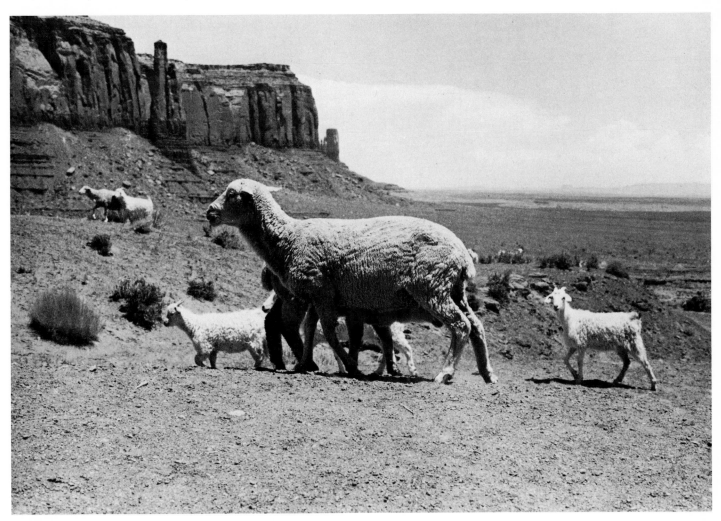

In this photograph the sheep occupies a minis-
cule part of the picture, yet the eye directs itself
to it because it is one of a kind.

Objects and areas can be made to dominate because of their contrasting relationship of light and dark, particularly if the contrast of light and dark is sharp. While taking a photograph, the photographer can often do much to effect the contrasts by changing one's vantage point, changing the position of the subject matter, or changing lenses.

A photographer can give emphasis to some areas by putting them in sharper focus than others. In most cases the eye will focus on the sharper parts. Repetition can also be used to achieve emphasis.

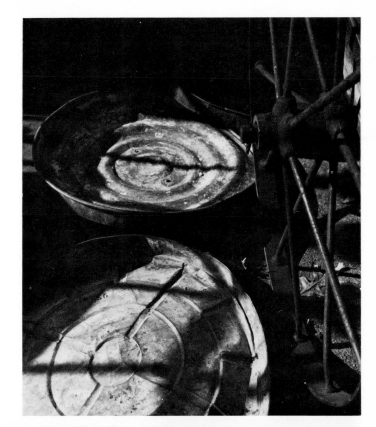

(above, right)
The lighter areas have been made to dominate in this photograph by moving closer, thus cutting off and keeping to the side a good part of the wheel and its shadow.

(right)
The boy's form is emphasized by the presence of a lighter background. Since the photograph was taken so that the profile of the nose and mouth was against the white figure 8, not only is the round shape of the head repeated, but the profile is made more emphatic.

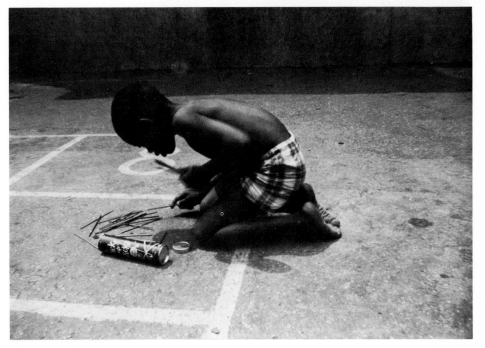

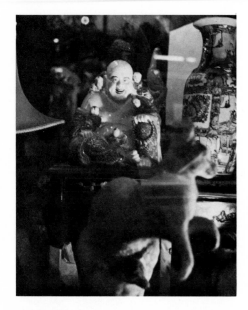

The Buddha figure is the obvious point of emphasis here, taking attention away from the kangaroo with baby in pouch which is intentionally out of focus. The presence of the kangaroo is, nevertheless, important to the spirit and composition of the picture.

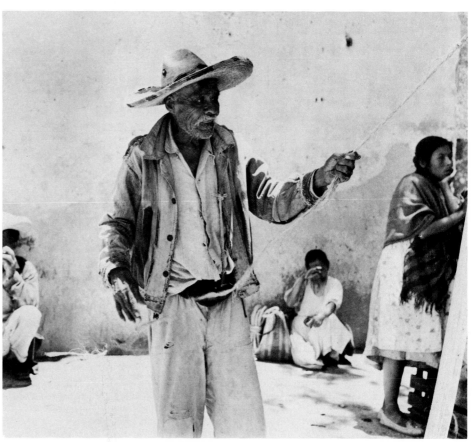

In this photograph the old gentleman pulling the string is the focal point of the picture. However, emphasis is also given to the gesture of hands and arms by the rhythm of varying arm and hand movements of the figures in the background.

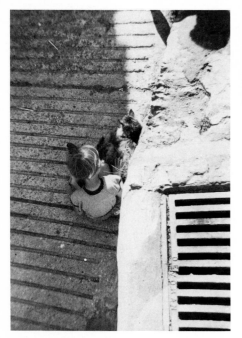

The rhythm and direction of line established by the street and drainage grate help point to and emphasize the young girl patting the cat.

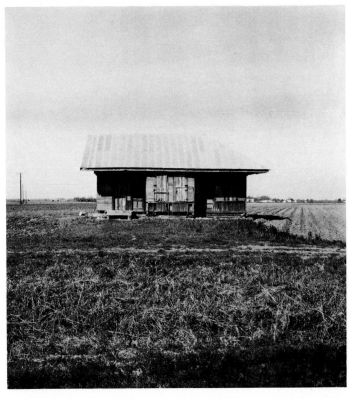

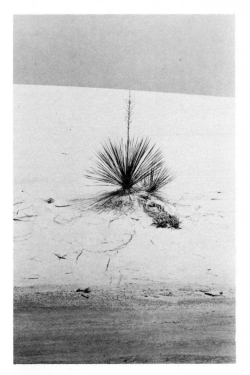

Photographers must consider placement of the parts of a picture when creating emphasis. It may be that a photograph will be stronger if the point of emphasis is in the center. A center emphasis need not be a tangible object but may be a certain "sensed" point or area. Emphasis may be at a point off-center. Emphasis may be in the foreground. It may be in the background. Emphasis may be down; it may be up.

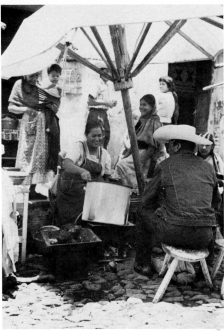

(top, right)
The vertical thrust of the yucca stalk is further strengthened by placing the plant in direct center.

(above)
The sense of isolation of this Southern tenant farmer's shack has been heightened by placing it in the center of the picture with expanse of sky and land on all sides.

(right)
The emphasis in this picture is an area just above the middle of the pot in the center of the photograph. The gazes of all who sit or stand are aimed in this direction. The point of emphasis is neither the pot — or the woman cooking.

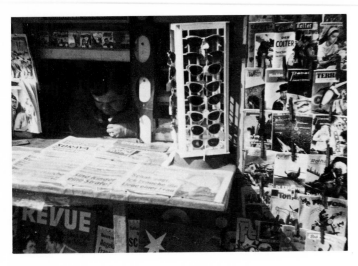

(above)
The eye automatically shifts to left of center, toward the German newsstand attendant asleep in his booth.

(right)
Back Lane, England. The emphasis is off-center.

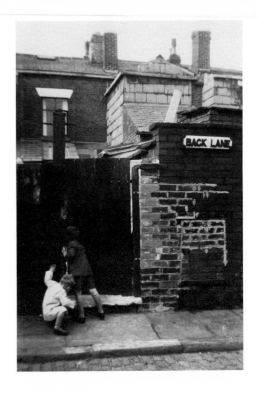

In these two photographs the emphasis is in the foreground.

(below)
Pensive Adam and his reflection.

(right)
Girl playing in Ravenna, Italy.

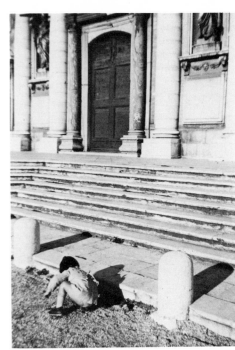

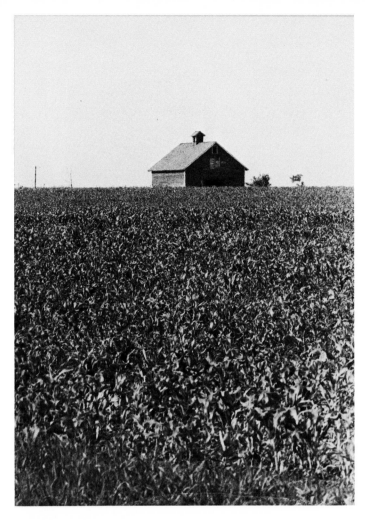

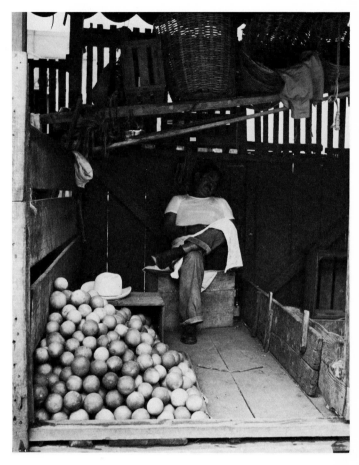

Here the emphasis is in the background.

(above)
Illinois cornfield.

(right)
Siesta for a seller of oranges.

Here the emphasis is *up*.

Pigeon perched on a roof. A moment later—the same pigeon in flight.

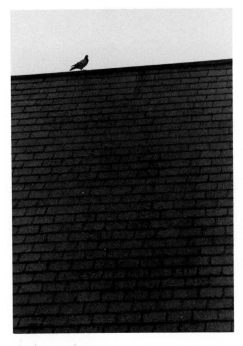 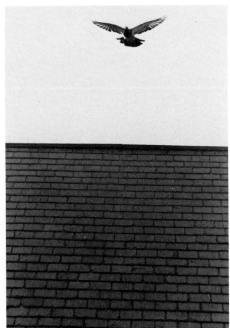

The emphasis here is *down*.

Pipe.

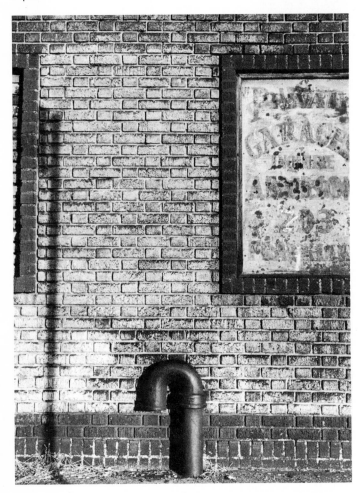

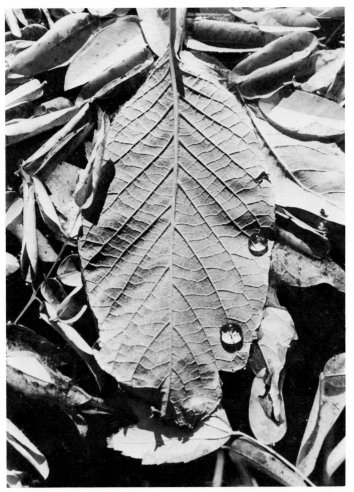

In arranging for a point of emphasis, it is important for a photographer to avoid what is known as the bull's eye effect, which occurs when a section or object becomes so dominant that the viewer's eye remains fixed on it and is not moved to explore other areas of the picture. Also to be avoided are photographs in which nothing at all appears dominant because of a general sameness, or those in which the point of emphasis is undesirable.

(below)
This prehistoric tree trunk, now exposed on an Irish bog, is of such interest visually that one remains focused on it with no desire to explore its rather uninteresting setting. This photograph illustrates a definite *bull's-eye* effect.

(left)
The two transparent drops of water on the center leaf are so dominant because of their uniqueness that the viewer's eyes tend to move back and forth between them, instead of exploring the rest of the picture.

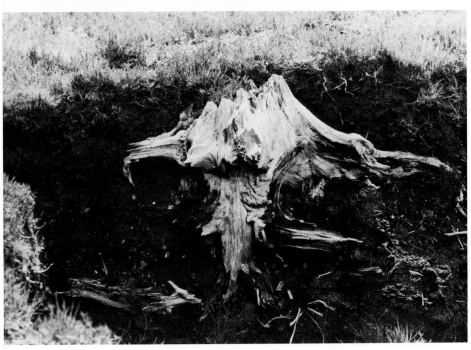

UNITY OR COHESION

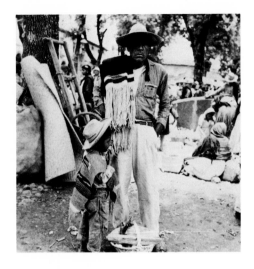

One of the principal aims of all art is unity. When a composition is unified, we have what is termed an "aesthetic whole." The composition "works", the parts all contribute to each other and fit together. Often considerable work must be devoted to attaining this unity, but the exhilaration that accompanies success is ample reward for waging the struggle. In fact, struggle is at the heart of the creative process.

We have seen how balance, variety and contrast, repetition, and emphasis are all necessary to unity. There are instances when the unity evolves easily, but there are many others when it is achieved only after many choices and changes. Frequently a series of darkroom changes can transform a potentially poor print into a good one.

This photograph was taken in a busy Mexican market with a twin-lens reflex camera. The print, made from the original negative on No. 3 contrast Agfa Brovira paper f 16 enlarger lens opening for six seconds, is a poor one. The center group is swallowed up visually by the confusion behind it. There is too much weight on the left side of the picture, making the whole poorly balanced. The right side is too light and even disturbingly washed-out in places. One cannot see the old man's eyes because of the heavy shadow under the brim of the hat. In fact, this shadow gets undue emphasis because it is one of the darkest parts of the picture and because it is a part of the central figure. The photograph, however, is not beyond improvement with the use of the darkroom techniques of cropping, burning-in, and dodging.

To improve the photograph the photographer decided to eliminate some of the background. This change was effected by adopting a rectangular format which involved cropping parts of both the left and right sides. The rectangular frame also serves to strengthen focus on the center group by repeating the vertical quality of the standing figures. The same paper and lens opening were used, but exposure time was increased to eight seconds because of the larger size. The problems of poor balance and poor light-dark relationship must still be solved.

To improve the print enough to meet both aesthetic and subject demands, the photographer had to employ the techniques of dodging and burning-in. Dodging, or holding back light from selected areas while keeping the exposure time of other areas constant, provided the solution to removal of the heavy dark shadow under the brim. A small piece of paper the shape of the shadow was attached to a long hat pin and placed over the area after four seconds, thus reducing the exposure time of this section by half that of the other area which was exposed for eight seconds. An increase in exposure time was necessary in other areas to darken them. Cards slightly larger than the printing paper were used to make tracings of the areas to be burned-in, or given increased time. (See drawings below).

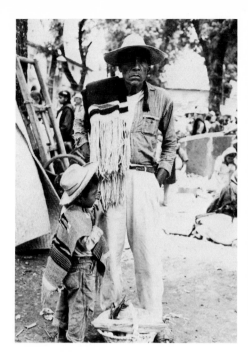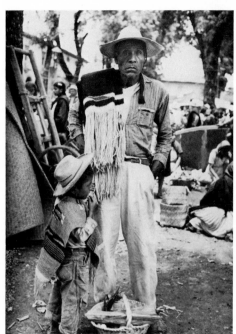

In the process of dodging or burning-in, the card must not be held too close to the easel and must be moved gently during the additional exposure period to avoid having the boundary lines of the cutout shapes appear in the final print.

The first card was used to increase exposure time, thereby darkening the right side from the bottom of the tree to the bottom of the picture. This change made for better balance and a clearer division between the old man's pants and the ground. The additional time was eight seconds.

The second card was used to increase definition of the woman's baskets and light skirt. An additional sixteen seconds was needed because of the naturally light color in bright sun.

The third card was used for seven seconds to bring out detail in the basket at the old man's feet.

The fourth card was used for seven seconds to further define the mat on the left side. The overall result is a balanced composition with an obvious point of emphasis. The old man's eyes are clearly visible, and yet one does not lose the sense of their being in a shadowy area.

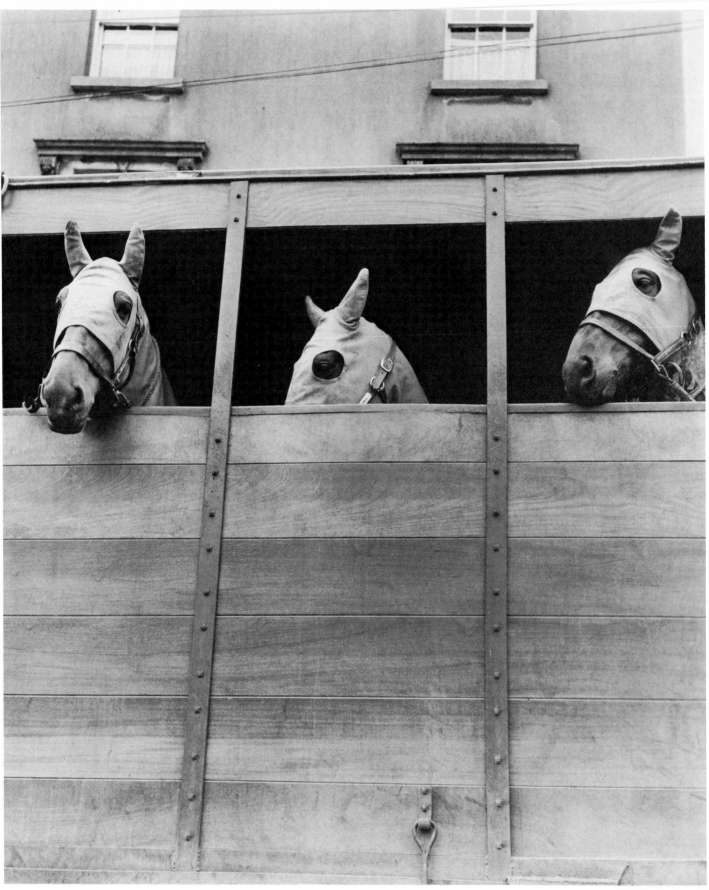

Chapter 2
THE PHOTOGRAPHIC EYE

There is much to be said about the need for learning to see "photographically." This ability may be developed easily and quite naturally for some. For others, it may come only after much work, both with the camera and in the dark-room.

Any photographer must learn to see the world in terms of the abstraction from nature which will appear as the negative and be developed as the print. Any area one contemplates photographing must be seen not only as a whole, but as a composition of parts. Hence the photographer must become aware of the characteristics of those parts, as well as their role in the composition as a whole. The process of design involves working with these parts and all their characteristics.

Every part of the visual world has shape or form. It also has color with a certain value, which constitutes its lightness or darkness. It has texture and some characteristics of line and space. In the language of art, these visual properties are known as the art elements or design elements. When looking at an area, a photographer must conceive of it in terms of all these design elements and the characteristics which they manifest. This special way of seeing, or sensitivity, is developed through careful observation, a characteristic of all good artists. The aspiring photographer must rekindle the same kind of curiosity a child uses to investigate the world. Innumerable textures, lines, patterns, colors and values, shapes and spatial qualities, and combinations of them should excite the photographer. In discussing the design elements, we will treat them separately but it is important for the reader to keep in mind that most objects and areas exhibit these elements carefully unified with each other.

SHAPE

Shape is defined area. In nature shape may be two-dimensional, having length and width, but no depth, in which case it is often called pattern; or it may be three-dimensional, with length, width, and depth or volume, in which case it is often called mass or form. In photography, three-dimensional shape is recorded as a two-dimensional image. The three-dimensional nature of the objects or areas is rendered by placement and by changes in value (lights and darks).

Three-dimensional quality of form is often rendered in photography, and in nature, by value change. This value change is dependent on the characteristics of an object (or area), on the position of the object in space in a relation to the light source, and on the relationship of the object to other areas, objects, or parts.

(left)
The brick pattern, as well as the shadow at right, is flat or two-dimensional, and appears this way on the flat surface of the photograph.

(below, left)
This croton and pot exist in real space and are, of course, three-dimensional by nature. The interesting spotted areas or shapes on the leaves are two-dimensional. One does not question the three-dimensional reality of the leaves, stem, and pot because of their convincing placement within the space of the flat picture plane.

(below)
The three-dimensional quality of the pots is described by the interplay of values within the area of the shapes, the contour of shapes themselves, and their color and texture. Placement of shapes within shapes, as in the handles and mouths of the pots, also help to suggest three-dimensional quality.

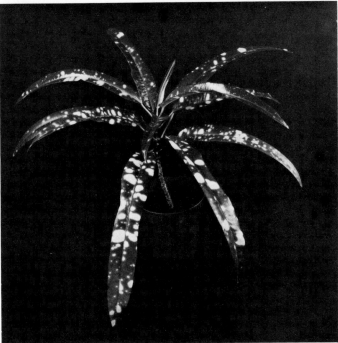

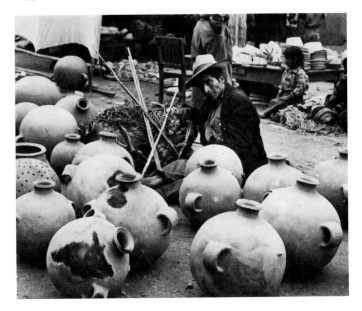

Photographically, it is possible to change three-dimensional shape so that it appears to lose its three-dimensional quality. This process may fulfill a certain aesthetic or expressive intent which the photographer seeks. Elimination of most or all of the grays in black and white photography will create this effect. The elimination may be accomplished in a number of ways, including the use of a special film or special developer or the rephotographing of prints and negatives. Perhaps the simplest and most common way is to photograph with a strong light source and print on a special high contrast paper.

Both of these photographs were taken using a strong light source and placing the subject against a dark background. The negatives were then printed on a high contrast paper.

One's attention is drawn in this photograph to the contour of the young girl's body by elimination of most of the gray values. Photographing her against a black curtain made the shape of her body stand out even more emphatically.

This cow's skull was also photographed with strong light against a black background and printed on a high contrast paper. With so little gray, one's attention is drawn to the shape as a whole. Three-dimensional form is understood rather than defined by gray.

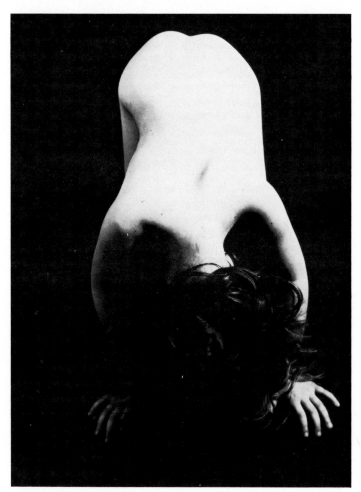

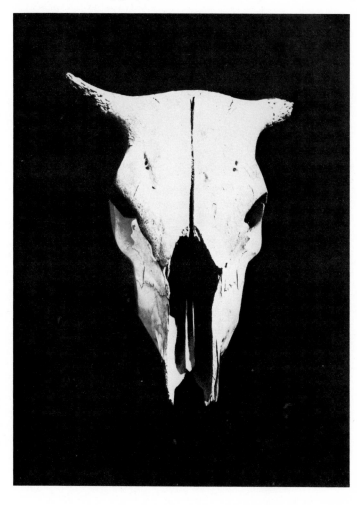

Another way to make shapes appear flatter is to photograph them against the sun, taking the light reading from the brightest area of the backlight. What are created are silhouettes which are often the basis for exciting imagery and plays with shape. Complex shapes are simplified, reduced, and defined. One dominant silhouetted form in a photograph will often serve to direct the viewer's eye to a study of other shapes within the picture.

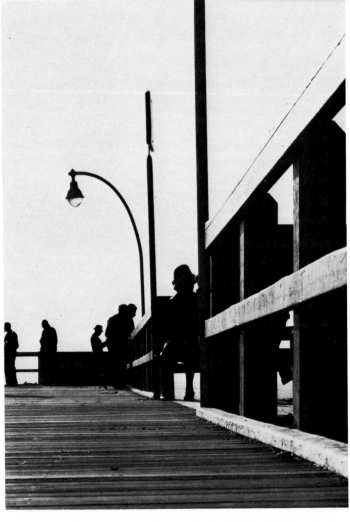

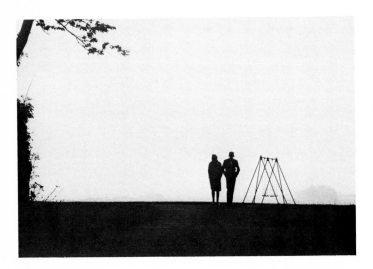

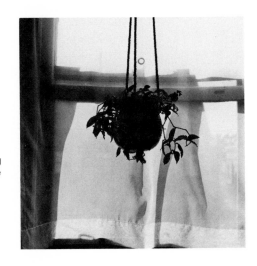

(right)
This series of photographs of a central hanging pot is an interesting study of changes in shape and clarity. The changes are effected by the light summer breeze which moves the gauze curtain and curtain pull and their shadows. Note the change in clarity of the windows and the other shapes of the houses across the street.

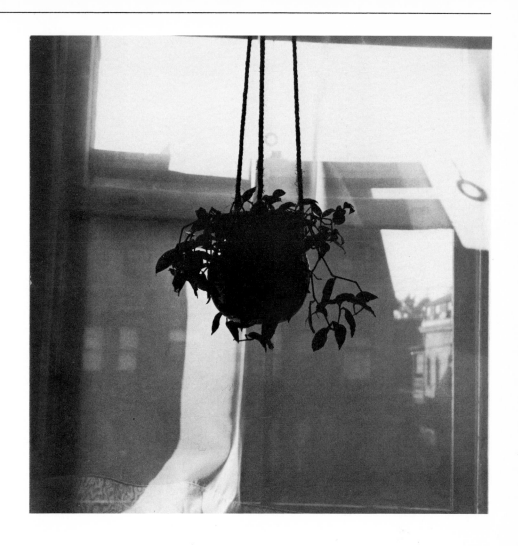

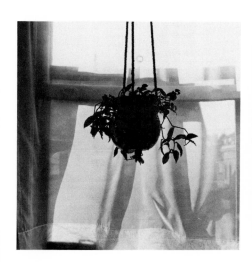
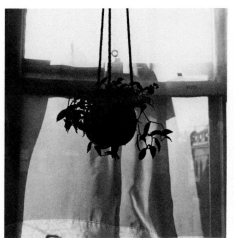
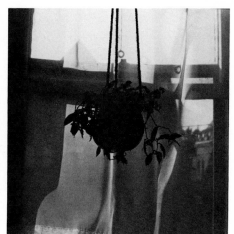

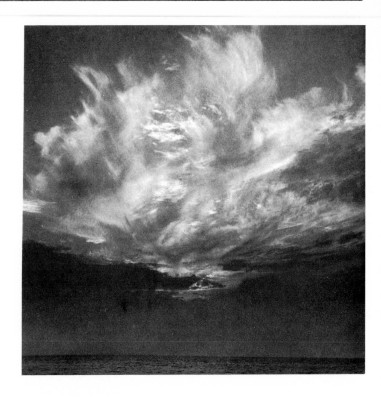

Every art element exhibits qualities of every other element. A particular shape, for instance, will have unique properties of space, texture, color and value, and line. That line may be its contour. The shape itself may also be a type of line. All lines have shape and are shapes.

There are many ways in which a photographer can make the shape of an object serve as the subject or emphasis of a photograph. For example, an object may be isolated so that it becomes the focus of the composition. The methods of isolating are varied. One of the simplest is either to find or place the object against a contrasting background, light or dark as the case may be.

The anthill and the cloud are as fascinating for their texture as they are for their shape. Note the round, geometric quality of the anthill in contrast to the irregular contour of the cloud.

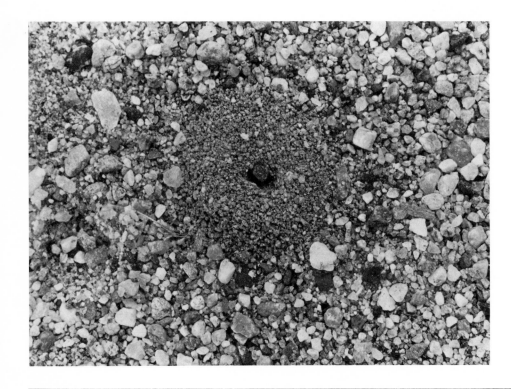

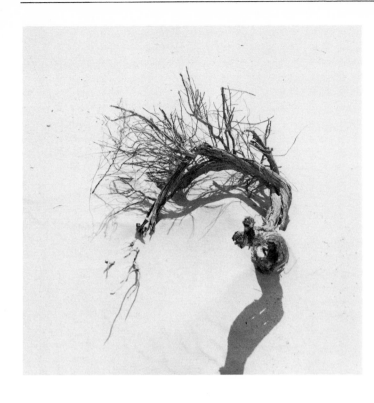

(left)
This section of dried shrub was found lying on sunlit sand at White Sands, New Mexico. The natural white background very effectively highlights the shape of the shrub which is highly linear in quality.

(below)
This sunlit tire was found apart from, but leaning against, a group of other tires, stacked up, for the most part, in the shade. Although of the same color, the light-dark relationship made the shape of the isolated tire the dominant focus of this photograph.

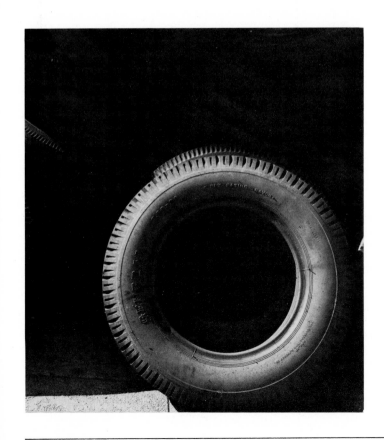

Isolation of shapes in vast spatial areas can also make for interesting photographic imagery. There are many examples of this type of isolation. One fine illustration appears in Monument Valley, Utah, where wind and water erosion over thousands of years have created giant outdoor sculptures, magnificent shapes of red sandstone rising above the flat desert valley floor.

Note that in the photograph of the centrally placed single shape the viewer's attention is directed to the shape. The viewer is drawn to examine this shape and its characteristics as it stands majestically in the vast surrounding space. In the photograph with two shapes, however, the viewer's attention is drawn less to the shapes themselves than to the interesting relationship that exists between them in space, size and shape. The eye moves back and forth between them, comparing and contrasting their various characteristics. The space between the shapes has a special significance or dynamic quality.

Emphasis on shape can also be achieved by creating a composition with like or similar shapes or one with series of like and contrasting shapes.

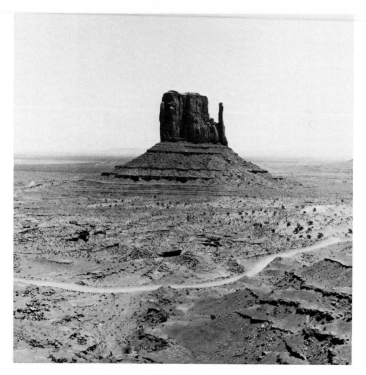

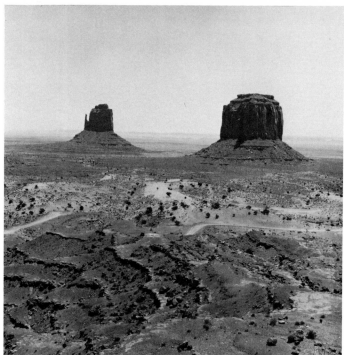

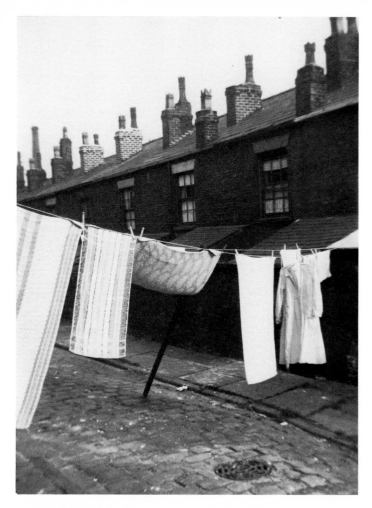

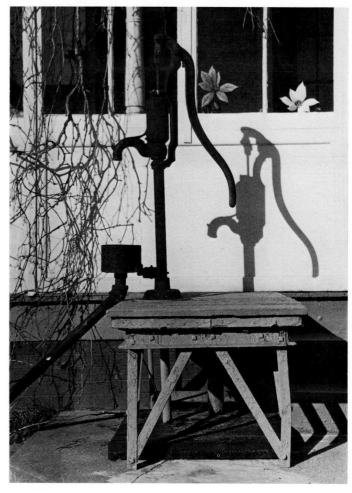

(above)
This photograph of a clothesline behind a
group of row houses in an industrial part of
England is essentially a play of groups of
shapes: the clothes on the line, the windows,
the chimneys, the pavement slabs, the street
stones and roof tops. Note the geometric qual-
ity of most of the shapes and the contrast
provided by the wedge-shaped chimney pots.

(right)
The shape of the pump has been emphasized
by its shadow on the porch front.

Shape has been emphasized in the following three photographs by the repetition of like shapes.

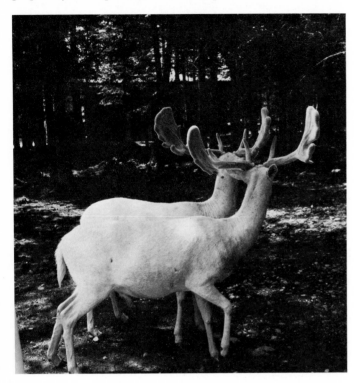

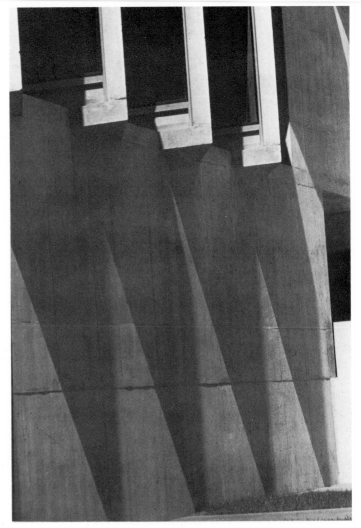

(left)
A photograph of two reindeer who for a brief instant assumed a similar position. This position calls special attention to the shape of body and antlers.

(above)
The sections of a series of windows play with their shadows on a contemporary building.

(opposite)
Note the interrelationship among all parts of these garbage cans: the bodies, the lids, the two handles and the shadows. The placement of the parts with the varying degree of opening between the lids and bodies also endows these inanimate objects with an animate and even humorous quality.

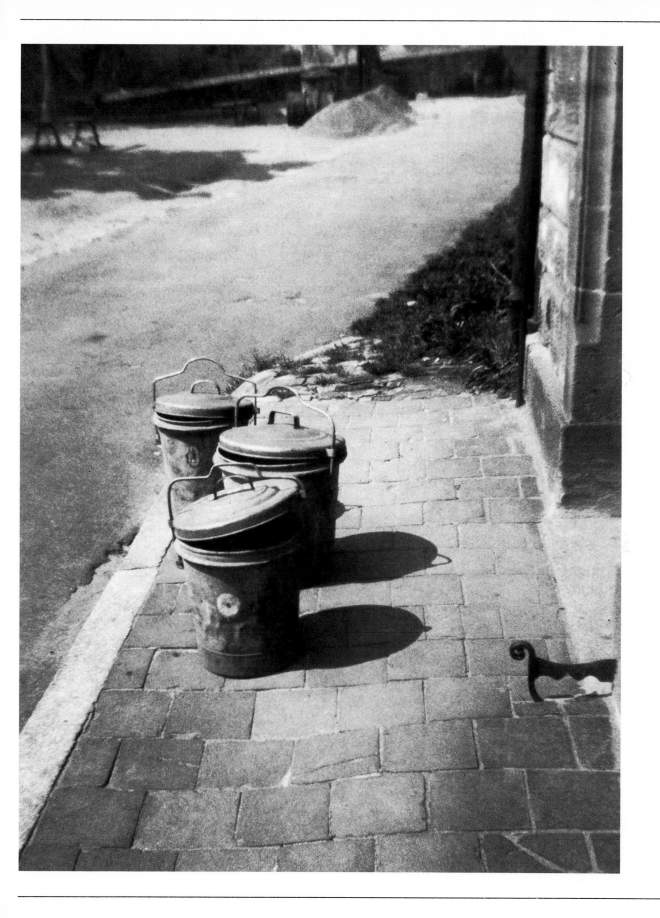

Attention may be directed to the shape of an object if it is photographed from an unusual angle or angles. By force of habit, most objects are viewed from only one angle, usually the front. Often true discovery results from the examination of an object from unaccustomed angles. Most objects and areas are composed of a number of shapes; many times shapes are contained within shapes. Frequently parts of objects and their properties will make for interesting photography.

Here are two photographs of parts of the very ordinary park water fountain below. By photographing its parts from different angles, some delightful imagery resulted.

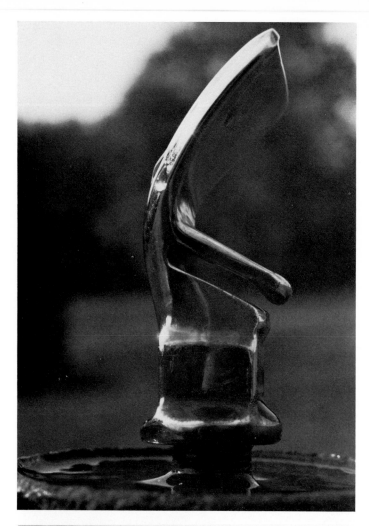

(top, right)
Here is a fascinating play of shape with reflective surface. There is a spirit of humor and animation; some living being, animal, human, or monster, is opening his mouth wide.

(bottom, right)
The mouthpiece from this angle takes on the character of a primitive effigy with stylized round nose and mouth. The interplay of round shapes of varying sizes also adds interest.

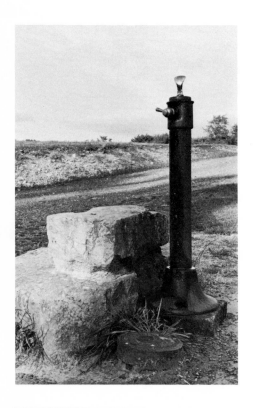

The myriad possibilities for change in shape within a single subject or area are interesting to explore. Human, animal and bird forms are capable of many shapes.

Sometimes the change in shape will occur only in a section of the subject. Note how, in this series of a flamingo, the body and leg remain stationary while the head and long neck change in character of shape.

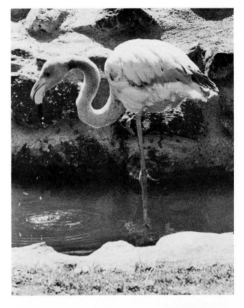

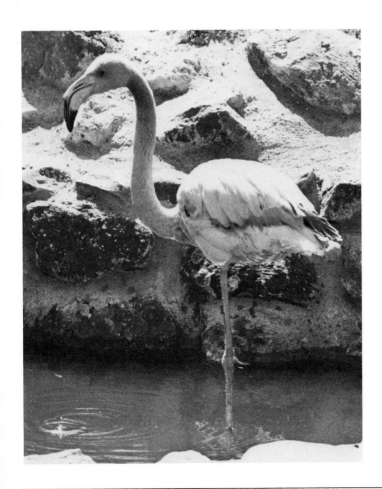

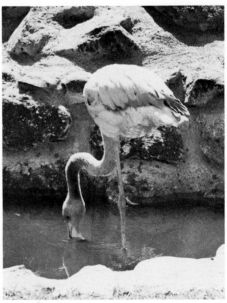

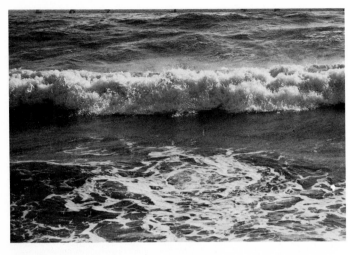

One of nature's phenomena rich in photographic potential is ocean tide. The variety, change, and plays of shape are many. The photographs here were taken within a thirty-square-foot area of ocean within a few minutes of each other.

The relationship of animate and inanimate to the character of, and change in, shape can be especially interesting and revealing if presented in a series of photographs.

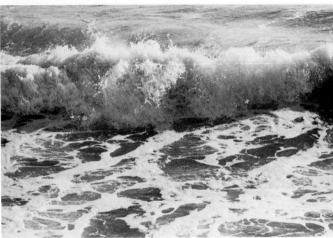

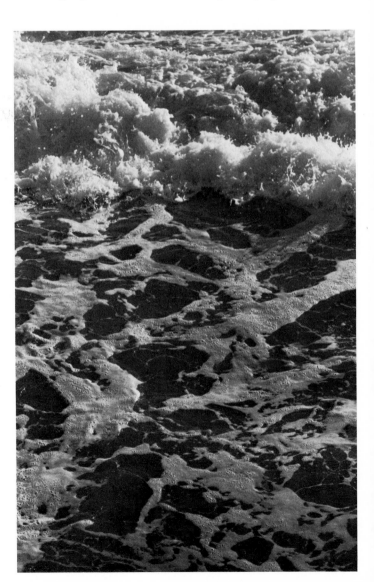

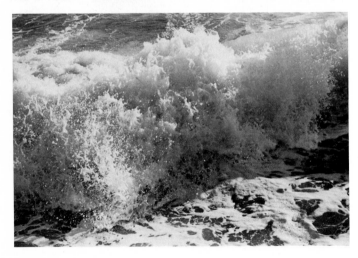

(right)
The shape of the piano legs is effectively contrasted with that of the legs of the young girl, another example of the relationship of animate and inanimate. The presence of the dog with his own expression and gestures adds interest and contrast. In the first frame he even seems to make the presence of sound quite real by assuming the attitude of an attentive listener.

In the photographs below the shapes of the white notes, black notes, and fingers are remarkably similar, all having marked linear quality. The change in the shape of the fingers in each frame is responsible for the interesting contrast.

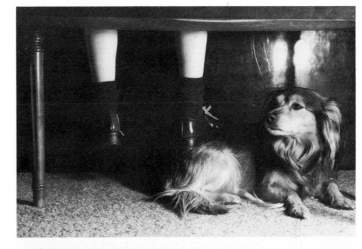

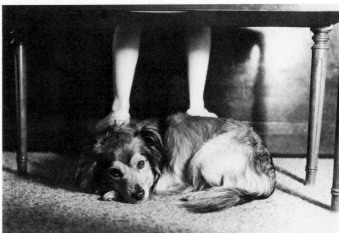

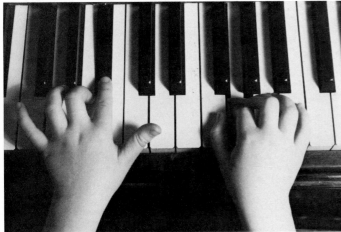

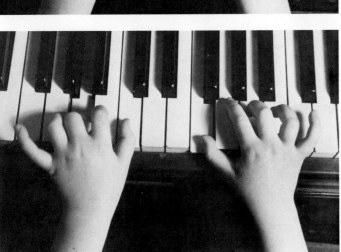

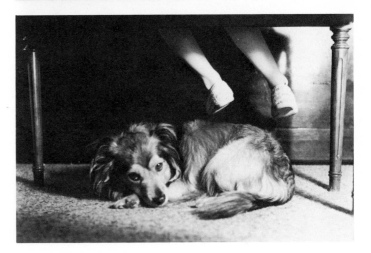

It is important for a photographer to develop an awareness of the character of shape in relationship to change. The response of shape to change is a vital part of the nature of things and often provides a source of rich photographic imagery. Often the shape that is caught in a brief moment enables the viewer to see at length and for all time what is transitory or fleeting. The camera can capture and retain on film this moment, these shapes, whereas the eye and mind will most often lose them. All passes too quickly. In the following photographs the variety in shape a very familiar object, the flag, can take within a few moments on a windy day. The contrast with shapes of clouds in the first two photographs of the series is also of interest.

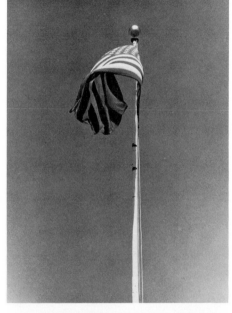

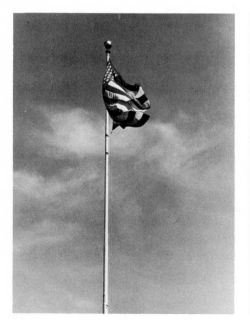

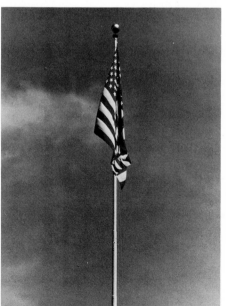

Investigating the interplay of shape occurring within objects can result in some exciting photographs. There is often a sense of mystery surrounding an inside view. The shape of the space itself, as well as its area and depth, can be fascinating.

(right)
A close-up study of the inside of an orchid. Here shape, space, and value relationship are particularly outstanding. The mood is one of delicacy and fragility.

(below)
A study of the interior of a geode. The relationship between the broken quartz frame of the exterior and the rounded and interlocking shapes of the interior, is of particular note.

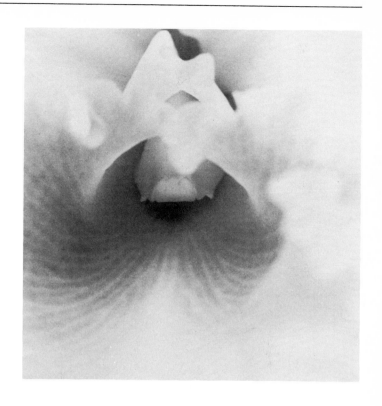

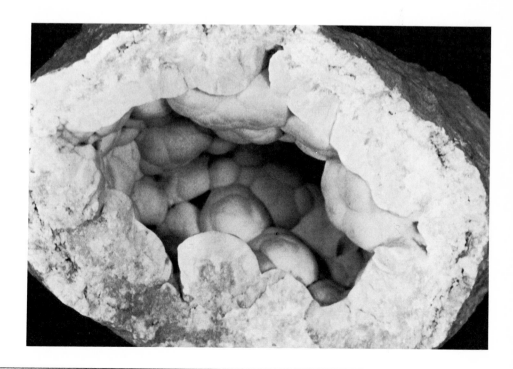

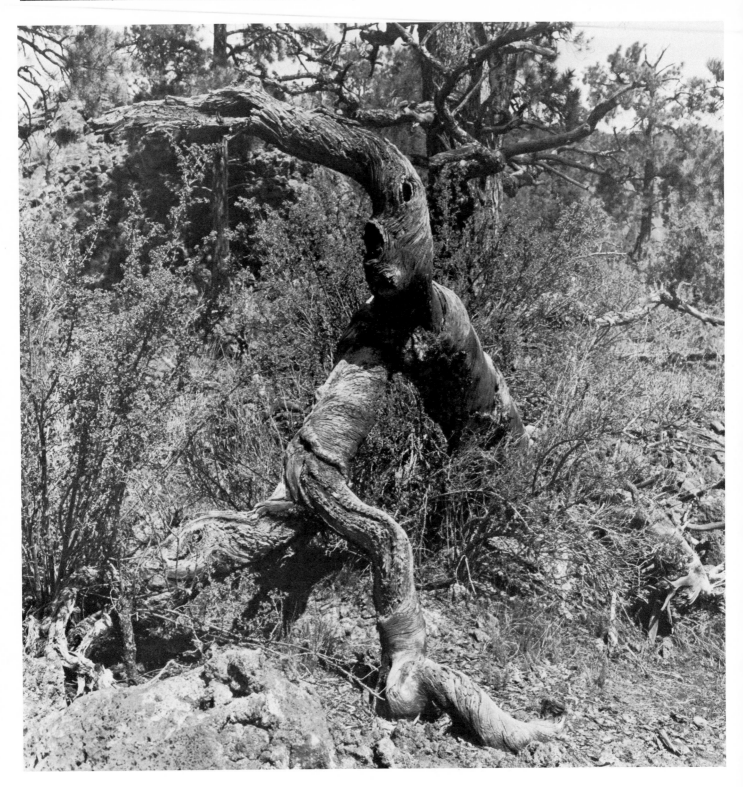

Can you find the monster?

Sometimes the shapes that occur in nature can suggest other objects and make interesting photographs for that reason. Familiar is the game children play with shapes of clouds, in which everything from kings to monsters can be found. Just such suggestive images can be seen here in pieces of old wood.

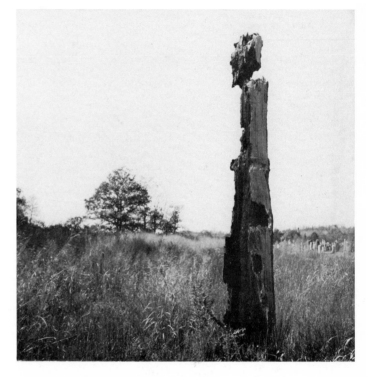

An old king with pointed beard surveys his domain.

(top, right)
Pipes and shadows.

(below)
Oil spills on concrete.

(bottom, right)
A common sight in Ireland, a section of wall rebuilt with multishaped rocks and bits of old broken gravestones.

Even common objects and areas can make exciting subjects for photographs.

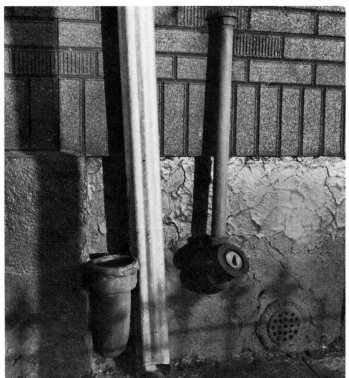

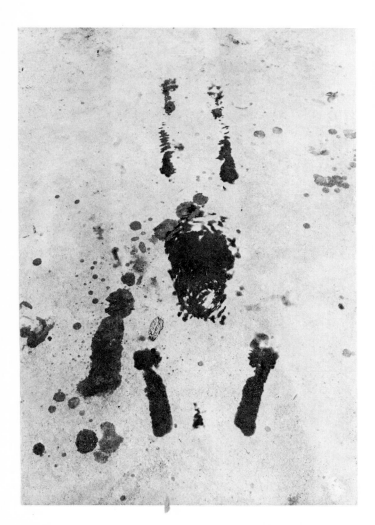

LINE

Line is mark or mass characterized by being proportionally longer than it is wide. In nature lines occur both alone and in combination with other lines. Lines, like shapes, can be two-dimensional and three-dimensional. If a three-dimensional line is photographed, its volume will be recorded in terms of lights and darks, provided that certain lighting conditions exist.

This is a photograph of a twig, which is three-dimensional, and its shadow, which is two-dimensional. Because photography is a two-dimensional art form, both are recorded on a flat surface. Textural and light-dark relationships on the twig convince the viewer of its three-dimensional reality. The interest in contrast between the two- and three-dimensional forms provided the incentive for taking this photograph.

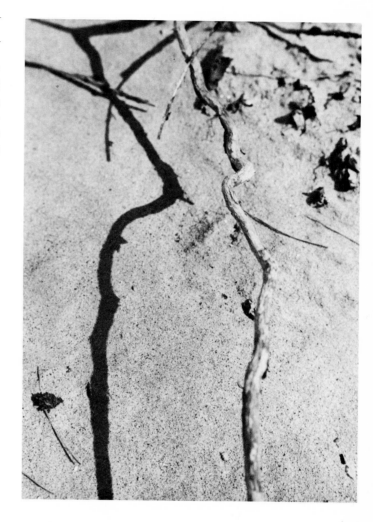

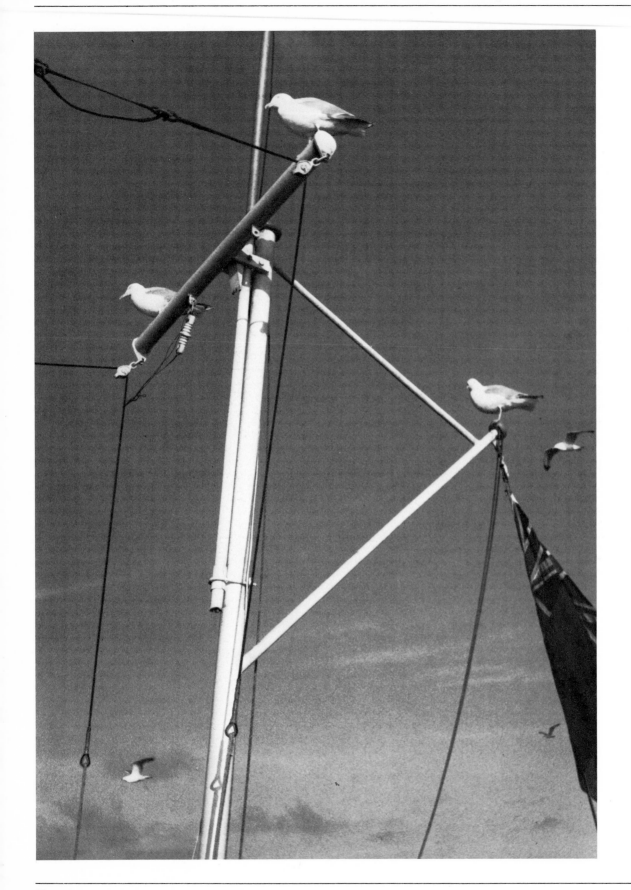

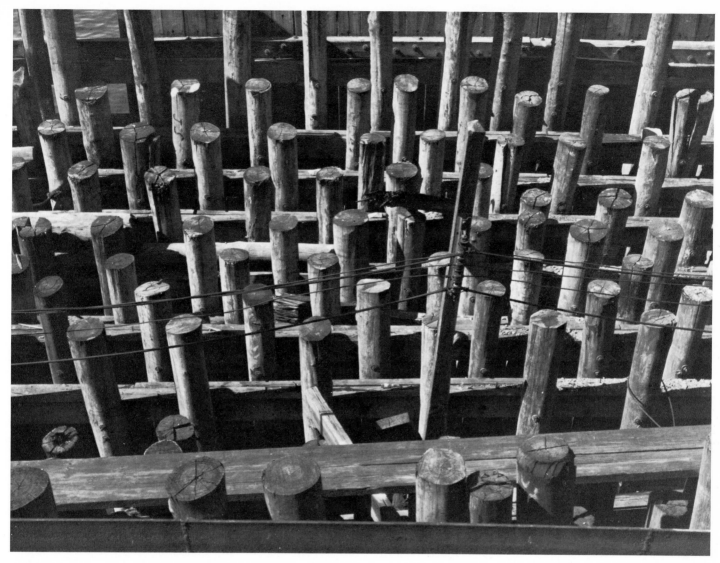

(above)
This is a play of three-dimensional lines, in the form of poles with variety of light-dark relationships on their continuous rounded and relatively smooth surfaces. This light-dark play helps define the volume of the poles, in addition to increasing the visual appeal of the photograph.

(opposite)
In this composition of lines, there is a nice variety of light and dark, of thick and thin, and of direction. Note how the strong sun has flattened the appearance of the main vertical poles, making an interesting contrast with the more defined three-dimensional quality of the crosspole on which the two sea gulls are perched.

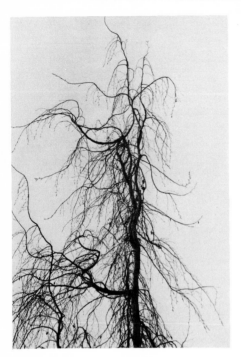 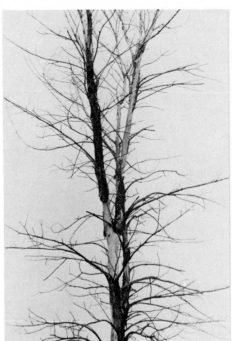 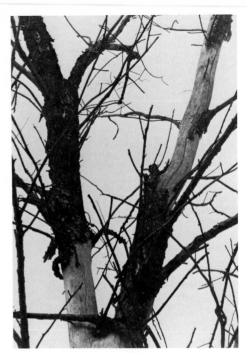

One of the most obvious examples of line in nature is the configuration presented by barren trees against the sky. The patterns created are infinite in variety.

One should not feel the need to use a whole tree photographically. Details of certain areas of a tree can make powerful photographs. A change of lens while photographing or cropping during printing is sometimes all that is needed for interesting detail studies.

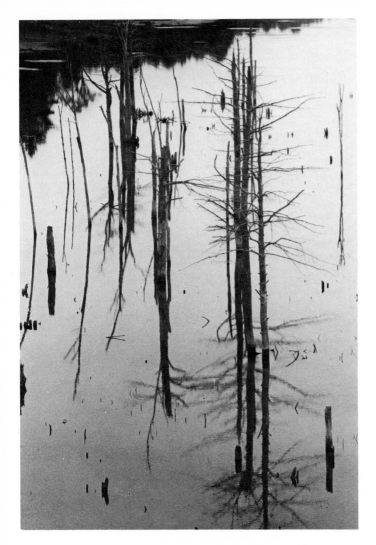 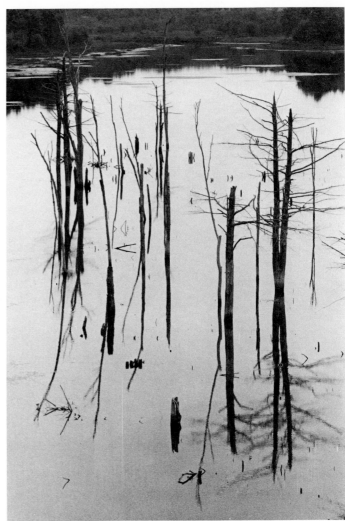

A variation on the theme of barren trees against the sky is a play of line reflections in water.

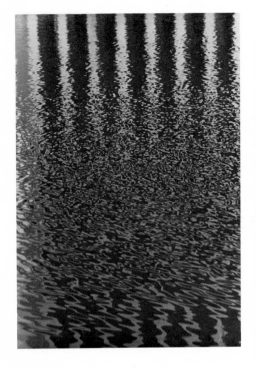 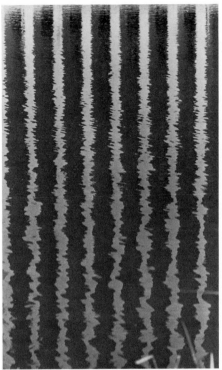 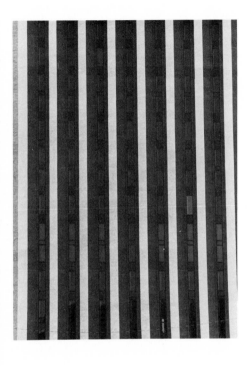

The photographic potential of line reflection need not be limited to trees and water. Other objects and reflective surfaces combine with equal effectiveness. Change in the object or the surface or both can also add interest.

Here are photographs of the vertical lines of a modern building and two reflection studies of those lines in a neighboring pond. One can observe how the character of line changed with the degree of agitation of the water. In the photograph at left, the agitation was obviously greater than in that at right where the water movement was quite gentle. The difference in line contour is of particular interest.

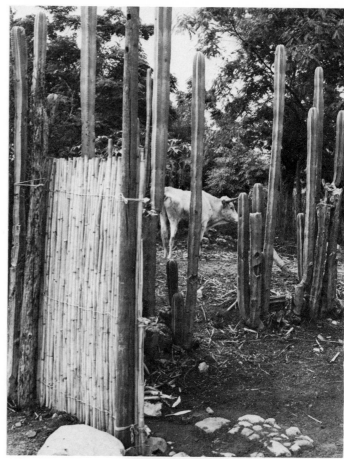

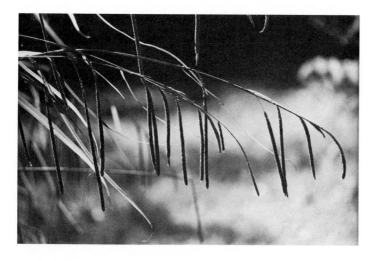

A search for lines and line interplay in the visual world will turn up some intriguing finds.

Note the many and different characteristics of line exhibited in these photographs including short, long, thick, thin, straight, curved, vertical, horizontal, diagonal, light, dark, smooth, rough, and a variety of combinations.

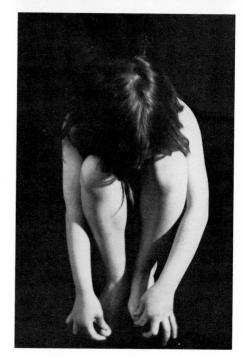

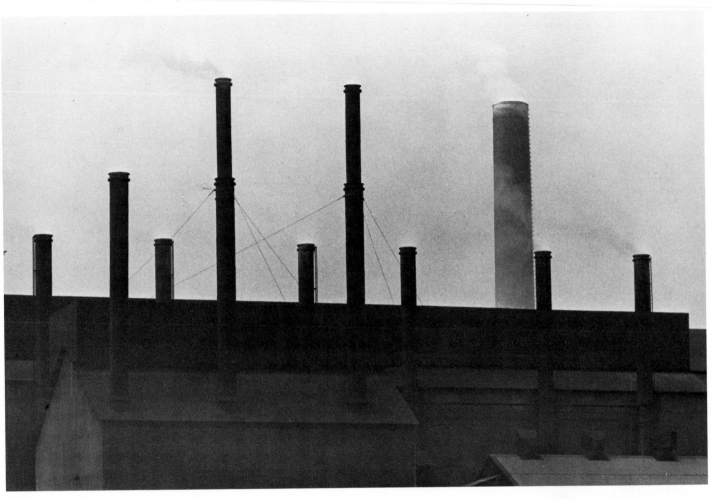

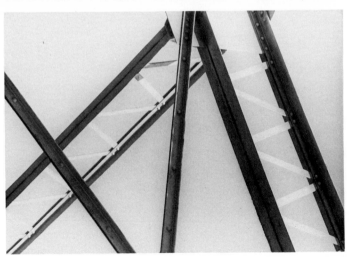

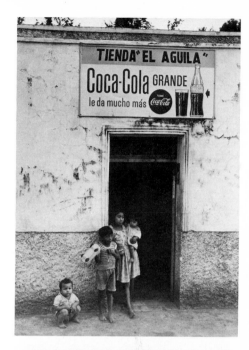

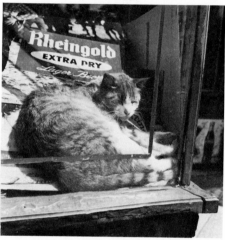

A photographer may open a new world by recognizing the aesthetic potential inherent in type and lettering. Letters and words can also add meaning and significance to the content of a photograph.

(top, right)
"Large size Coca-Cola gives you much more."— studies in contrasts.

In addition to defining the skeleton image, lines also define the pointed arches of the Gothic-style staircase, the section of wall with chalked image, as well as other mainly geometric shapes within the picture.

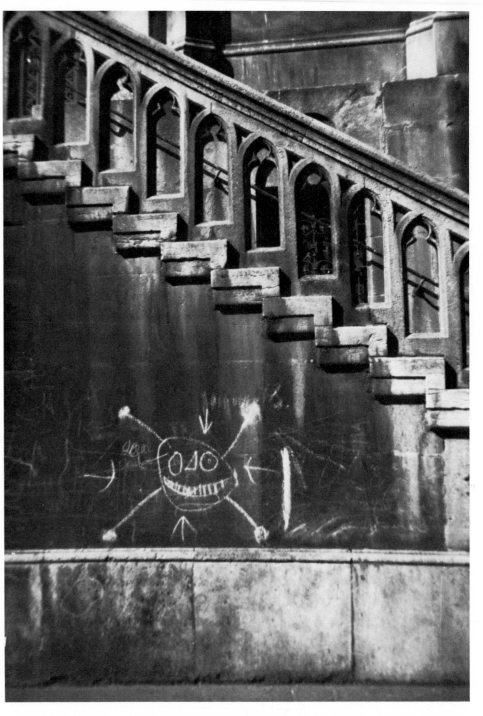

Lines which serve as outlines delineating shapes provide another source of appealing photographic content.

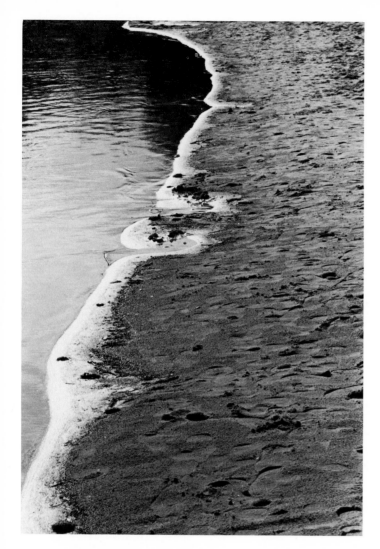

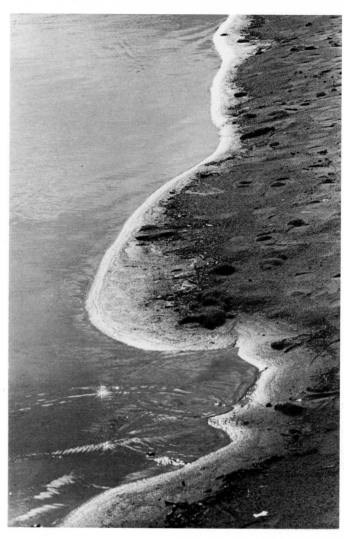

The two photographs above were taken at a
lake where the change in line contour at the
water's edge creates differing shapes of sand
and water.

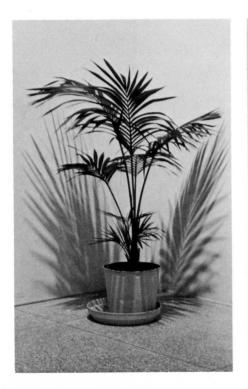

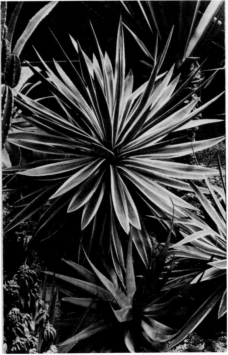

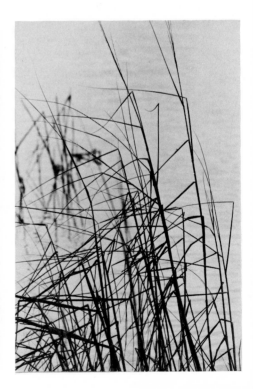

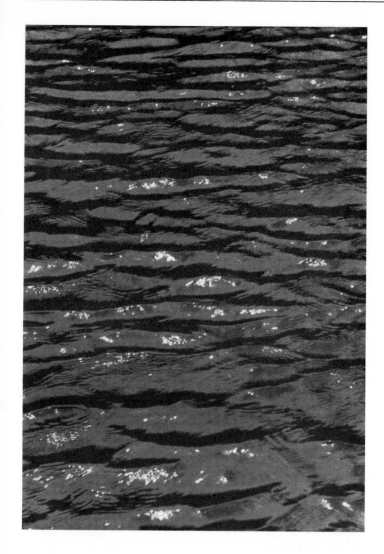

Groups of lines, especially those creating rhythmic patterns, are often rewarding as photographic subject choices.

Lines will frequently add interest in portraiture.

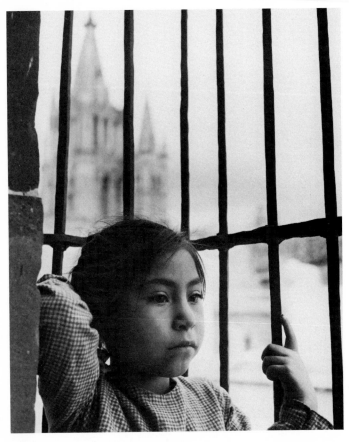
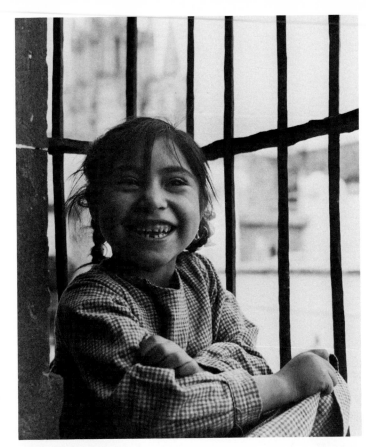
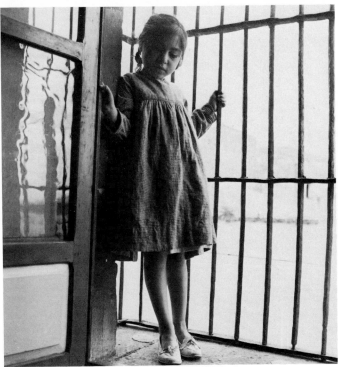
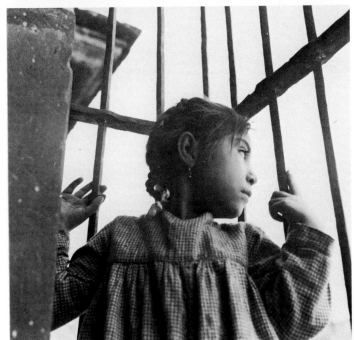

TEXTURE

As with the other design elements, the world is full of textures which make fascinating content for photographic imagery.

Texture is the surface character of an object or area. Thus texture may be smooth, rough, slick, furry, or one of a number of other qualities which describe surface. Textural considerations for the photographer start from the moment a subject is first observed and do not cease until the photograph is actually viewed. Among the many considerations involved are: selection of material or area taken, film type, selection of lens, lens opening and time setting, distance from area or object, lighting, selection of paper, and even the final presentation of the photograph. The glass through which a photograph may be seen has textural properties which should be taken into account in the presentation of photographs for viewing.

(opposite)
Portraits of Helena.

(below)
Smooth and shiny old wood.

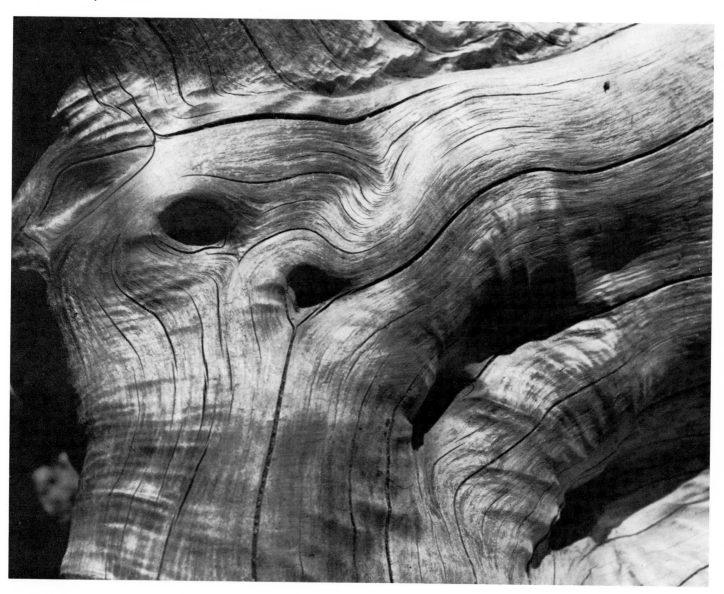

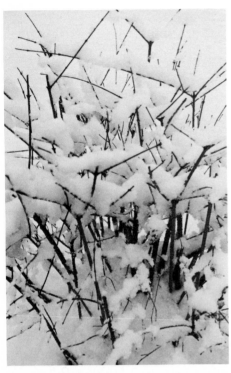

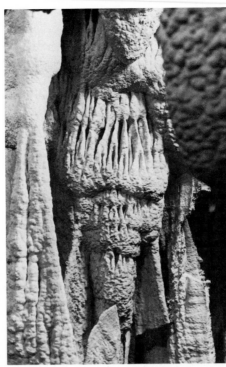

(left)
Light and fluffy snow on bush.

(right)
Rock formations, Carlsbad Caverns,
New Mexico.

(below)
Rocky desert surface, Utah.

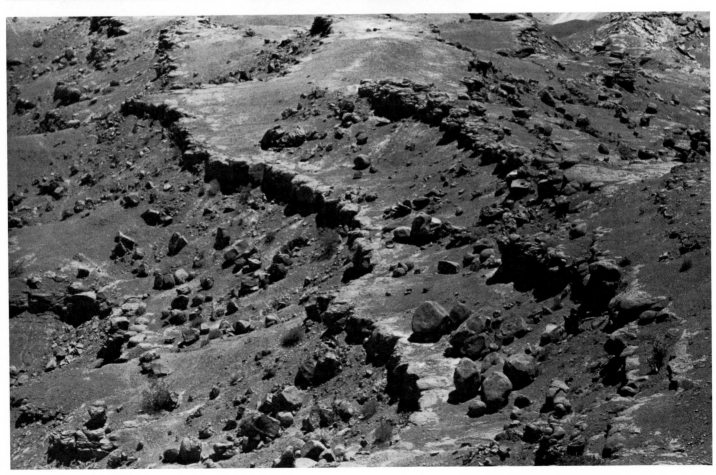

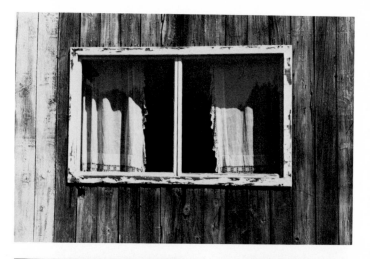

Contrasts of one or more textures within a photograph can add interest. It is often not necessary to move far in the search of textural contrasts.

Some areas exhibit so many different textures that there is textural chaos. In such a situation, an experienced and sensitive photographer will pick out the more interesting parts from the larger whole and create a composition from them.

(top, right)
Detail of old house.

(middle, right)
A Dutch doorway.

(bottom, right)
Corner of a Mexican market.

(below)
Contrast of various textural surface: wood, cloth and stone.

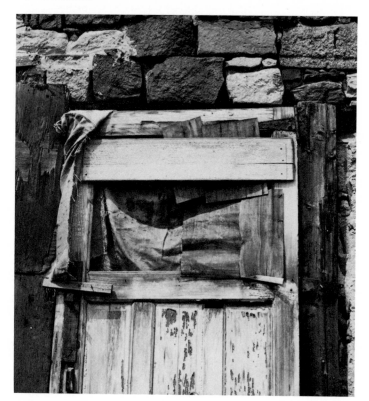

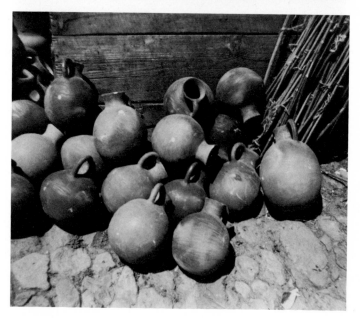

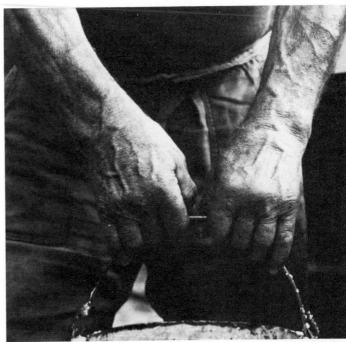

(right)
The hands of a 75-year-old farmer.

(bottom, right)
Here is a close-up of an old upturned tree stump found in New Mexico. Age and all that it implies, is responsible for generating the interest which the subject commands. Note how the deep shadows help to set off the surface texture.

(below)
The full, rounded, smooth flesh of a child.

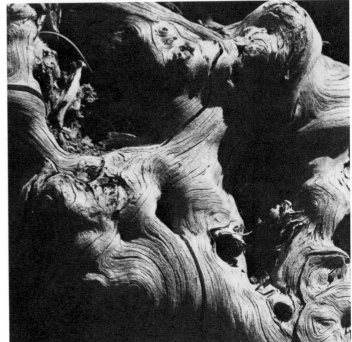

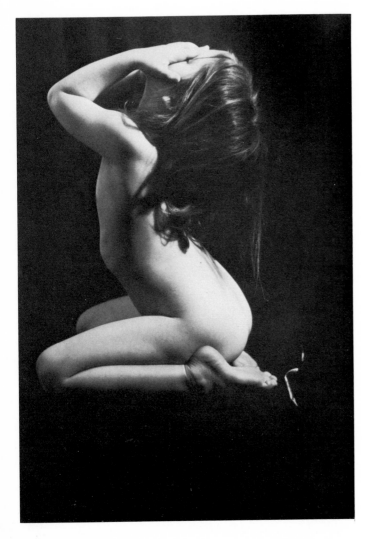

Certain factors in nature affect texture; one of the most interesting natural phenomena is the process of aging. Endless discoveries relating texture and age are possible. The potential for photographic expression is also good. Although all stages of development have their own unique appeal, some are stronger photographic subjects; for example, the effects of age on human flesh.

Textural changes occur even in inanimate substances. The word *patina* is often used in reference to surfaces which exhibit a film or incrustation resulting from textural changes taking place within the materials themselves or on their exposed surfaces. Such surfaces are often of great visual interest and may enrich or complement other content in a photograph.

In this photograph there are a number of patinas contrasted: partially painted metal, painted and unpainted weathered wood, and old cement blocks.

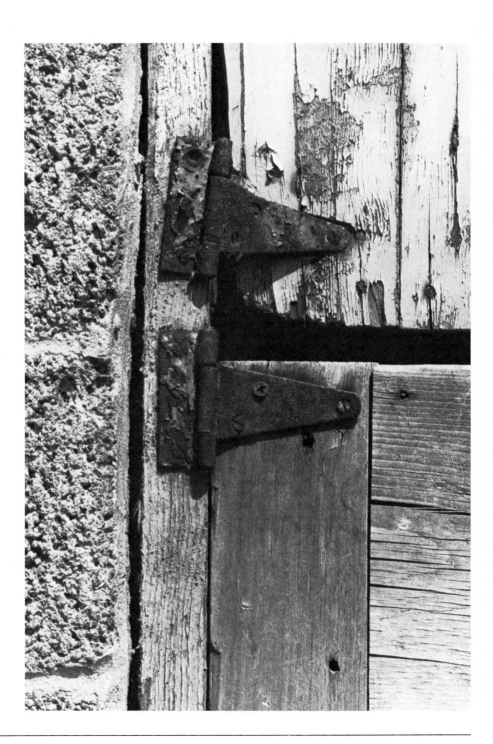

The contrast between the textures of living animal and human forms and those of inert materials and objects may be quite effective.

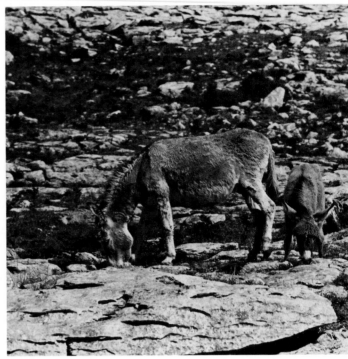

Donkeys, Ireland.

Cat, Italy.

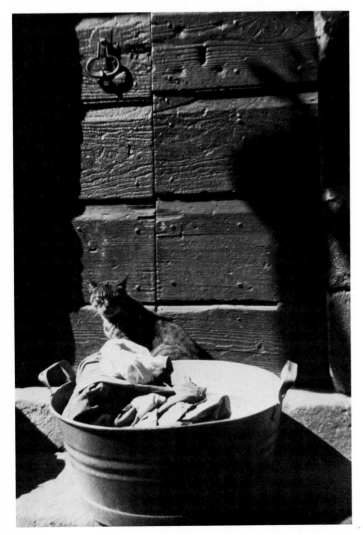

In these photographs, various textures contrast with and complement the human subjects.

(above)
Maria. In this photograph the interplay of the textures of hair, skin, and flower and the way in which light affects their definition are particularly interesting.

(top, right)
Sisters, England.

(right)
Seller of baskets, Guatemala.

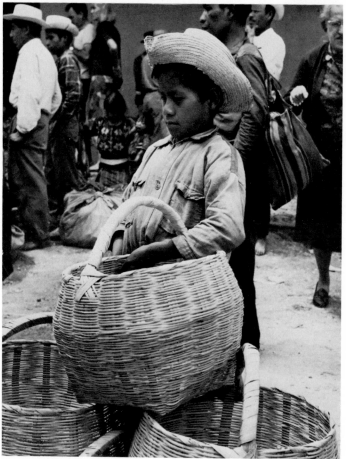

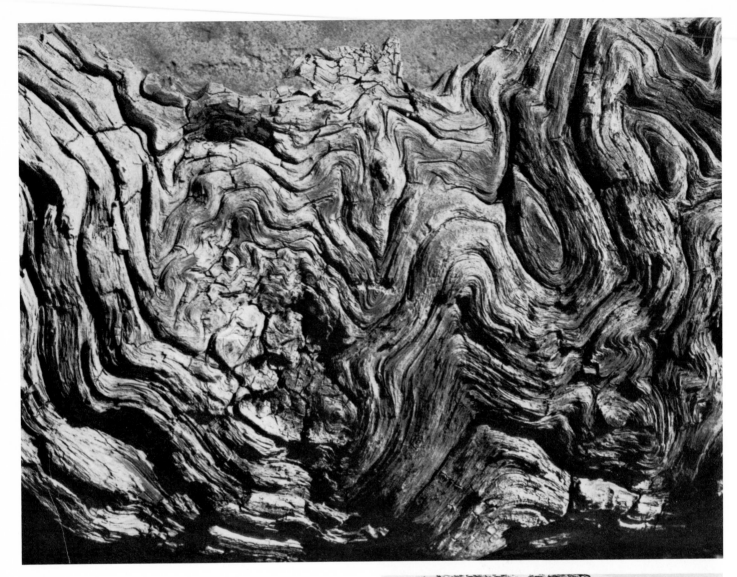

(right)
Irish cliff.

(above)
Old weathered wood.

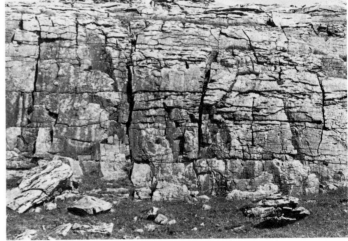

Although these photographs may be highly textural in their emphasis, note how important line is to the identity of the texture. These examples show the interrelationship of design elements. Note, too, how different the quality of line is in the two prints. In the photograph of the old weathered wood, the lines are essentially curvilinear, while in that of the Irish cliff they are primarily horizontal and vertical in direction.

Likewise value is important to textural quality. Lighter values, white and light grays, seem to create light and soft textures. As the values become darker, the textures often seem heavier and even harder. This relationship is illustrated in these photographs which contrast three essentially fluffy textures. The white cotton candy and the whiter sections of the clouds appear soft and light. The darker smoke from the steel mill, although fluffy, appears heavier in textural quality.

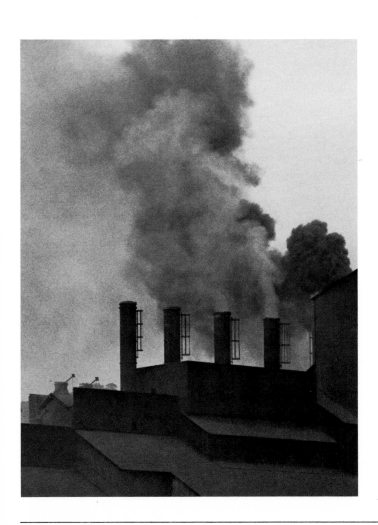

Detail, coral.

Sometimes the hard texture of a light object may appear softer if light in value. On the contrary, the soft texture of a darker object may appear to be harder because of its darker value.

One cannot overemphasize the importance of the role of light in revealing textures. The nature of texture in a photograph will vary as the type of light varies. In some instances light conditions as they affect texture can be controlled by the photographer; in others, they cannot. It is also true that while certain lighting conditions may be ideal for a certain situation, other conditions may be perfectly acceptable and may create interesting effects. A few basics will be outlined here, but the amateur should realize that the nature of light as it affects all aspects of photography is a very complex subject with much to learn regarding both natural and artificial lighting.

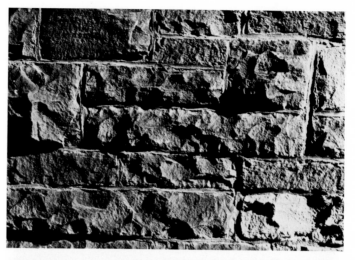

Three-dimensional texture is generally best revealed by side-lighting, which produces the best effects of highlights and shadows. In most cases frontal lighting will blot out the value changes that define the textures. For this reason many photographers will neither use flash bulbs nor allow a subject to be bathed in direct sunlight, despite the old rule which advises photographing with the sun over one's shoulder. For textural definitions, side-lighting at angles of from 45 degrees to 80 degrees to the line of vision is best in most cases. One light source should be dominant or shadows will become confusing.

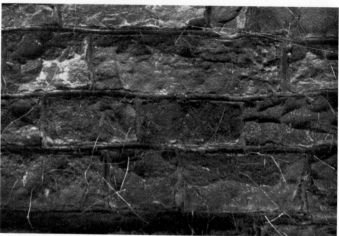

The sun, the great illuminator, affects how objects are seen. The direction of the sun will determine to a great extent the textural definitions of every part of a picture. Season and weather conditions will also influence textural definition.

Here are three studies of the rich relief surface on a stone masonry building. The photographs were taken of three sections of the building each with a different lighting situation. The same number 3 contrast printing paper, printing time, and enlarger aperture were used. An overall light reading was used in taking each photograph.

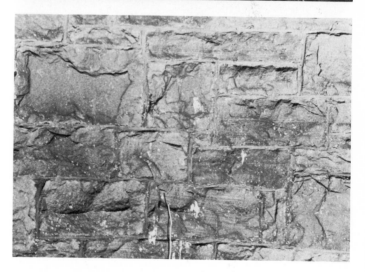

(top)
Sun coming from the side. Here is a highly defined textural surface with rich shadow play.

(middle)
Shade. In this photograph the texture has a soft quality. When printed on number 3 paper, the photograph lacks the highlights necessary to provide good contrast. Variety in the texture is defined only by color and value changes on and within the stone itself and not by shadow patterns.

(bottom)
Full sun. There is a bright, but washed-out, overall quality here. Shadow is minimal.

The following photographs of a shed and an area surrounding it were taken on a very sunny summer solstice. Note how the textural quality of the various parts changes with the direction of the sun and the time of day. The shed faces southeast.

(right)
7 A.M. The early sun has reached only a portion of the facade, enough to cast shadows and shroud textural definition in parts. On the sunless sides the lighting is even, but the smooth reflective quality of the panes of window glass catches the early rays of sun as do portions of the trees above and the grasses below, whose texture is revealed nicely.

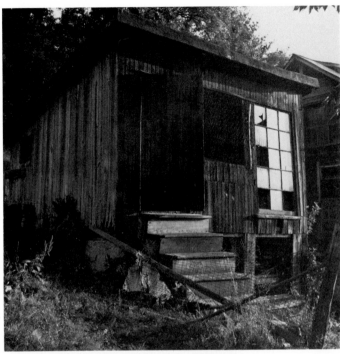

(below)
11 A.M. The midday sun has reached portions of the facade not hidden by the intervening tree. It has defined the chicken wiring in the front window, brightened the panes of window glass, defined portions of the weathered wood more sharply, and changed the textural appearance of most portions of the tree above and the grass below. The pattern created by the shadow of the tree is also of interest.

(bottom, right)
6 P.M. The southwest side is nicely defined texturally in the late afternoon sun, but the textural quality of the chicken-wire window is lost and the texture of the front is less sharp. The window glass, although duller now in quality, still holds appeal.

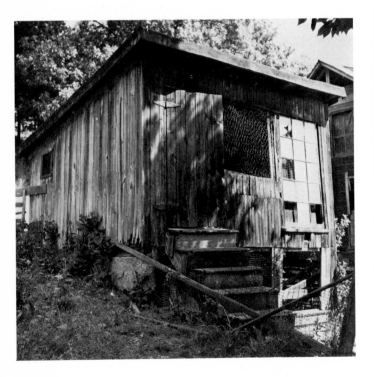

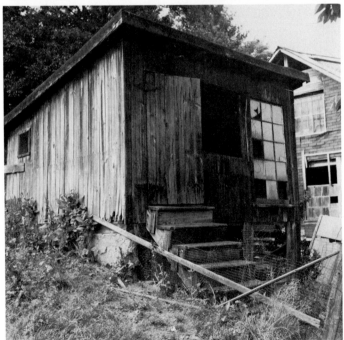

It is often a source of wonderment to discover how textures, as well as values, shapes, and other elements within an area, will change with continued observation. To play with these changes in photographic imagery can be fun, and indeed can make for some powerful photographs.

Here are four studies of a common fire hydrant and the area surrounding it. Note the differences in texture, as well as the differences in the other design elements. Even the photographs with snow are amazingly dissimilar.

(right)
Sunshine in summer.

(below, left)
The onset of a heavy snow. Note the blurred diagonal movements of snow throughout the picture.

(below, center)
Snowing lightly. A fine hairlike texture is created by the movement of the lightly falling snow.

(below, right)
The snow begins to melt, creating the darker wet patterns on the hydrant and the fluffy quality of the snow.

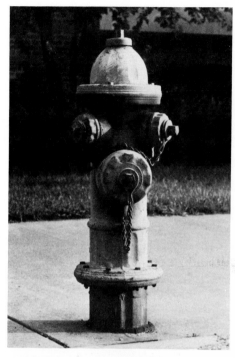

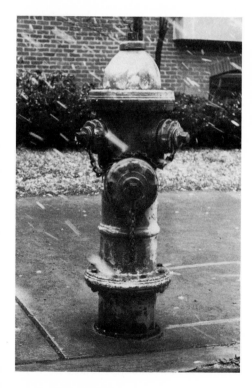

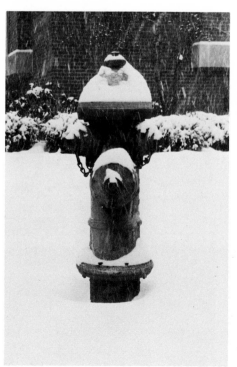

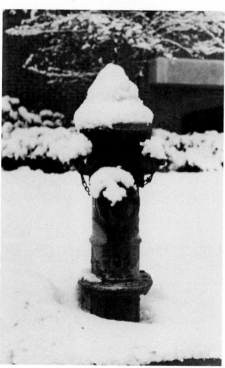

A photographer may wish to direct a viewer's attention to the textures of a single object or area and eliminate textural competition from others. One way to achieve this isolation is, with careful selection of lens and aperture, to focus on the object or area to be highlighted and to make the others out of focus or blurred. Of course, blurs do have texture, but in most cases the eye will focus on the clearer more distinct textures. Frequently the blurred or out-of-focus quality will serve to unite many different background textures, thus helping to create a better unity.

The use of blurred textures is not restricted solely to removing textural competition or providing textural contrast in a photograph. At times their use may be vital to conveying the meaning and establishing the spirit of a photograph.

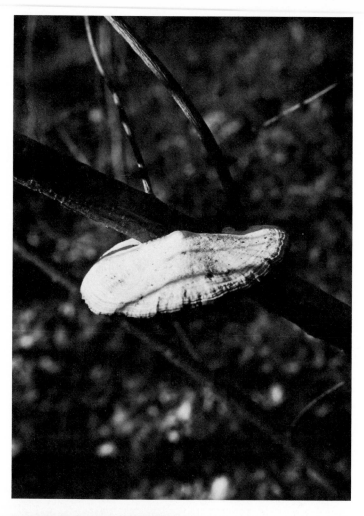

(top, right)
Mushroom on tree in woods. The power of this photograph is due to textural clarity in relatively few areas of the branches and mushroom, contrasting with the blurred quality in the background.

(right)
Both foreground and background are purposely left out of focus to concentrate the viewer's attention on the curious tortoise.

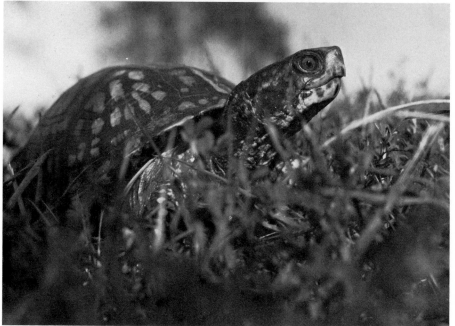

The blur of the tomahawk is important both to the meaning and the fun of this photograph taken at a Mexican festival. The blur indicates the motion directed at the photographer, serves as a focal point, and provides fine contrast when compared to the other distinct textures in the picture. The round shape within the blurred area also repeats the roundness of the eye, the nipple, and the painted circle around it.

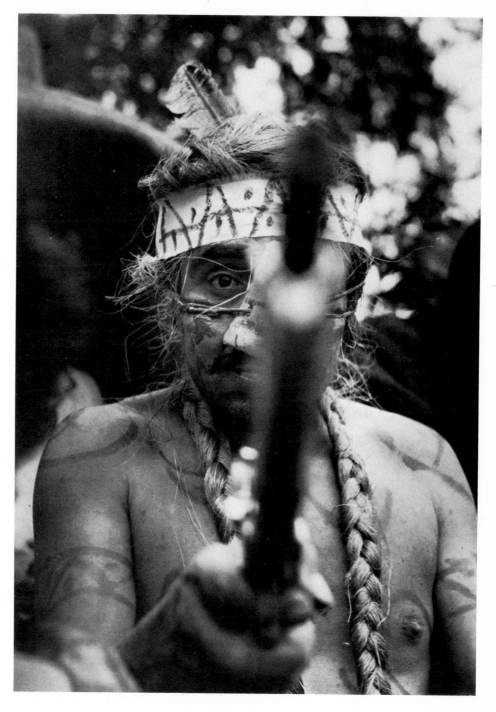

In this photograph of haystacks, the photographer attempted to highlight the interplay among similar, yet unidentical, shapes in space. Their position and character suggest a strangely animate, even amusing, play between them. Texture, although shown, is not of prime importance. The sunny areas of grass were left light intentionally to contrast with the stack forms, which were photographed from an angle to reveal as much of their shady side as possible. By making the dark side dominant, the viewer's attention is directed more to their forms than their textures. In the photograph below, only one stack was shown and the exposure was changed to bring out more of the detail in grass and stack. Texture and the powerful single cubic shape were made to dominate.

Emphasis may be placed on texture by simply getting close to an object or area. Often, when objects are viewed from a distance, shape, space, contrast, or some other element or principle (or combination of them) will predominate — many times intentionally so. Proximity will often intensify textural quality not only because texture becomes more visible from a closer perspective, but because other objects and areas of interest are eliminated.

To get close enough to reveal texture clearly may involve an appropriate change of position of the photographer or the camera.

(top)
Railroad rail and tie. This interesting textural contrast of metal, old wood, and stone was taken from above by carefully placing the camera in a position parallel to the ground. Otherwise, greater distortion of the rail width from top to bottom of the picture would have made the photograph awkward.

(right)
Simply kneeling down on the ground was all that was necessary to bring out the texture of this growth on an old tree stump.

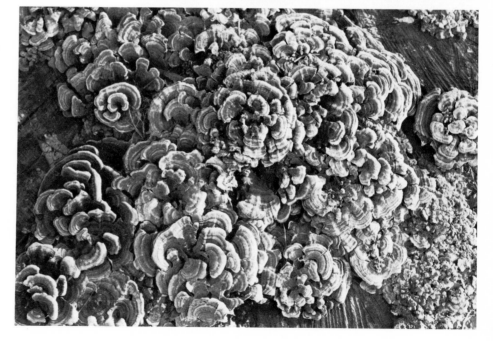

Fascinating texture studies can come from objects or areas arranged in groups. Alone or isolated, the same objects may appear to be quite different texturally.

These are photographs of a section of painted pressed tin, a material used in the late nineteenth and early twentieth century to simulate stone masonry construction. Because of the high relief and sidelighting, interesting topographical studies are created. Isolated, a single block shows a striking topographical quality similar to views of the crust of the earth and moon. The repeated patterns in the photograph at right create a fascinating group texture. Note the change in texture of the frame in the upper band which helps break up the continuous overall quality.

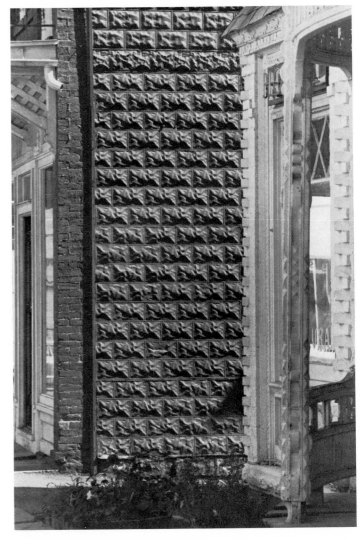

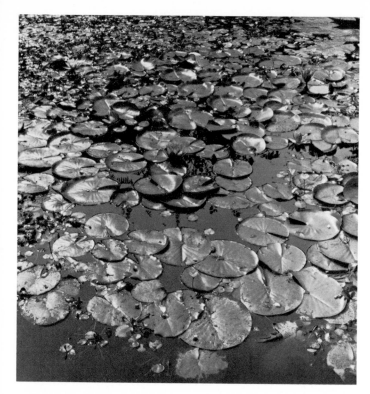

(right)
A forest of frost patterns on a window pane.

(above)
A group of lily pads and flowers.

Photographic film itself has texture, often called grain. The distribution of the silver bromide crystals on the undeveloped film determines the quality of that texture, but the quality will change during the development of a negative when the silver crystals or grains tend to coalesce. The quality of the grain depends on the type of film, the exposure, and the type of processing. The grain will affect the texture of the final print and will be more obvious with greater enlargement. Graininess is a term used commonly to refer to the mealy, spotted, or mottled texture which is apparent in varying degrees in many photographs. Graininess is not always undesirable; in fact, it is often achieved purposely for a desired visual effect. The degree of graininess is determined by every choice the photographer makes, including that of: film, subject, type of light, type of developer and processing methods, and type of enlarging paper and degree of enlargement.

The two photographs of pigs were intentionally made to differ aesthetically. The pig at right is more abstract and apparitionlike. Because of the grainy textural quality and the white background with only impressionistic patches of grass and shadow, the movements and appearance of this pig seem light. In contrast, the pig on the next page is very real, heavy and pig-like in appearance. Textures throughout the picture are clear; even the wet hairs of the pig's body can be seen.

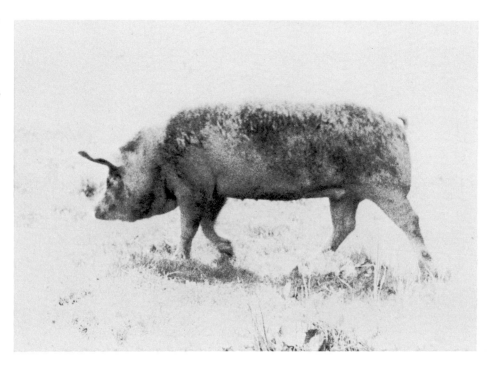

The difference in the two prints resulted from the manipulation of a number of factors known to affect the grain of a photograph. On the one hand emerges a photograph with little or no obvious grain, called a fine-grained photograph. On the other, is the photograph with obvious grainy texture. The finer grained photograph was taken with a fine-grain film in a late afternoon sun which was directed at the area shown. This light helped to illuminate, define, and separate the different textures within the picture. The grainy photograph was taken with a fast film. All of the pig except his upper ear was in shadow. The fine-grained photograph was taken using minimum exposure and was developed in a fine-grained developer at a temperature of 68 degrees in normal development time with only intermittent agitation. The grainy photograph was overexposed to achieve a dense negative. The film was developed in Dektol, a paper developer which is diluted 1:1, for only three minutes at 75 degrees, a high temperature, with continuous agitation. Before fixing at a normal 68 degrees temperature, the film was subjected to alternate rinses of ice cold and hot water. High contrast paper was used in printing the grainy photograph; a medium contrast paper was used for the fine-grained photograph.

(right)
If the photographer includes a larger field than that which is to be printed when taking a photograph, a more pronounced grainy quality can be obtained. Likewise, details from grainy photographs will exhibit a more obvious grainy quality as shown in this detail made from the grainy photograph of the pig.

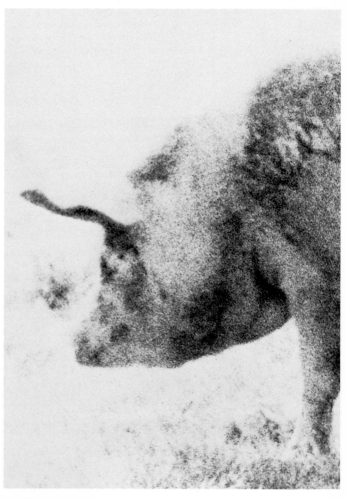

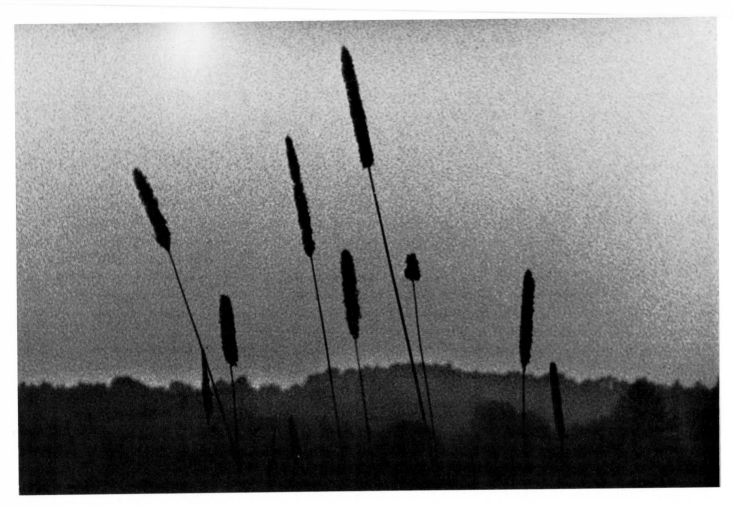

Tall grasses and setting sun.

Grain can be used in a very creative and exciting way to establish mood or special visual effects. It can add another dimension to a photograph, in much the same way that brushstrokes do in paintings. In the late nineteenth century many Impressionist painters made brushstrokes obvious in their paintings. The painters used the brushstrokes to suggest the shimmering quality of light and to establish a mood and atmosphere. Similarly, in these photographs grain helps establish their unique spirit.

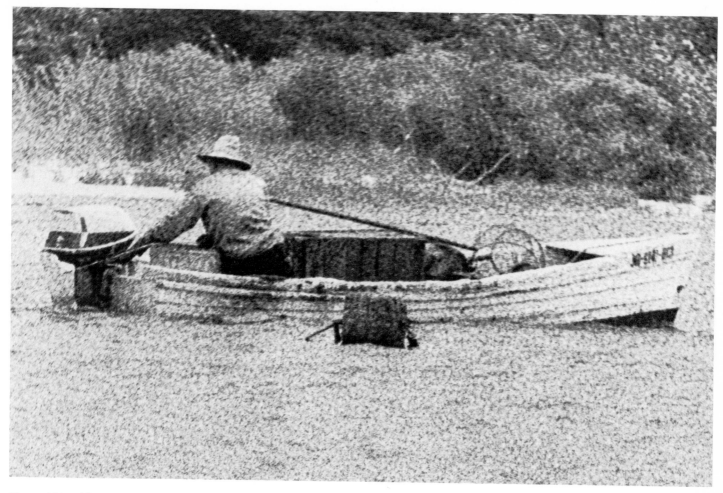

Man crabbing, Maryland.

A number of photographers who enjoy playing with the visual effects of various textures choose to depart from trying to reproduce the real textures of the subject. They opt rather to alter textures. This can be accomplished in many ways. One way is to use special lenses designed to produce a variety of effects. Most of these lenses can be attached easily to the front of a camera lens like a filter and will either alter the sharp definition of textures or change them entirely. An alternative method is offered by texture screens which are available commercially in a number of patterns. The screens are specially prepared negatives of textural patterns intended for use in contact with photographic negatives during enlarging. Printing time for each negative can be different if the photographer wishes. This adjustment will darken, lighten, sharpen, or diminish the effect of either one of a pair of negatives. Also, with careful dodging and burning-in, only certain parts of either negative need be printed.

Woman at well, Burgenland, Austria.

Here is the same photograph with and without, the use of a texture screen. Note the changes made in the spirit of the scene. The particular screen that was selected is used to simulate the effects of reticulation, a process often used by photographers during film development to distort the emulsion layer of a negative and give it a fragmented rather than an even texture. The actual process of reticulation (which involves use of a developer or fixing solution at high temperatures or the use of a cold fixer after a high developing temperature) will change the negative so it cannot be normal again. The advantage of a reticulation screen is that one can obtain the effect without loss of the normal negative.

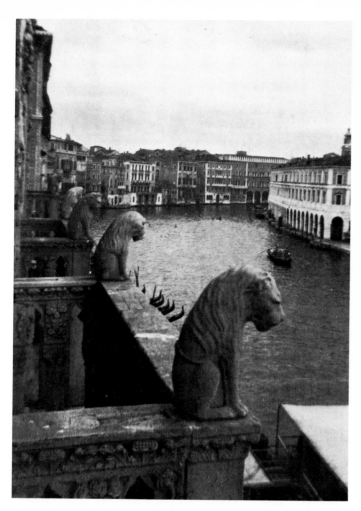

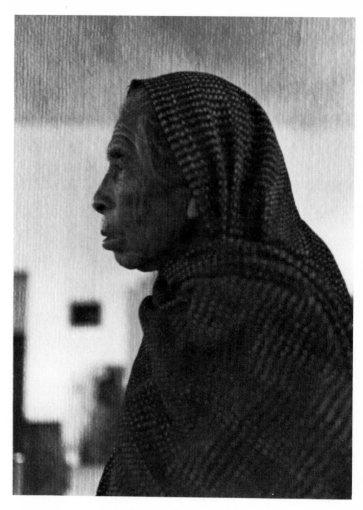

Like many commercial textural screens, the two used here are based on the textures of fabrics. The screen used on the left is called "rough linen". "Old Master" is the screen on the right. Lions of a Renaissance Venetian palace looking down at a palace-lined canal are perhaps as fitting a subject as any for rough linen, a fabric used in many Renaissance tapestries.

Old master texture was used in this portrait of an old woman to heighten the sense of age, to break up the flat white background, and to give the photograph a greater sense of timelessness and strength.

It is possible to make one's own screen by first photographing any desired textural pattern and then simply placing the negative together with one or more others in the enlarger's negative carrier during the printing process. This method is known as *squashing* or *sandwiching*. Exposure time for each negative need not be the same. Curtains, wiring, rain-spattered windows and other materials can be used as screens through which a subject is photographed.

Raindrops on a glass window photographed through a screen. The blurred shapes in the background are the trees outside.

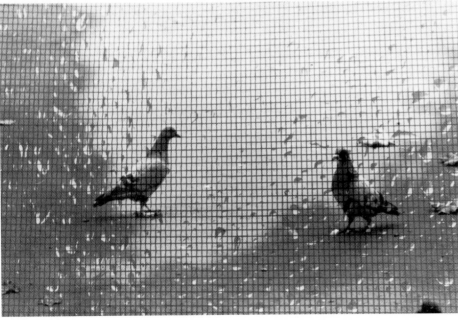

An interesting sense of motion stopped is established by the grid of the screen superimposed on a photograph of pigeons. The raindrops and play of tree shadows make for pleasing contrasts.

Fair-weather clouds

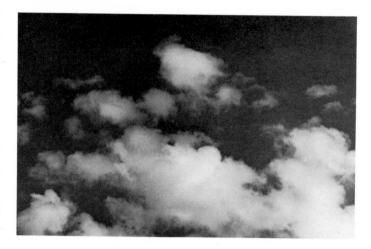

By sandwiching the negatives of the clouds and the screen with raindrops, a fascinating textural play was created.

The texture of old wood with some remains of old paint.

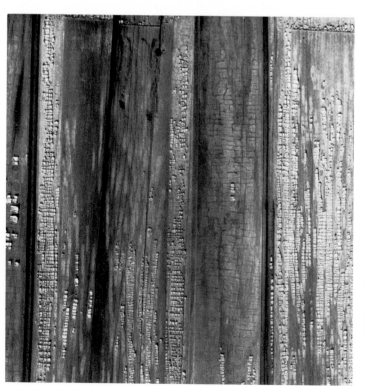

A delicate textural play made by superimposing a photograph of a rose. Note the interesting sense of transparency that is created.

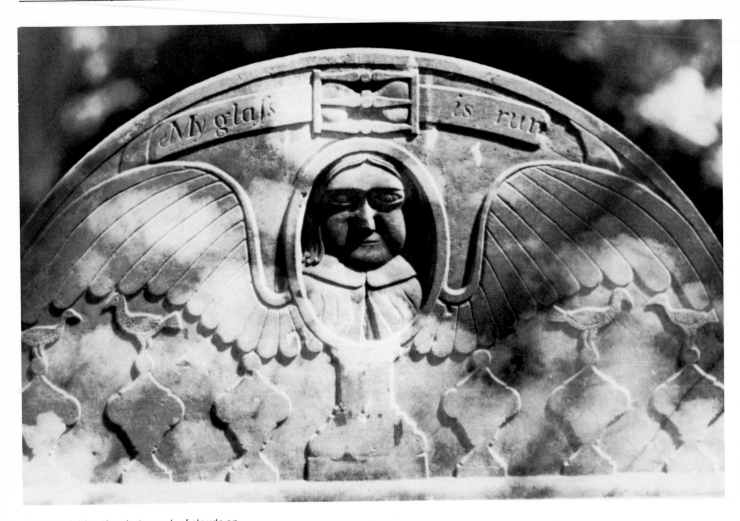

By sandwiching the photograph of clouds on the previous page with a detail from the grave-stone of an eighteenth-century New England deacon, the stalwart gentleman and his bird companions seem to have gained entrance already into the celestial realm.

There are numerous examples in the visual world where a subject can be seen only through some type of screen and the presentation can be most effective.

Photographic papers, like all printing papers, have different textures. Certain photographers have favorite papers which they use consistently. They may also prefer certain papers for particular types of photographs. The choice of a paper which satisfies may result from experimenting with a variety of papers. When experimenting, the selected paper should be used long enough for the photographer to become acquainted with its potential.

Another variable affecting the texture of the surface is the drying of the photographic papers. Some photographers prefer to obtain a glossy surface; others will choose a matte or semimatte finish. The photographer should become familiar with the different effects produced by the various drying methods as a way of obtaining interesting creative alternatives.

An additional factor to be considered is the method of display. Should glass be used in front of the photograph? If so, what type of glass, glare or nonglare? Glass over a photograph will affect the overall texture of a print and thus, necessarily, the response of the viewer. Some photographers do not like glass. Others do, but exercise selectivity over the types of glass to be used in combination with certain papers and certain types of prints. Some photographers resort to glass primarily for protection of a photograph.

In this photograph there is appealing contrast between those sections seen through a sunlit balustrade and lattice and the other, mainly shaded, parts left exposed.

This is a stimulating play of textures and shapes: fencing, tree, tablecloth, and towels. One of the towels is seen through both the fencing and the tablecloth.

(right)
Water and reflections seen through a screen of hanging weeping willow branches.

(below)
A delicate textural study effected by photographing through a gauze curtain.

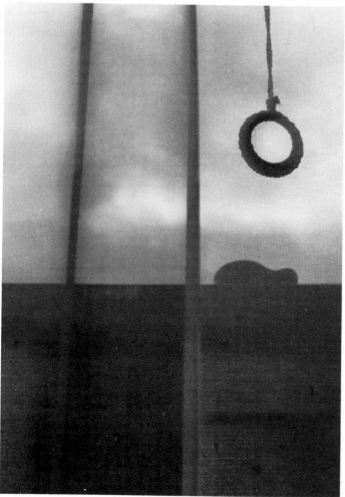

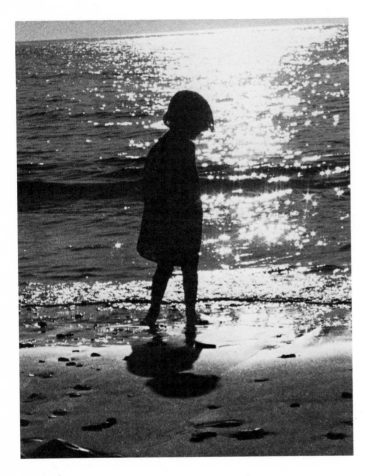

COLOR AND VALUE

Color and value are very important parts of the visual world. In black and white photography colors will be recorded on film in various shades or values of black, white, and gray. The term *value* in black and white photography refers to the degree of lightness or darkness on a black-gray-white scale. It is important for a photographer working in black and white to begin to see these various values in relationship to objects and areas observed through the viewfinder. Good photographs are often the result of a good contrast in values distributed in a certain way in a photograph.

A photographer can choose to exercise a considerable degree of control over value to make it serve a creative end. The design or mood created by a certain distribution of values may be the most interesting part of a photograph. Values may aid in illuminating the content in some way.

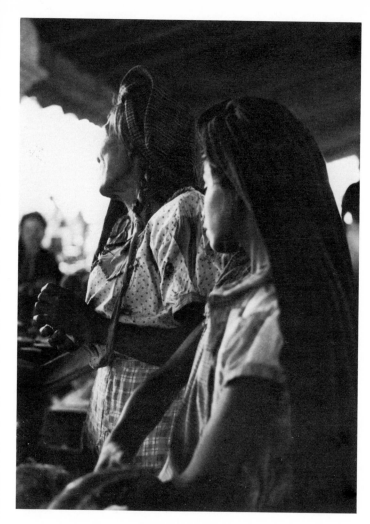

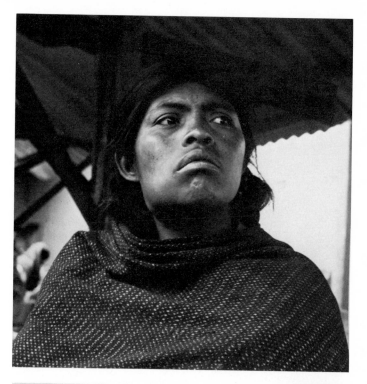

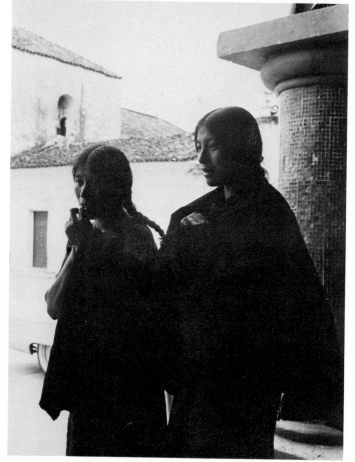

In these photographs taken in Mexican marketplaces, the distribution of values has helped create revealing, and dramatic, portraiture.

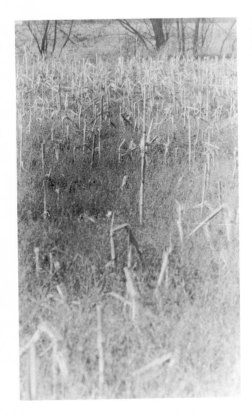

This gray photograph is the result of poor development technique. The film developer used was too old, making for lack of contrast in negative and print.

This squirrel study was taken on a very gray day. Gray days tend to make value contrasts much less distinct. Despite the use of a moderately high contrast paper, the print is without the value contrast needed to give it interest.

Many interesting areas in the visual world do not make good photographs because all the values within them are too closely related. For example, in this photograph there is little distinction between the values of sand and water. The slightly darker sand mixed with other material at the water's edge was not dark enough to provide sufficient contrast, even when high contrast paper was used.

Contrast as it relates to values is an extremely important consideration in photography. Contrast in value sets off one area of a photograph from another and selectively defines parts of objects. The incorrect choice of film for a particular type of photograph, as well the incorrect or poor developing and printing conditions, may cause lack of contrast within the field of a photograph. Certain types of weather and lighting conditions also contribute to absence of value contrast; the result is usually a gray photograph, one with little contrast.

To fulfill aesthetic intent or to convey meaning in a photograph, a photographer will many times allow gray to be dominant. Dominant gray does possess a definite expressive potential and should not be confused with grayness that results from little value contrast. Note that, although gray may be dominant in these photographs, there is adequate value contrast.

Late afternoon sun hovering over an industrial highway—a "gray mood" photograph.

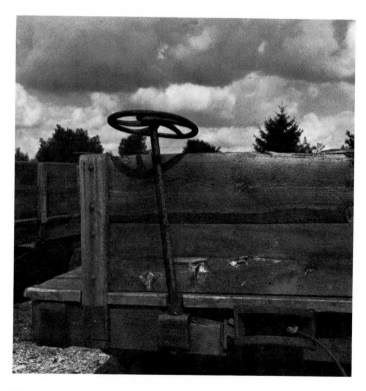

Clouds above an old abandoned railroad car.

These photographs illustrate a wide range of values from dark black to brilliant white with many intermediate values of gray. The values are distributed throughout the pictures with good variety and contrasts, and with good weight balance and unity. Brilliant white is used for accent in both photographs.

For most photographs, it is desirable to have a broad black-gray-white value range. The amounts of each will be dependent on aesthetic and content considerations, as well as on the actual distribution of values within the area photographed.

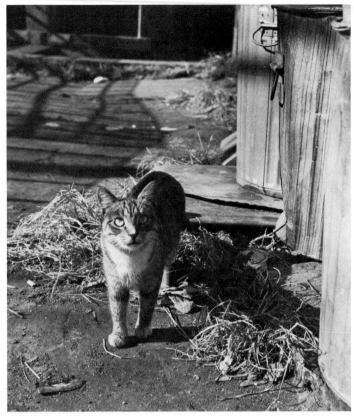

(left)
An English pram.

(above)
Cat, Brooklyn, New York.

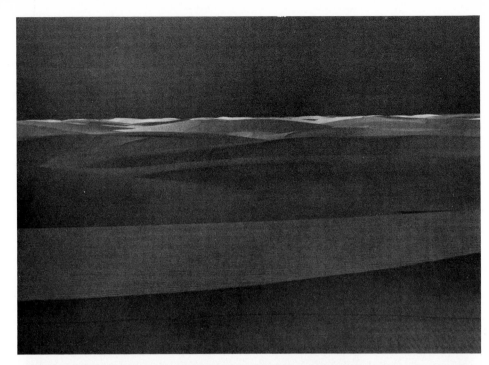

Certain subjects lend themselves to very powerful value studies. Such an area is White Sands, New Mexico, where one need not travel far to find interesting value contrasts of sand and sky.

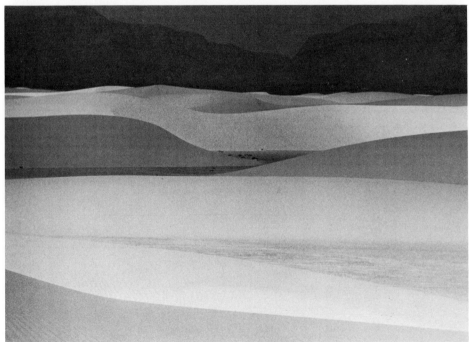

Photographs with rich black and white contrasts and little or no gray are usually very striking and eye-catching. A number of photographers work exclusively in black and white for the rich design potential inherent in the bold contrasts. Fashion photographers, in particular, exploit these contrasts. High contrast can be created in a number of ways including use of special films. However, high contrast exists naturally in many areas in the visual world — in stark black and white or in colors that have such dark and light values that they appear as black and white when photographed with black and white film.

There are also areas where gray-white-black contrasts make for bold and dramatic photographs. The dramatic quality is heightened when the value areas are large, few in number, and distinctly set off so that they contrast boldly with each other. High contrast paper may help to eliminate more intermediate values, but it is not always necessary.

(above)
Coal mining town, Pennsylvania.

(left)
Under the bridge, Brooklyn.

(opposite)
Cast iron gridwork ceiling, Petit Palais, Paris.

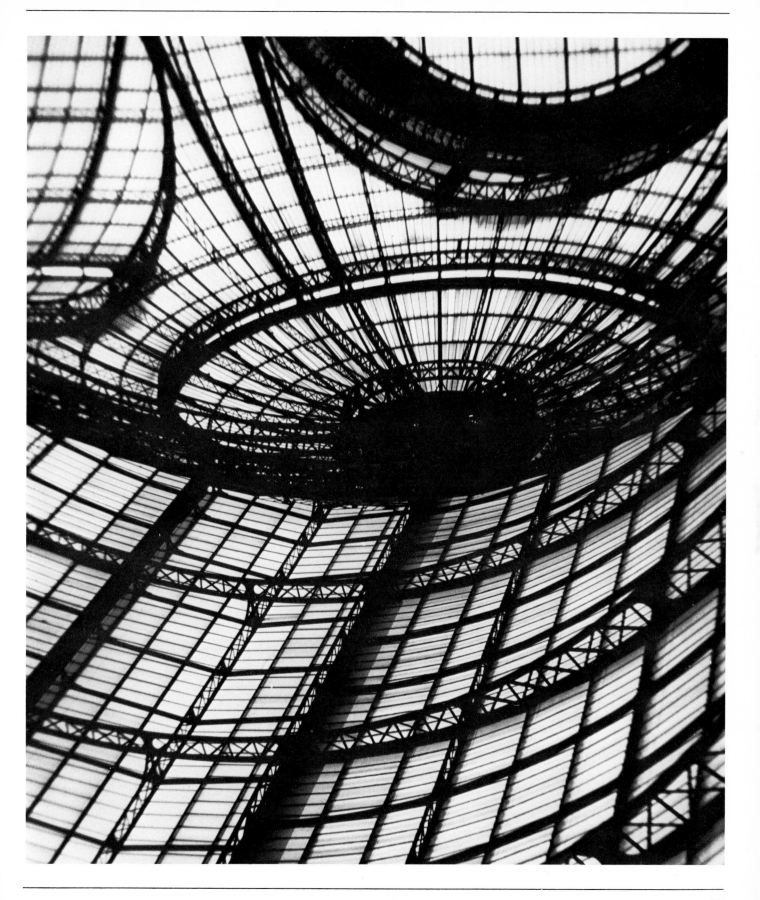

The type and degree of contrast of the photographic paper used is critical to the values achieved in a final print. Experimentation with several papers for a long enough period of time to determine their potentials will usually result in discovery of a paper that is personally satisfying. The higher contrast papers change values, making contrast sharper. In some families of papers, middle or intermediate values are sacrificed when higher contrast numbers are used. Photographs are often strikingly more dramatic with the higher contrast papers. Printing exposure time will also affect values and value contrasts.

It must be borne in mind that contrast grades vary with different manufacturers. One cannot expect the same results from a No. 5 paper of one manufacturer and the No. 5 paper of another. Sometimes there are even changes from box to box of the same number by the same manufacturer!

Here are illustrated the different effects achieved from the same negative with the use of different papers. All but the first print were made with Agfa Brovira, a favorite paper of the author. The subject is a setting sun.

This is a photograph made with No. 2, a paper of low to intermediate contrast from a family of papers which were tried, but disliked, by the author because of the absence of rich blacks and brilliant whites, even with the higher contrast numbers. The grays often have a muddy quality. The printing exposure was at f11 opening for eleven seconds.

This print was made with No. 3 contrast paper at an f11 opening for six seconds. The values and their relationship here are closer to the ones actually exhibited by a setting sun than those in any of the other five photographs.

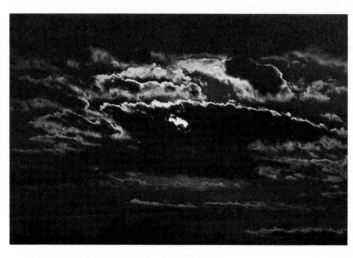

In this print the exposure time and lens opening were the same as in the previous print. However, the negative was printed on a higher contrast paper, No. 5. Note the richer and more brilliant blacks and whites and hence the stronger, more dramatic contrasts. Agfa Brovira paper maintains the intermediate gray values despite the more brilliant black. This feature does not characterize many papers, in which detail is lost with the higher contrast numbers.

This photograph was exposed at f 11 opening for fifteen seconds on No. 5 paper. It appears as a dramatic sky, moonlit rather than sunlit.

Both of the photographs below were made with an f 11 enlarger opening, but were exposed for eleven, rather than six seconds. The one below left was printed on No. 3 contrast paper; the one below right, on No. 5. The difference in brilliance and contrast between the two is not as obvious as in the photographs with the six-second exposure, but it is still detectable. The dramatic mood is heightened even further.

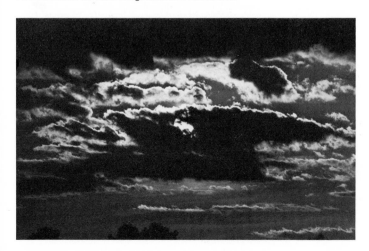

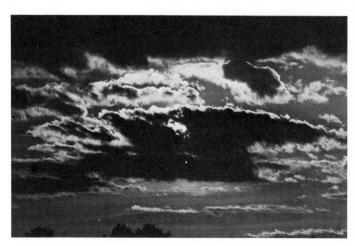

Good camera technique is important to the value range recorded in a black and white negative and print. One must learn to use the exposure meter to serve particular aesthetic and expressive ends. The end in mind will determine what the exposure should be, in other words, what lens opening and time setting to use according to the subject matter, the lighting conditions, and the characteristics of the emulsion of the chosen film.

All exposure meters, except the spot type, give an integrated reading of a total area. The direction of the angle at which the meter is held is most important. Directed downward for an outdoor scene, the meter will give a considerably different reading in most cases than when directed upward at a sky area. The same is true with a camera having a through-lens metering system. The angle and direction of the camera when the exposure is read are very important to the value relationship recorded on the film.

Here are three photographs of the same area which illustrate the importance of exposure to the final image. No filters were used and the printing paper, enlarger aperture, and time were the same.

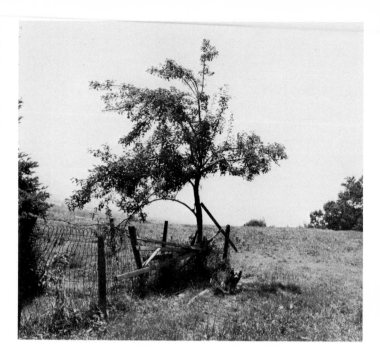

(below)
The meter reading was taken from the sky. After the print was made, the sky appeared richly detailed with fine contrasts, but detail in the ground was lost. Note that taking the reading from the sky darkens all parts of the picture. The pear tree is so dark that it appears as a silhouetted form against the sky.

(above)
The meter reading was taken from the ground so as to reveal detail in the grass as well as in the small dog. As a result, the sky was so overexposed that no clouds are visible.

(below)
An integrated reading was made, in which the meter was directed at an angle that included both the sky and ground areas. The balance, as far as detail is concerned, is much better, but the clouds are still somewhat faint.

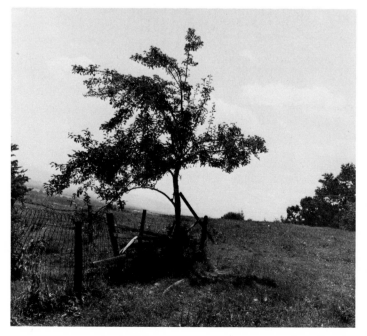

Changing the development time can often help to improve the value range of a negative to the point at which neither detail in highlight (or sky) nor that in the ground is lost. If a photographer exposes for detail in the darker areas while taking a photograph and then reduces the development time, highlight densities can be prevented from reaching a point where they can be printed only by burning-in. This procedure does not affect shadow densities. Black and white films have their exposure latitude on the overexposure side. In most cases, it is better to overexpose than to underexpose.

Detail lost in the highlight areas because of the need to expose for detail in the darker areas can be restored by burning-in, giving additional printing exposure time to those highlight areas.

Dodging, or decreasing printing exposure time, may help to bring out detail in darker or shadow areas.

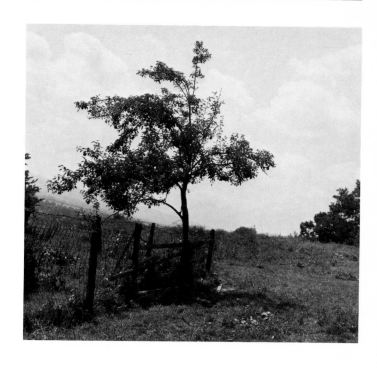

The photograph at right was taken with another roll of film. The exposure reading was made from the grass area and the whole roll was underdeveloped—for Tri-X film, only four minutes at 68 degrees. There is a good balance in detail; detail in both sky and ground are richly and clearly defined. Printing paper, enlarger aperture, and time were the same as for the prints on the opposite page.

Below at left is the photograph at the top of the opposite page, here with additional exposure time given to the sky area. The result is somewhat unsatisfactory because of the white near-outline areas around the tree. A card has to be made for the shape of only the sky area to prevent a disturbingly darkened and silhouetted section of tree above the horizon line. The use of such a card, which must eliminate such a complicated shape as a tree and yet maintain the sky areas between the branches, is very difficult without some loss of evenness.

Below is the same photograph as that at far left on the opposite page. The lower part was dodged, or given less exposure time, to bring out greater detail in the grass area. The ground could not be lightened too much or the contrast with the darker sky would have given the photograph a disturbingly unnatural quality.

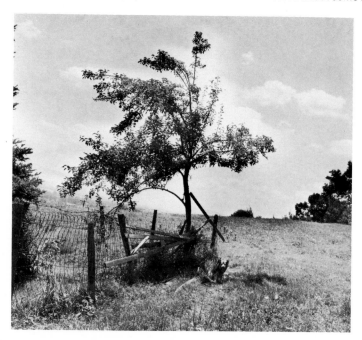

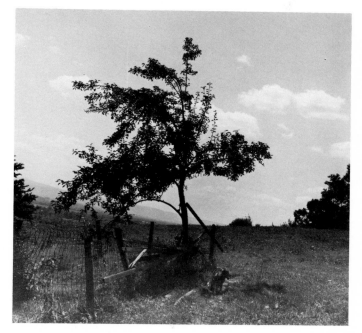

In photography, as well as other art forms, the question of what is correct is relative. In fact, whether such a term should really be used at all in the fine arts is open to debate. Many fine photographs result from the so-called incorrect exposure, which represents a departure from that needed to render faithfully the values in nature with their original brightness. Value relationships which heighten the sense of the abstract or depart from the natural in another way may make for rich and exciting imagery. It has already been pointed out that more abstract effects can be created by altering value with paper of different contrasts and with adjustments in printing time. Learning how exposure affects what appears on photographic film and therefore in the print is important to good photographic technique. However, one should not become a slave to the theory and its mechanics. Often the time taken to measure correct exposure will mean missing a timely shot. With experience one develops a sensitivity to, or feel for, light in various situations. This seasoned photographer will not hesitate to guess, if necessary, what is correct or to depart from it to obtain special visual effects.

The desire in this photograph was to expose the film so that the leaves would appear as flattened shapes with little or no detail and the background would be dark with little or no detail. Because of the wide difference between the bright lighting on the leaves and that of the dark shadow, a reading between the lightest light and darkest dark was used. Consequently, the sunlit leaves were overexposed and the background was underexposed. Most of the detail was lost in both areas and the strikingly sharp black-white contrast resulted.

In situations where lighting is even throughout the field of the picture, measuring exposure is usually not a problem. In situations where lighting is different in various parts of the picture, decisions must be made regarding exposure. The picture area in these photographs exhibited widely divergent types of lighting, from very bright light to deep shadow. Aesthetic considerations determined the choice of exposure.

The meter reading for the photograph above was taken from the window with reflected sun. The other parts of the picture were therefore underexposed. The resultant grays, blacks, and framed bright highlight provide the photograph with its interesting mood and contrasts.

The meter reading for the photograph at right was taken from the water. The effect was to make the figure of the young girl tossing pebbles into the water a semi-silhouetted form outlined by the bright highlights from the setting sun which she faces. Detail and patterns in the water are nicely defined and contrast with the pattern of silhouetted stones in the air. This contrast was also part of the original intent.

In the window of a Victorian house with turned balusters, is shown the reflection of a house across the street. Deliberate overexposure was employed in the photograph to make the reflected house appear as a silhouette. The shingles, shutters, and balusters were purposely arranged to frame, and contrast with, the silhouetted contemporary house.

Overexposure with strong backlighting can be used intentionally to produce sharp contrast and silhouettes. Ordinary scenes can take on a new dimension, often a sense of mystery, because much of the definition of objects and areas is lost. To minimize flare, or replicas of lens diaphragm on the image, a lens hood should be used. Flare images may however be quite desirable in some cases for providing another dimension or adding interest to a photograph.

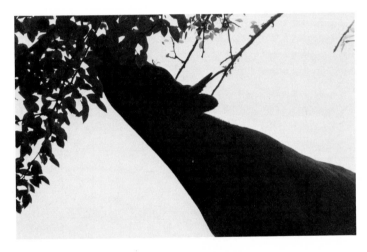

This photograph was intentionally overexposed to contrast the form of this cow eating a pear with the background sky.

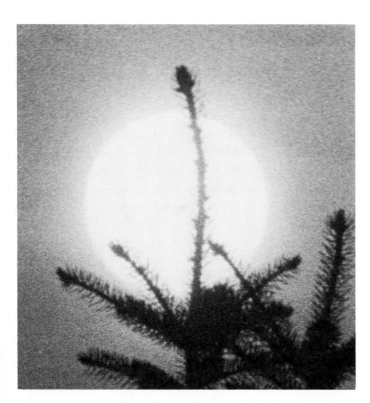

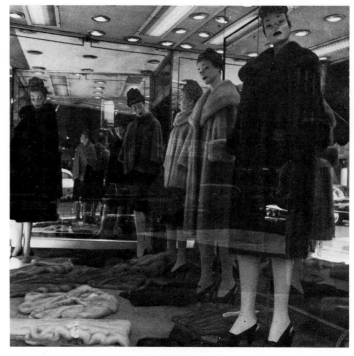

Sometimes bringing the light source into the picture can make for exciting images with fascinating value relationships. This is a play of the early morning sun with the top of a spruce tree. Note the lighter value of the section of the tree directly in front of the sun.

The sources of light here are the artificial lighting of the interior and the lighting reflected from the street outside the window. There are fascinating value relationships in this photograph. The patterns and values of the lights play with the relections and the fur-coated mannequins in a delightful way.

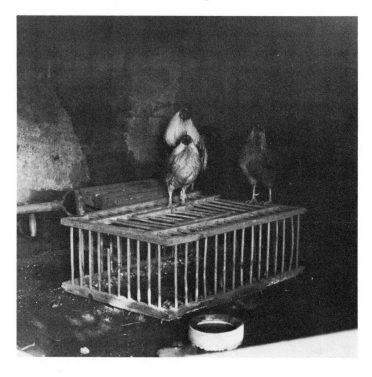

This photograph of a rooster and two hens was taken in an area underneath a chicken coop. The sense of darkness and yet visibility and detail within that darkness is fascinating.

Sometimes it is not possible to obtain *correct* exposure because of the lighting conditions, the lens, or the film characteristics. One can push, or extend, light potential by increasing film speed and using special developer and developing techniques, but this may mean sacrificing value range and fine grain. If one does not wish to push the film speed, one can mount the camera to a tripod or set it on or lean it against a handy object to assure as much sharpness as possible. Hand-held shots in low-light conditions are risky if sharpness is needed, but the risk is frequently rewarded with some pleasant surprises. A good picture is worth the chance; even thin or underexposed negatives are often printable on high contrast paper, sometimes with good results. Also, one should not underestimate the areas too dark to render with detail in low-light situations. Dark, underexposed areas may help the picture and make its setting or environment more real.

When working in low-light situations, especially with a camera with a built-in light meter, and a reading is not possible, one can take the reading from a smooth, bright, white surface, if available, and increase exposure 2½ *f* stops or divide the normal ASA or film speed by five for average subject matter having a normal range of light and dark values. Commercially available, pocket-type calculators are also useful in determining shutter speed and aperture in low-light situations.

(right)
These are mannequins erected in one of the country's oldest iron foundries to show the steps in the molding of hot metal coming from the furnace in the background. The room was a dark one. The darker areas capture the essence of the working atmosphere in which many generations of men spent so much of their lives. Despite the low-light conditions there is a good deal of detail even in the dark areas.

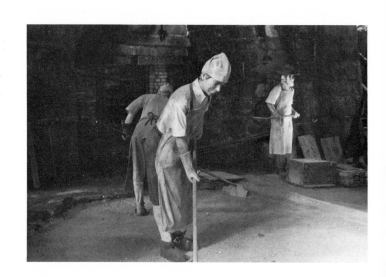

Photographs with areas of solid black, areas in which it is often too dark for a film or exposure to pick up detail, can be very powerful for just that reason. The solid area adds interest, frequently contrast, and a sense of space. When black areas are found in the background of a photograph, they can be particularly effective.

Areas of solid white background can be as powerful to value and picture contrast as black ones. Other values need not be changed by special exposure or print techniques as is the case for a silhouette effect. In fact, the inclusion of a variety of blacks and grays can enhance both aesthetic and expressive content.

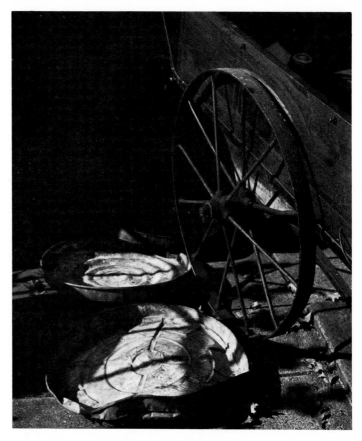

Wagon wheel and trash can lids.

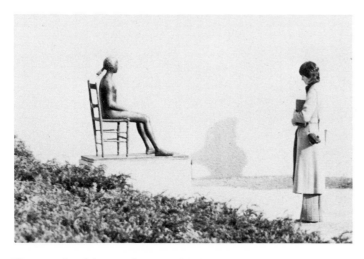

The seated and the standing at the Hirshhorn Museum and Sculpture Garden, Washington, D.C.

Filters play an important role in a creative photographer's work with value and value relationships. There is a tendency, however, particularly in the novice, to become overly concerned about and confused by the great variety of filters and their respective potentials. As with the selection process for different photographic papers, it is best to proceed slowly and examine the effects produced by one or two filters for a period of time before trying others.

Filters change values and value relationships by transmitting certain colors to the film and by absorbing, or holding back, other colors. The colors transmitted will, in effect, be given more exposure, thus making them lighter in relationship to the colors absorbed. Filters of a specific color will transmit that color and absorb other colors. To make the color and its values within a certain area appear lighter in relationship to other colors in the picture frame, a filter of the same color as the area should be used. This will hold back or darken other colors on the spectrum. To darken the color within a certain area, a filter of a color different than that of the area should be used.

The use of filters requires change of exposure time or shutter speed. The amount of change suggested for each filter is called the filter factor. There are circumstances in which this factor may not be applicable. A photographer will become familiar with these through use and experimentation. The exposure change depends on the color and depth of the filter, the color sensitivity of the film, the color of the light, and the color of the subject.

While filters are used to obtain contrast in many types of photographs, perhaps their most common use is to provide contrast in those photographs in which sky is included. Yellow, orange, and red filters will absorb the blue of the sky and hence the sky will appear to be darker in a black and white photograph. Consequently, clouds can be emphasized or, on cloudless days, the value of gray in the sky can be intensified so that it does not appear to be washed out. The yellow, orange, and red filters will also serve to darken the values of any green landscape areas or blue water areas in a black and white photograph.

These photographs of the same landscape were taken with no filter, a medium yellow filter, and a medium red filter, respectively. They were printed on the same No. 3 contrast paper for the same length of time and with the same enlarger aperture. A somewhat washed-out quality distinct in the photograph using no filter changes decidedly with the use of the filters. With the medium yellow filter the green landscape assumes richer values, the blacks become more brilliant. The contrast in values between the white clouds and the sky is also much stronger. The water is darkened. The medium red filter darkens the sky, foliage and water so that the effect is highly dramatic.

(top)
The Berkshires—no filter.

(middle)
Medium yellow filter.

(bottom)
Medium red filter.

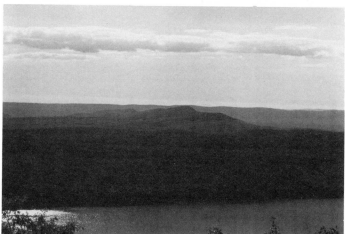

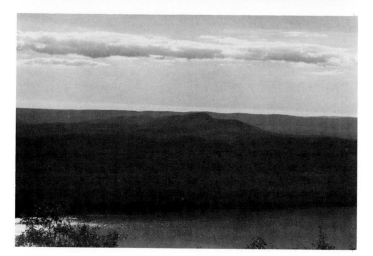

One's use of filters need not be limited to photographs with sky and clouds. Experimentation will help in discovering many ways in which filters can strengthen the effects of value play, specifically, and of photographic expression, in general.

For those who like rich contrasts and dramatic effects, a medium red filter will prove to be extremely valuable. Its use will often mean the difference between a photograph with rich contrasts and bright highlights and one which is dull for lack of them. A medium red filter will often make it unnecessary to use a high contrast paper to ensure essential contrast. In pictures where the values throughout are closely related, this filter will be particularly helpful. Here are three sets of comparisons. In each case the photograph on the left was taken without a filter and the one on the right was taken using a medium red filter. The same number 3 contrast paper, printing time, and enlarger aperture were used for each photograph in a set.

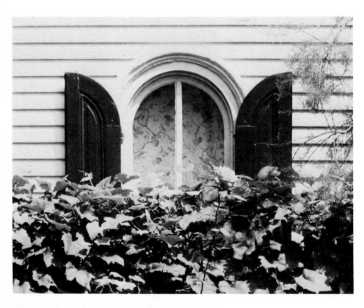
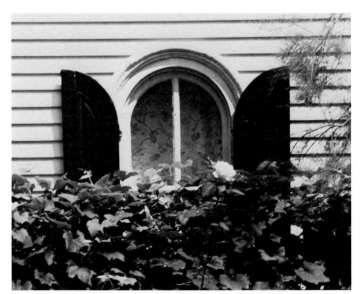

Here are two photographs of a section of a white clapboard Victorian house with window, green shutters, grapevine, and red rose. The red filter deepened the values of all the green and shadow areas, making the contrasts between light and dark much sharper. The value of red rose is also clearly distinguished from that of the green leaves.

In these photographs of a section of a steel mill where grays and reds of similar values dominated, the use of a red filter gave a very needed contrast. This is true not only in the sky which is much more exciting in the photograph at right, but in every other section of the picture. The contrasts in the building and slag pile are also much richer and stronger.

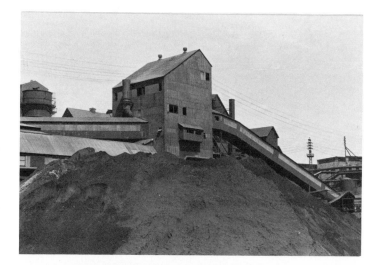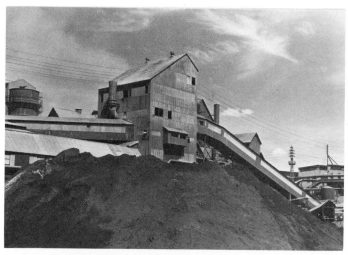

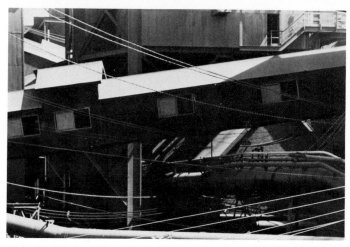

In this geometric play of the detail from a steel mill where there were also many like values, the contrasts are far more vivid in the photograph at right.

In black and white photography it is important to realize that values change as they become more distant. On most film emulsions, values are rendered as being lighter the farther away they are from the camera position. One must bear this in mind, especially with landscape photography where the background may appear quite washed-out unless some changes are made. Filters will help in certain cases, and so will changes in exposure.

Burning-in, or additional printing time, will also darken or bring out background areas. Because the eye is so accustomed to seeing background areas as lighter, burning-in of the background will tend to make the sense of space more shallow. This result can have both positive and negative effects, and one must make judgments for each specific case.

In this photograph of the *Floating Gardens* at Xochimilco, Mexico, the background areas, including the trees, are lighter. Here they are suggested only by splotches of light gray.

After the process of burning-in was completed in the background areas, the trees were brought out quite distinctly. The values of the background are close to those of the foreground. This photograph lacks the fading away quality of the accompanying photograph. The lagoon does not seem as long. However, the interesting tree shapes and their relationship surely make up for the loss of picture depth. Design here is also better because of a better balance and contrast. In the accompanying photograph the large central white area with its vague splotches is somewhat disturbing.

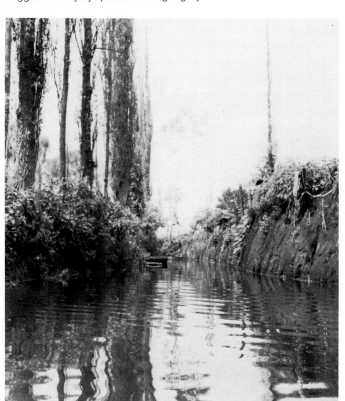

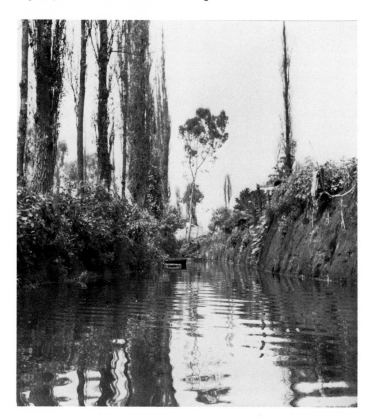

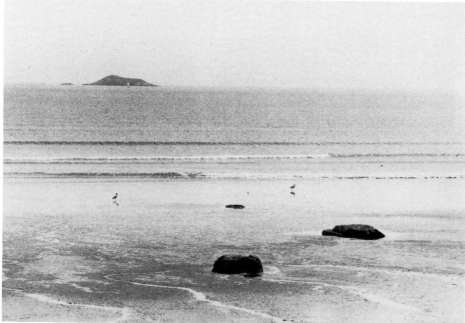

Egg Rock from Fisherman's Beach, Lynn, Massachusetts.

The addition of middle gray achieved by burning-in the lighter background provides the bottom photograph with a richer play of values and a stronger quality than the other with its bleached-out quality. The sense of depth is not hurt too much since the middle gray of the distant rock is still obviously lighter than that of the rocks in the foreground.

Sometimes the aesthetic and expressive ends of the photographer may best be served by letting distant values remain as the film records them.

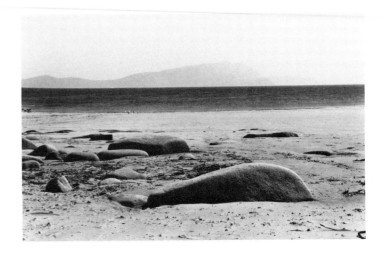

(right)
The Corraun Peninsula, Ireland. The shape of the distant peninsula with its lighter value echoes that of the rock in the foreground.

(below)
Steel mill and hills.

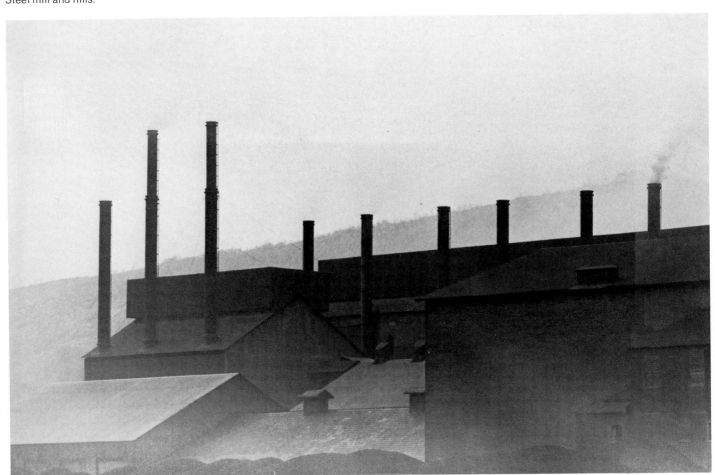

Swings, County Clare, Ireland.

The value changes and relationships that are created by the use of a strong light source should be of concern to the photographer. They can enhance some photographs and destroy others. Deep shadows, such as those found around the eyes and under the nose in portrait photography, are the result of strong light. In many instances, the shadows created by this type of light can add interest, spirit, and mood to a photograph.

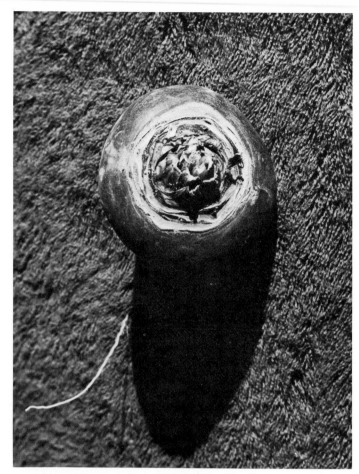

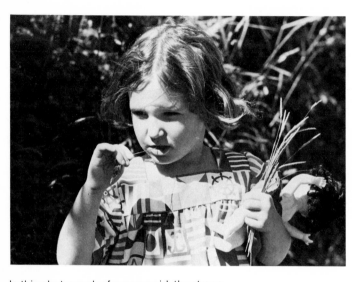

In this photograph of a young girl, the strong sunlight coming from the left side has created pockets of shadow around the eyes and a strong value contrast on her face. Shadows are also created on areas of the dress unexposed to the direct sunlight. Many looking at this photograph would undoubtedly complain. Some would advocate dodging to lighten the shadows or encourage burning-in to bring out more detail in the dress and soften the sharp value contrast in the face. However, the author found that the shadows and strong contrasts enhanced the original value relationships and contributed to the spirit of the whole. It is a hot, sunny day. The girl with her doll is chewing on a piece of succulent grass. Why surrender the spirit and effects of a sunny day and this child's relationship to it?

A strong light source was responsible for the emergence of the long, dark black shadow and the strong textural definition on the turnip which have made this photograph fascinating. The brilliance of the dark opaque area sets off the round, highly textured turnip and is of great interest in itself. Again, this shadow conjures up that sense of mystery about the dark and unknown.

(opposite)
Changing baby's diaper.

The soft, gentle effects so often desired in portraiture of young children are created here by the combination of light coming from a north window ten feet to the right with reflected light from the white walls. The value contrasts on the face are gradual; the effects of the light and medium grays are soft. The gray and white values of the out-of-focus doll in the foreground, the lighter values and out-of-focus texture which are created by the moving hands on the baby powder, as well as the light, out-of-focus background, all add to the sense of delicacy of a one-year-old child.

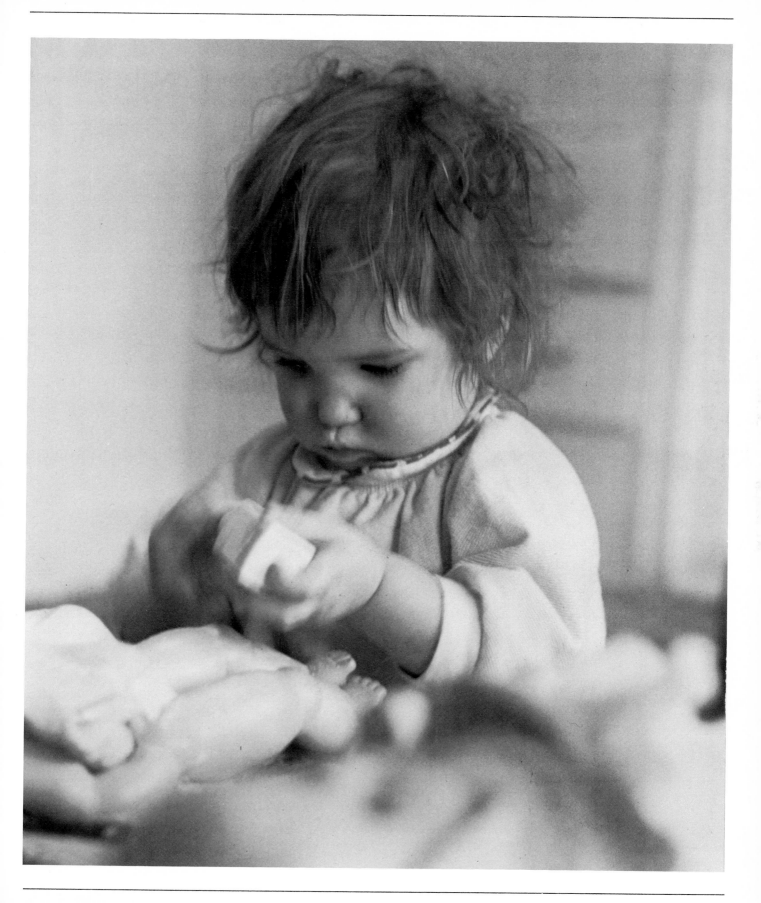

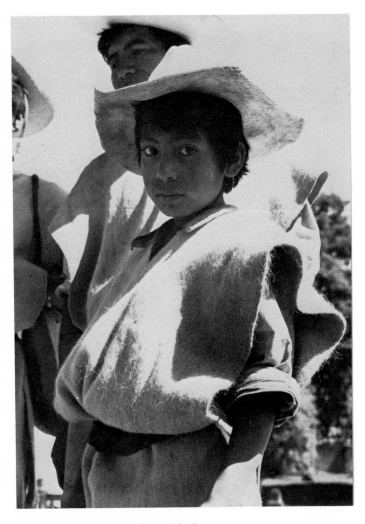

Boy, San Cristobal de las Casas, Mexico.

The brim of this young boy's hat has provided just the right degree of shade to achieve the even illumination of his face. The pockets of sunshine and the bright backlight provide areas of value contrast setting off the medium gray facial values. Note also the vital spark added by the black and white of his eyes.

Many subjects and areas are best photographed in a more even, less contrasting type of illumination. Such photographs can often be obtained without sacrificing that contrast which is characteristic of good design. In fact, even illumination may be desirable in only part of a photograph. Such even illumination results when a similar type of light emanates from many directions simultaneously, such as on sunless days, at predawn, at twilight, in shade, in interiors having light walls which reflect light, to name a few. Situations in which light comes from many directions can also be created by a photographer with special arrangements of artificial lighting and reflectors. In addition to specially purchased reflectors, makeshift reflectors can be set up and used in order to direct light to a certain area. Light objects, particularly white ones, are most often used for this — sheets, curtains, and pieces of cardboard being among the most common.

The greater the degree of evenness in the illumination, the more subtle and gradual the value relationships will become. The whole will often assume a softer, gentler quality. The subject will be defined not so much by the sculptured, chiseled effect of directional lighting where shadows heighten definition, but rather by value contrasts between objects and areas. Value contrasts with the background can also serve to set off objects and can often be arranged to effect this. An illusion of softness can also be created by using special diffusion lenses or employing techniques such as photographing through glass smeared with petroleum jelly.

In portrait photography a softer, more even illumination is often desirable. This type of lighting softens by eliminating the strong shadows and the strong definition of wrinkles and other such distinct features. Hence the cut-up effect of abrupt value changes, which can often be undesirable, is avoided. Soft lighting will also prevent squinting, which is caused by a subject's response to harsh light. Outdoors in semishaded sections is a good place in which to achieve this softer, more even value play in portraiture. Ideal locations may be found under a tree, against the side of a building, under a canopy, or even under a hat! These places usually offer patches of sunlight which provide needed highlights and yet are not distracting. Indoors, softer lighting effects can be provided by window light and the reflected light from walls.

Many photographers, in part due to the claims of manufacturers anxious to sell special equipment, become preoccupied with the technical aspects of photography. This is true with many types of equipment, but especially so with lighting equipment. While many good photographs are made, and should be made, only after carefully regulating light sources or awaiting the development of proper light conditions, much can be said in favor of accepting, getting to know, and using the light as it exists. Often natural light can be more beautiful and revealing and hold greater photographic potential than one could ever imagine. One should not avoid the rainy day, the cloudy day, the situation involving poor light. Explore them all! Those clouds can make all the difference in the world!

(right)
This Illinois farm on a clear day can be interesting, particularly for the sense of the endless space of the prairie, but the same space filled with clouds and their play of values has its own unique power.

(below)
Vultures.

(below, center)
Prairie sculpture.

(below, right)
Cornfield.

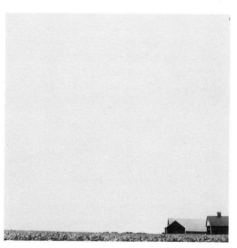
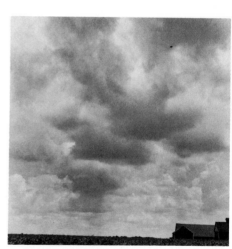
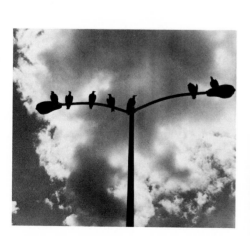
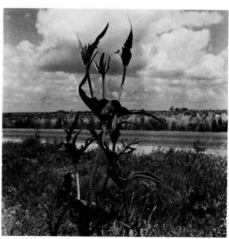
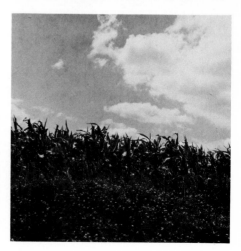

SPACE

Space is area or distance between certain points. Space may be two-dimensional or three-dimensional. Photography is concerned with the translation of both two-dimensional and three-dimensional space onto a two-dimensional surface, a piece of flat photographic paper.

Traditionally, it is more common to think of space strictly in terms of the area surrounding objects or points of interest. In design vocabulary, this unoccupied space is often called negative space, or negative area, in contrast to the positive space or positive area, which is occupied. Both kinds of space are always present, and thus figure importantly in the creation of good design.

(above)
This photograph of the Grand Canyon takes in many hundred cubic feet of three-dimensional, or actual space. Three-dimensional space has height, width, and depth. The rock formations closer to the camera are larger relative to those behind. Likewise, the clouds appear smaller because they are more distant. The sensation of depth, as recorded by the camera, is almost as the human eye experiences it.

(left)
This is a photograph of a design on curtain fabric. Similar to the photographic paper, the fabric is two-dimensional, having height and width, but no depth or thickness. The area of design photographed is only a few square feet. Although both the fabric and photographic paper are flat, there is a decided sensation of depth because of the interrelationship and placement of the shapes, values, and textures. Some flowers are situated in front of the leaves, others, behind. Some flowers seem to be in the same plane as some leaves. The white areas appear to be behind both flowers and leaves.

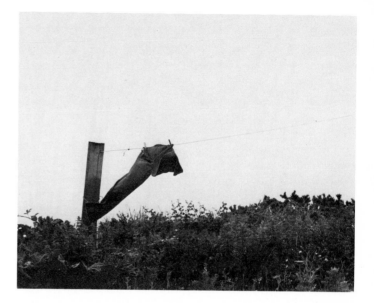

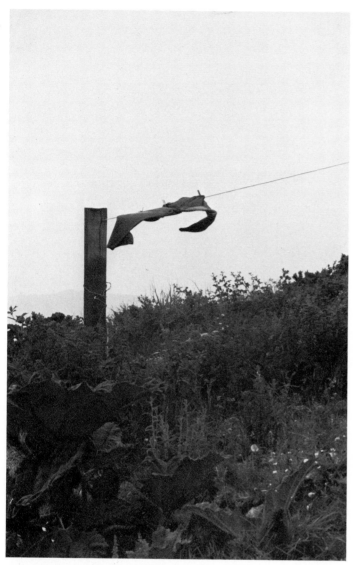

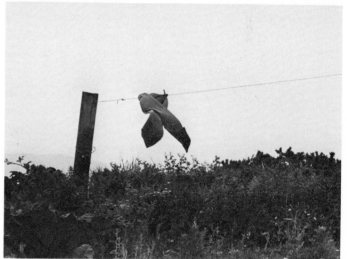

In this series of photographs one can see in the pair of pants being beaten by a strong wind how important the negative area is to the compositions. The negative area defines the interesting play of change in shape and sets off with contrast the more active area of ground below. In addition, the negative area gives breathing space, or expanse, essential to the feeling or mood desired.

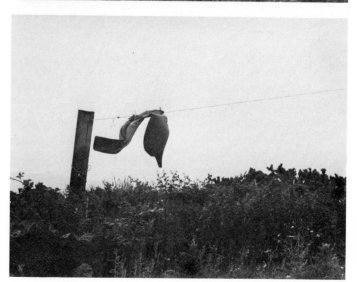

A photographer, in developing an awareness of space, should become sensitive not only to the space around, negative area, but also the space within — what is called the positive area. There is always a space within, as well as a space around.

Sometimes one may wish to eliminate surrounding space to concentrate on qualities of the space within. New spatial relationships are then established.

Perhaps the interplay of objects with their surrounding space is one of the more exciting discoveries a photographer can make, and it is at the essence of making a good composition. A photographer has many choices: to add or eliminate space, foreground, background and sides; to rearrange objects in relation to the surroundings; to move the camera, to change cameras; to change lenses. In short, a myriad of possibilities exists.

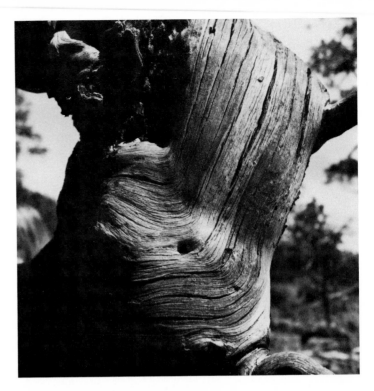

The areas around this weathered wood are really somewhat disturbing.

A close-up focuses on the qualities of the wood which have their own spatial dimensions.

The white areas or space of this stone shed is fascinating. One is made to examine or feel the sense of expanse and its textures.

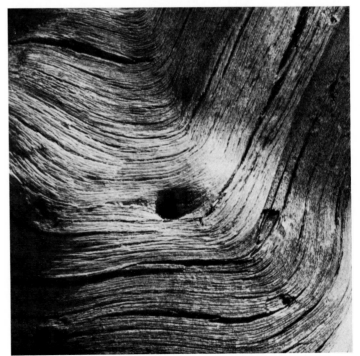

This series of photographs was taken of a blossoming black walnut tree. In all of them the relationship of the branches, blossoms, and surrounding space was the foremost concern. However, the potential for different compositions becomes clear with a change of lens, a change in the placement of the branches and blossoms within the surrounding space, and a change in the amount of the more active area included.

50 mm lens.

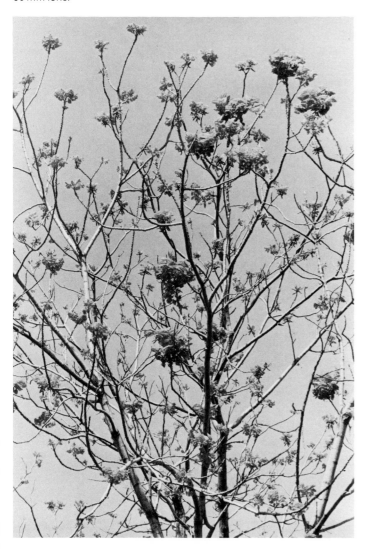

300 mm lens.

Knowledge of the depth of field principle and its use is important to all photographers. The principle relates to the sense of space within a picture, as well as to the potential of all cameras and lenses.

When a photographer focuses on an object in three-dimensional space, other objects (or parts of them) which are located in front of, and/or behind, the focused object within that space, will not appear to be as sharply defined. The decline in sharpness is gradual and is dependent on the aperture, the focal length of the lens, and the distance from the lens to the subject. The zone within which sharpness is, in most cases, acceptable is called *depth of field*. The smaller the aperture and the shorter the focal length of the lens, the greater the depth of field will be. Sharpness can be affected, however, by use of shutter speeds that are too slow or by subject and camera movement. At maximum aperture, the degree to which depth of field extends is reduced, and therefore sharpness is sacrificed. In many cases, the degree of depth of field can be read from a scale on the lens or on the camera body and checked for each respective aperture and shutter speed. This is one of the creative controls a photographer exercises over the image. Frequently it is possible to see through the viewfinder an approximation of the depth of field one will see later on the negative and print.

This series of photographs records the interrelationship of movements and space between the little girl and her dog pursuing their individual activities. The principle of depth of field was used to blur the young girl in some of the photographs and to focus on her in others. The old railroad track was intentionally included to provide added spatial dimension. The position of the photographer remained stationary although the position of the camera was moved slightly to the side and up and down.

First the dog was made the focal point, the point of sharpest focus. Although the presence of the girl is important, her figure, as well as the background and a section of the foreground, were blurred to direct the viewer's attention initially to the dog. The eye was then left free to explore the rest of the picture and the relationship of space and movements between the subjects. Near maximum aperture was used so as to make the zone of sharp focus rather shallow. Since the subject was close to the camera, the depth of field was further reduced. In these examples, only the railroad ties both directly preceding and following the dog remain in relatively sharp focus.

In the last three photographs there were changes made in aperture and focal point to emphasize the interaction between space and movement. The shutter speed remained at $1/60$th of a second throughout the series.

Amanda and Adam.

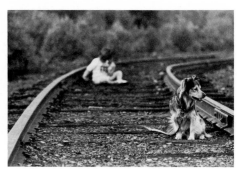

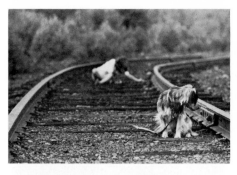

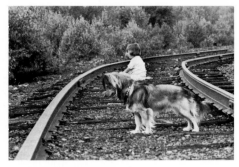

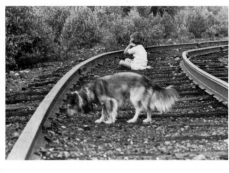

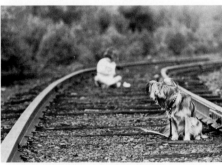

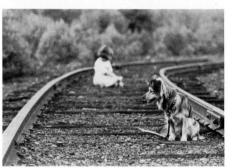

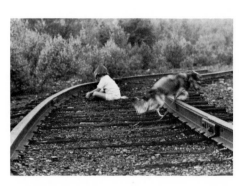

(above)
In this profile study a smaller aperture was used to get both dog and child in relatively sharp focus. The focal point is somewhere between the two. Note that the point of relative sharpness extends about twice as far behind the focal point as it does in front of it. This extension of depth of field is characteristic of photographs made from a normal distance, such as is the case here. Also, the farther away the focal point is, the deeper is the zone of sharpness. Note how much closer together the subjects seem here than in the previous photographs. The effect of deep space is not as great as it is when the background is actually out-of-focus or beyond the range of depth of field.

(above)
In this photograph the aperture was opened up two stops and the girl was made the focal point. The dog and foreground are purposely blurred.

(above)
The same aperture was used here as in the above photograph. The focal point was shifted to a plane just in front of the dog. Note the increased sharpness of the foreground and the decreased sharpness of the background. The blur in the forward section of the dog is caused by his movement, and is in contrast to the clarity of detail in his tail and rear paw, as well as in his direct surroundings.

Close-up photographs call for special considerations in regard to the sense of space and the use of depth of field. Because the zone of sharpness becomes more shallow as one gets closer to the subject, the depth of field in close-ups is often just a flat plane. To attain maximum depth of field, one should use the smallest aperture possible which may, in turn, require using slower shutter speeds and in some cases, a tripod, to avoid loss of sharpness due to camera movement.

Reduction of depth of field can serve to heighten an aesthetic or expressive end. Close-up photography often reveals unknown aspects of objects by its power to isolate. In many cases the accompanying loss of sharpness will create interesting spatial dimensions.

In this series of close-ups of the snake plant (opposite), one can see the fascinating play between the in-focus and out-of-focus areas achieved because of the shallow depth of the field. The leaves have taken on a dynamic, moving, dancelike rhythm, and the space seems much deeper. The use of a black background also helps convey an illusion of depth. The new visual effects make the close-ups more exciting than the photograph of the whole plant.

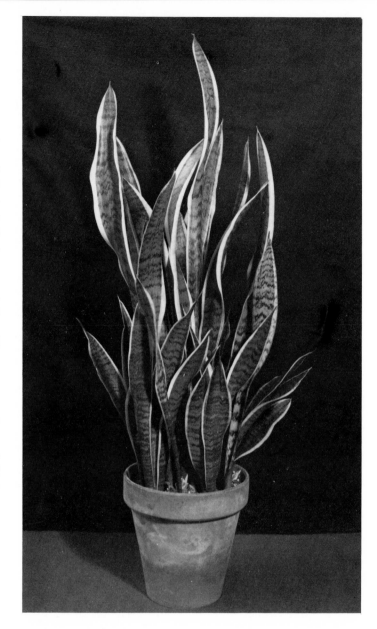

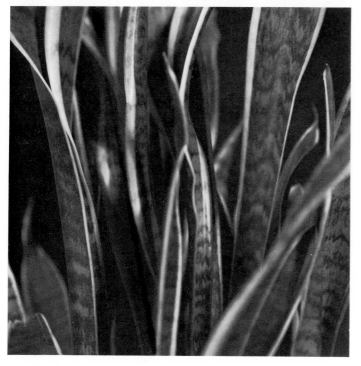

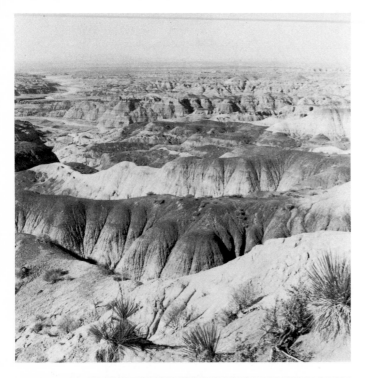

Many photographers become preoccupied with photographing awe-inspiring expanses. There is something exhilarating about being out in nature and capturing on film the vastness of space and the grandeur of nature. Many photographers go so far as to climb mountains or place themselves in precarious positions to capture that shot which will take it all in, sometimes on the tiny negative of a subminiature camera.

In photography of landscapes with wide expanse perhaps more than in any other type, there is a tendency towards sameness. For this reason it is important to consider good composition and the principles of design. A point of emphasis is particularly important.

Certain natural areas and parts of the world lend themselves more to photographs of this type. These photographs were taken in New Mexico, a particularly good state for photographs of wide expanse.

(above, left)
The Little Grand Canyon. This photograph illustrates the fact that change in size of similar shapes is a way to promote movement of the eye into space. The dominant rock patterns in the foreground appear as giant claws. This effect is greatly diminished in the formations in the background.

(left)
Yuccas along the road. This photograph is a good example of the power of a point of emphasis. The single yucca stem placed crucially in a near-central point, a point where the road and fence will eventually meet, is all important. This relatively thin line adds interest and emphasis and, placed as it is, interrupts the horizon line which would otherwise seem to divide the photograph in two. The sense of expanse is also heightened by the inclusion of a large area of foreground and by the placement of the yucca in a picture plane three-fifths of the way from the bottom. This placement causes the eye to move deep into space.

The effects of an elimination of a point of emphasis are illustrated here when comparing the photograph below with that at right. With the cacti in front eliminated, in addition to being a dull photograph, the sense of expanse is considerably less. In the photograph at right, the cacti in the foreground are visually picked up by their relatives behind, thus relating foreground and background space. In the photograph below the near horizontal of the horizon line takes dominance, divides the picture in half, and tends to make the eye see-saw from one edge of the photograph to the other and even off the print.

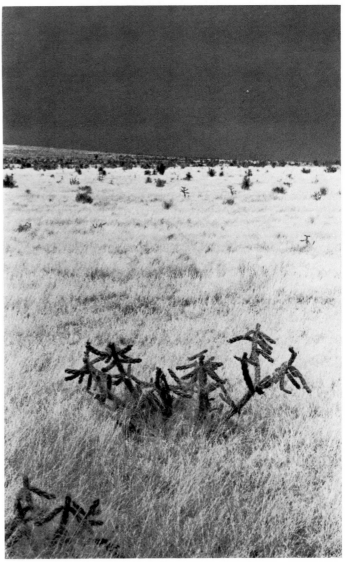

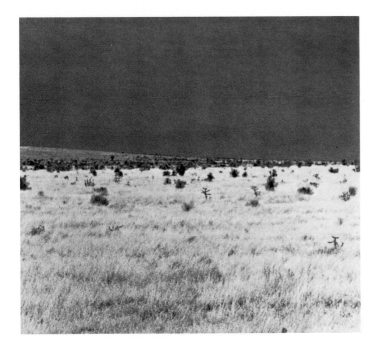

In this photograph there is a strong horizon line dividing it in half. The continuity of this line is broken, however, by the contrasting shape of the distant mountain which calls attention to itself by its contrast to the darker foreground. The clumps of trees in the foreground also relate in shape to the distant mountain, making for points of interest and emphasis.

In this photograph the foreground point of emphasis is very important. Without the old, twisted tree, this would be a very dull photograph.

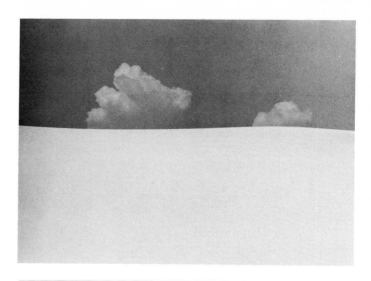

Plays with the horizon line, the point where sky meets sea or land, often make for interesting spatial imagery. The feeling of infinity or the sensation of the edge of space is to many filled with a sense of grandeur, mystery, and the unknown.

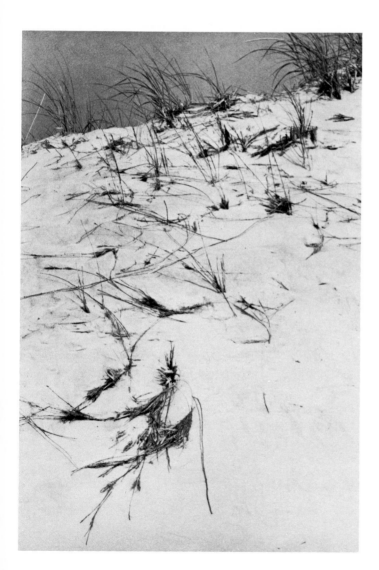

(top)
Clouds and sand, White Sands, New Mexico.

(above)
The stairs, Cliffs of Moher, Ireland.

(left)
Dunes, Ipswich, Massachusetts.

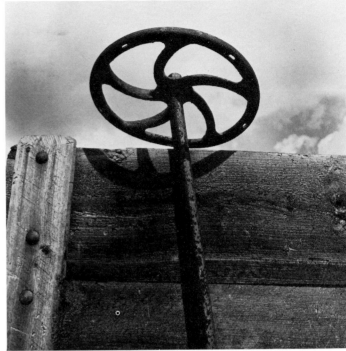

Exciting spatial effects can also be achieved by photographing objects and areas from unaccustomed angles. An elusive sense of space, or one that seems so because it either is unnatural or represents a departure from the accustomed view, is often created. These photographs were made within a few feet of one another.

(above, left)
Edge of railroad track with ties.

(above, right)
The wheel of a railroad car.

(right)
Three old railroad cars.

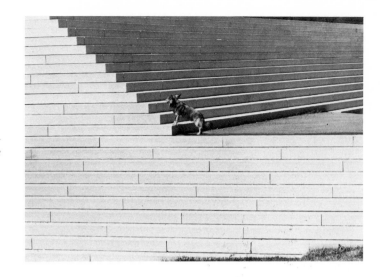

Frequently appealing also are images which reflect an up-and-down movement. To record this effect may require a change in the position of the photographer or camera.

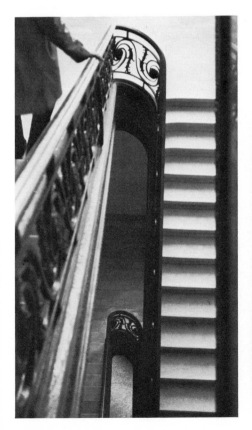

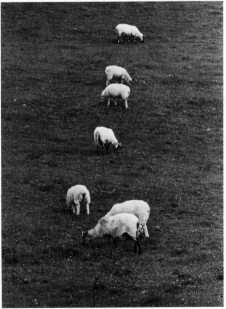

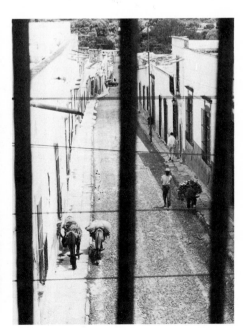

Striking photographs are often made where the principle of linear perspective is shown. When one looks out into space at parallel lines and objects along those lines, the lines will decrease in relative size and rise gradually relative to the viewer's position as they approach the horizon. The lines also will seem to converge in space, the point of convergency often called the vanishing point.

Photographs in which the sense of departing from or entering into space is highlighted are often impressive.

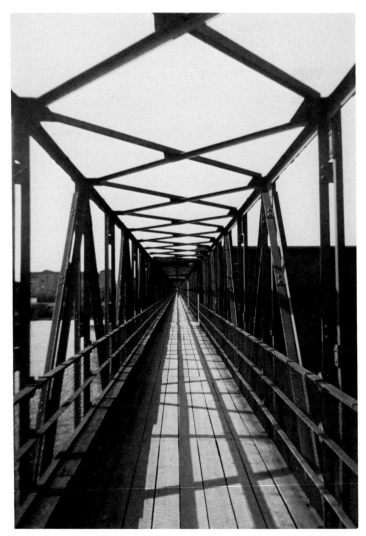

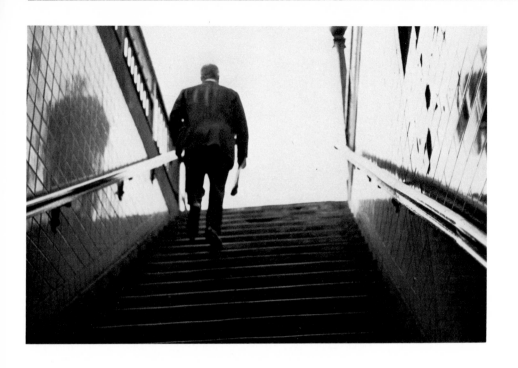

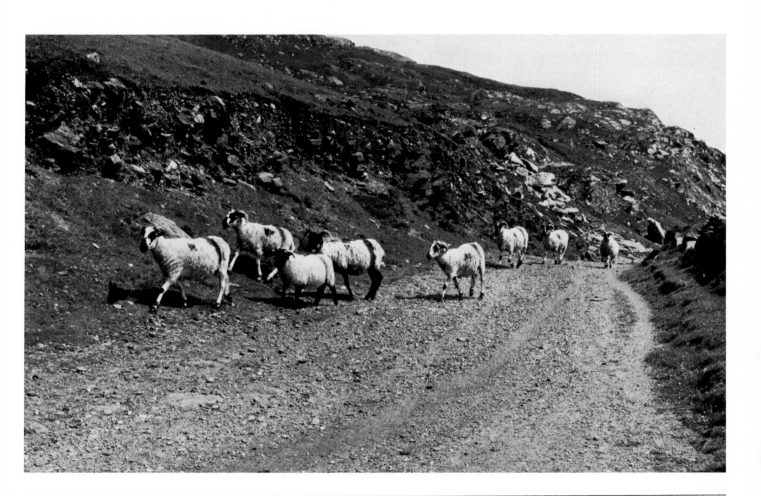

A photographer must be careful of objects which are so small in shape or, for some other reason, are not particularly outstanding. They may become lost in the surrounding area. Some of the space may have to be forfeited to effect concentration on the center of interest. To accomplish this end may mean a change in the type lens or camera, a change in the position of the photographer, or may involve cropping when printing.

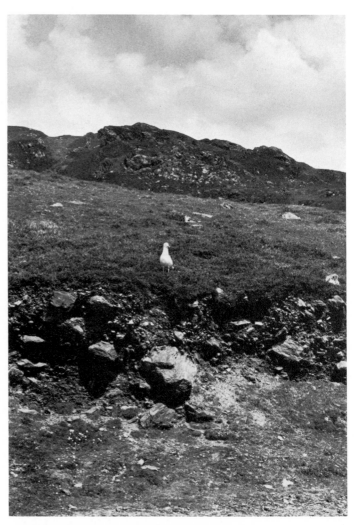

The sea gull is too small in this photograph. Its size cannot compete for attention with the overwhelming expanse of the surrounding area, and the gull appears as a white speck in a dark sea. Also, the road in front takes up too much picture space.

In this cropped detail the sea gull is still surrounded by a wide expanse, but the interest of the photograph is heightened because the gull appears to be larger. Also, the textures of the surrounding rocks, sea, and ground are more visible and contrast with the gull and each other much better.

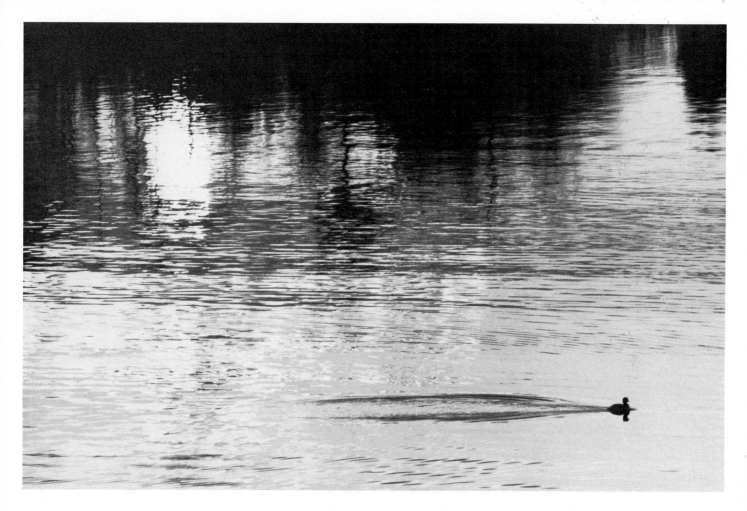

The theme of the smallness of man compared to the power, grandeur, and expanse of nature was common in nineteenth-century romantic painting. One can often attain a romantic effect by increasing the space around living and even inanimate forms. However, the photographer must be careful not to make figures or objects so small or so inconspicuous that they are lost to the viewer. Despite size differences, the forms should still be emphasized. Emphasis may follow quite naturally from the uniqueness of the forms but it may demand changes of lens or position, or cropping.

This little duck surrounded by a sea of water reflections and ripples swims along, leaving the viewer with an adequate awareness of his presence not only by his small silhouetted form, but by his own reflection and trail.

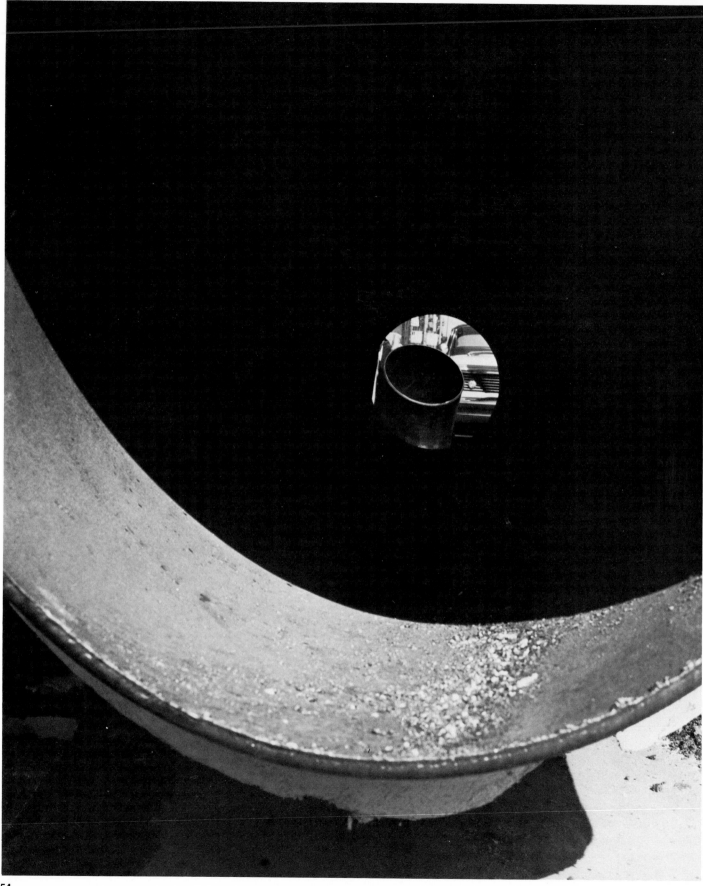

Chapter 3
THE PHOTOGRAPHER AS EXPLORER

To learn the language of design, is, in a sense, to assume the posture of an explorer. For the serious photographer, the exploration will be continuing. The human experience of searching, often struggling, sometimes finding, sometimes missing, is at the heart of the creative process. This exploration in photography should take place not only in looking for subject matter and in developing one's approach to it, but in every part of the photographic process. The search should extend to the manner of final presentation—how the prints will be framed and displayed.

To increase the depth of one's observation and one's ability to use the medium for creative expression should be the motivating factors of anyone serious about photography. Also one must be willing and able to take the time and care that all serious exploration demands. Various types of photography mean rushing about to catch just the right shot or the candid image. However, rushing through any of the subsequent aspects of the photographic process may well result in careless technique and, many times, in sloppy prints. Unfortunately, this shortcoming is characteristic of many amateur photographers and even of some professionals.

While no set of guidelines will guarantee one's emergence as a good explorer and photographer, a number of suggestions about appropriate methods of approach to the visual world and to photographic technique may help. If one brings a spirit of exploration to photography, the benefits in terms of personal enjoyment and increased skill should be most rewarding.

Avoid becoming overwhelmed by the infinite variety of possibilities for photographic imagery. Make a choice and explore it.

The choice may be a type of photography; landscape, portrait, flower. It may be investigations of a property of the visual world, one of the design elements, the quality of human movement, gestures, expressions, or any one of a variety of combinations of qualities and subjects. Avoid hopping from one thing to another without direction.

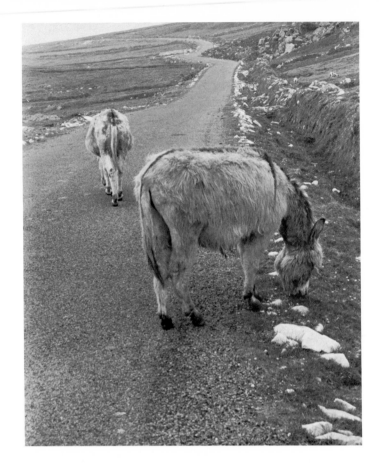

In training the photographic eye, it is wise to undertake a series of photographs of a particular subject or area, exploring it in as many ways as possible.

This series of photographs was selected from over fifty frames taken of two friendly donkeys one summer day along a mountain road in Ireland. For over an hour, they were explored by camera for physical characteristics, gestures, behavior, and spatial relationships. They were very willing subjects.

(above, right)
The spatial relationships and the contrast in direction are the outstanding features in this photograph.

(right)
This photograph is a study in behavior, as well as portraying an interesting physical relationship. The repetition in position and the textural contrasts are also of interest.

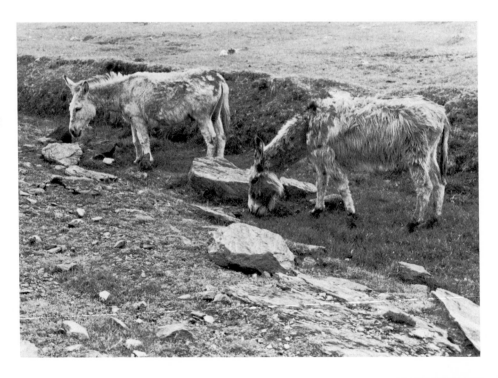

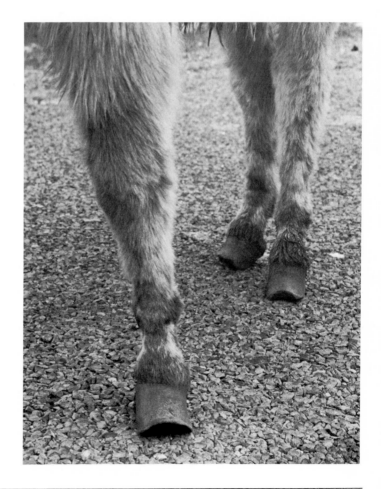

(above, left)
Here is a great relationship of shapes with a rich play of texture.

(above, center)
Line, texture, direction, and value contrast give this ''rear'' study an amusing quality.

(above, right)
Mr. Donkey, you have an admirable nose.

(right)
Spaces between and around, subject placement, shape, and textural contrasts are highlighted here.

When you find an area or subject which interests you, observe it at length. Return to it.

Study your chosen subject from different angles, and use different lenses. See how weather, light, season, and other factors affect it or change it. Cultivate favorite spots and subjects. Photograph them many times. Try to capture certain qualities each time. Become better acquainted with your immediate surroundings. It is common to ignore what has become familiar. Take another look around with your camera in hand.

Here are photographs of four black walnut trees seen every day from the author's window. They have been photographed in many types of weather, with a variety of sky, sun, bird, squirrel and even people relationships. Emphasis is placed on their seasonal characteristics and on their interrelationship as members of a group.

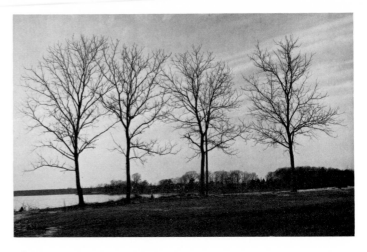

Winter

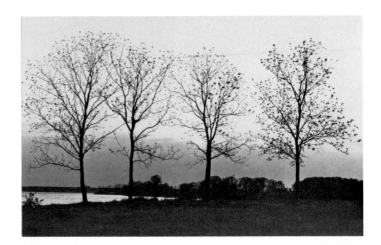

Spring

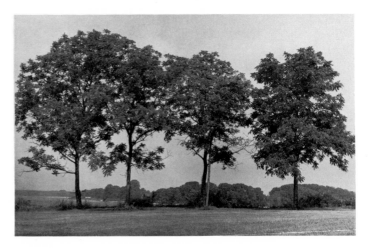

Summer

Look for photographic details within your photographs.

Here are three details taken from the preceding series of photographs. The sense of immediacy and the boldness that are achieved in a photograph of an isolated tree are not possible to capture in a group shot.

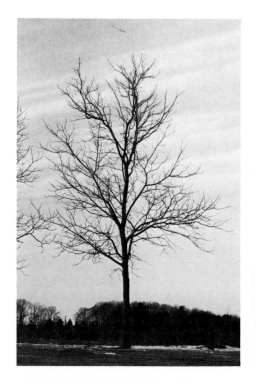
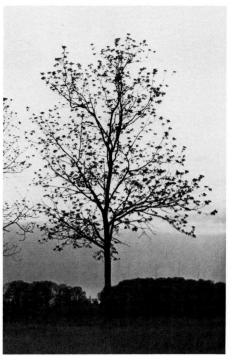

Try remaining in the same spot and exploring a subject or area with different lenses and a change of camera position.

Discovering the different worlds which each lens reveals can be an exhilarating experience. Some areas may be better revealed with use of a different lens.

These photographs of grasses in water were all made while standing in the same spot. Three lenses of different focal lengths were used, mounted on a 35 mm camera. The camera was moved from side-to-side and up-and-down in search of compositions. Each photograph has its unique quality.

50 mm.

135 mm.

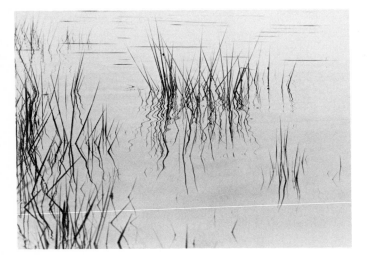

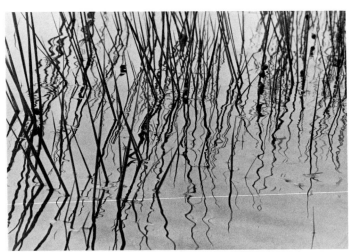

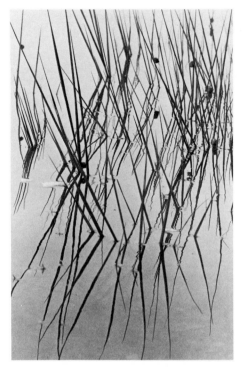

135 mm.

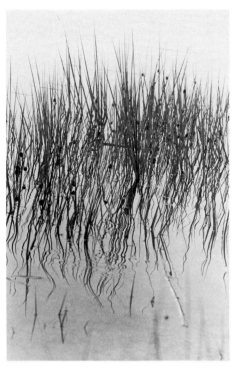

85 mm.

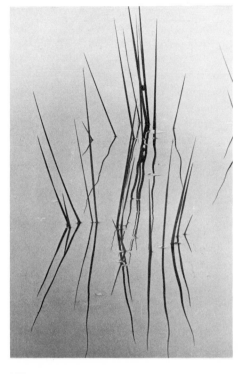

135 mm.

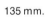

135 mm.

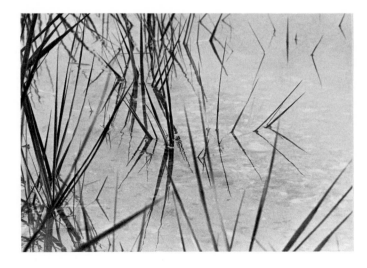

Try shooting a series of photographs from an unaccustomed angle. Avoid, at least for a while, the frontal orientation.

Learning to move around is important for all photographers. In doing so one discovers new perspectives and new possibilities for visual statement. Sit down, lie down, or climb a rock, or a rooftop to look at a subject. With this new orientation, try looking at the subject with different lenses.

Sometimes a certain interesting unknown quality will emerge when certain subjects are approached from the back. Without benefit of the frontal view in which the customary identifiable parts are evident, the viewer may concentrate on an unfamiliar aspect of the subject. With photographs of people, one often ponders the human experience or activity and its universality rather than looking at the individualized personal traits.

The profile, particularly of human and animal subjects, can be of considerable interest. More, but not all, of the individual characteristics are seen, and in that balance there is often a certain degree of fascination.

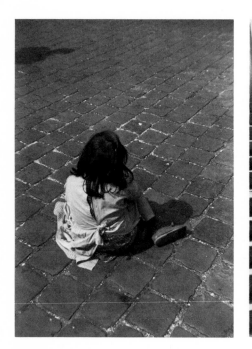
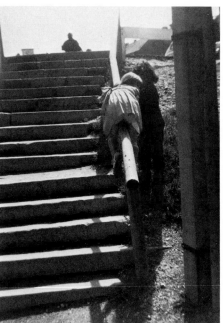
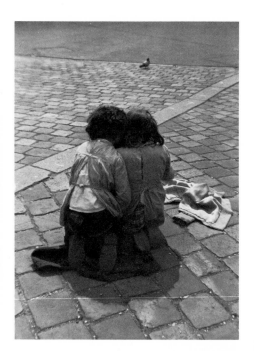

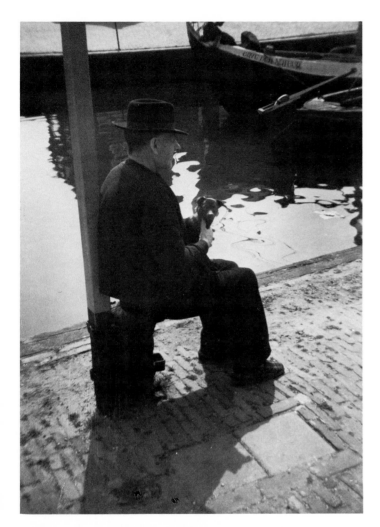

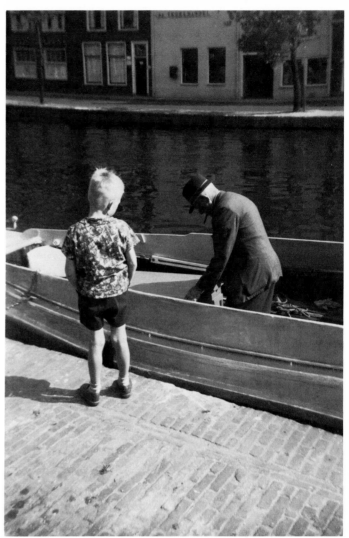

Poised during a quiet moment, the gentleman with his dog was caught profiled against the canal. Only the dog was aware of the photographer's presence. The contrast in the degrees of awareness of the subjects, provides a certain sense of amusement. The dog is ever alert, even small ones!

This profile of an old man working in the boat is contrasted with the rear view of the interested young boy. The combination of views seems to heighten the distinction between the two ages of man and to give the photograph a certain sense of universality.

Do not underestimate the power of the frontal view. In human and animal portraiture, the frontal view, whether posed or spontaneous, can be very powerful and revealing.

There is a good deal of controversy surrounding the right of a photographer to photograph people prior to receiving their permission. The controversy centers around the question of how much another's rights to privacy outweigh the photographer's right to a good and revealing photograph. To some photographers, this question is very disturbing; indeed some photographers will never photograph before asking permission. Others will use telephoto lenses and solve the question for themselves by rationalizing that because the subject is unaware of their presence, the infringement is permissible. Still others have no qualms about thrusting a lens in a subject's face despite his or her feeling. The good shot is the important thing, not the subject's right to privacy, and is well worth the risk of being spat on or kicked. The photographer who is interested in the candid approach to human photography, certainly has to confront this problem and resolve it in whatever way is most personally satisfying.

All of these photographs were taken without first obtaining permission from the subjects. All but the Mexican gentleman opposite indicated no objection once the photograph had been taken. One can tell from his expression that he was irate. This heightened emotional setting resulted in a powerful triple portrait which records the unique responses of the man, the girl, and the older woman to the photographer's presence.

The kind of relationship that is established with a subject can be reflected in a photograph. Indeed both the photographer and the subject of the photograph can enjoy the experience. Children are particularly willing subjects, but fun can be had even with their elders.

(opposite)
Mexican market—three faces.

(below, left)
Mayan boy—Mexico.

(below)
Mexican schoolgirl.

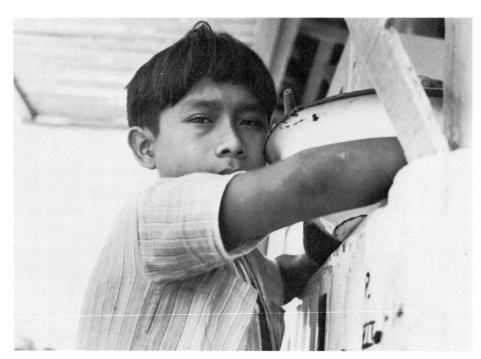

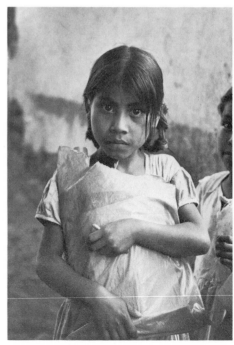

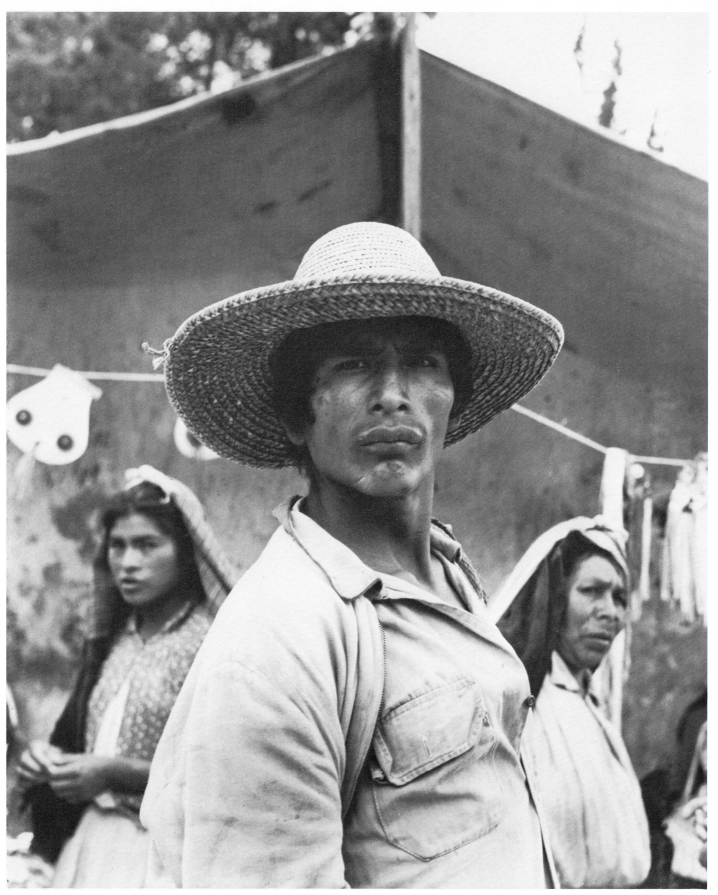

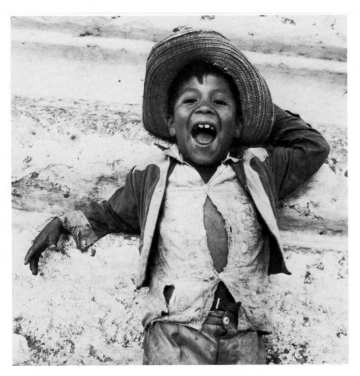

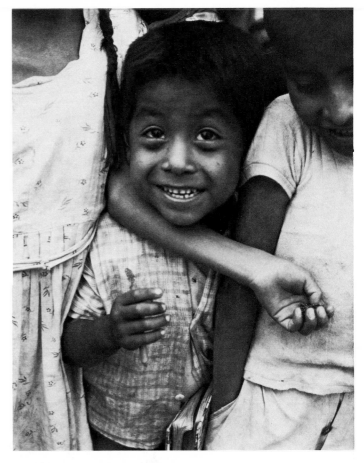

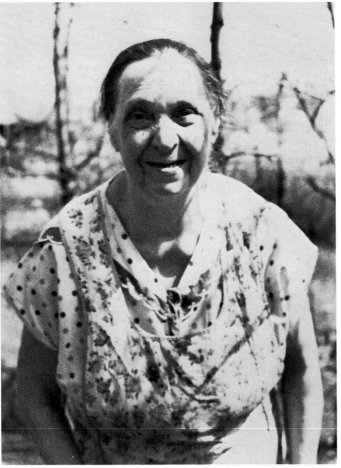

(above)
This "little devil" squeezed between his play-mates to have his picture taken.

(above, left)
A happy shout of youthful exuberance after having asked to be photographed.

(left)
Grandma liked playing with the camera also.

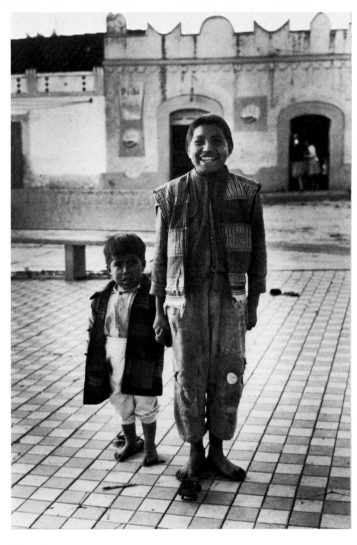

(above)
It was big brother who asked for the photograph. Little brother was brought along, but didn't quite know what to make of it all.

(above, right)
These young Mexican men were obviously flattered and enjoyed being photographed in all their finery.

(right)
These Brooklyn, New York boys inquired of the photographer if they were not as worthy photographic subjects as the cat who had first attracted the photographer's attention. Indeed they were.

Develop the ability to see compositions and patterns in groups of objects, whether animate or inanimate. Keep in mind the expressive power and importance of the negative spatial area, as well as that of the objects themselves.

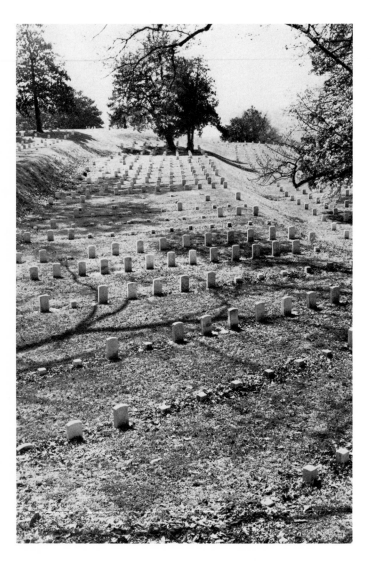

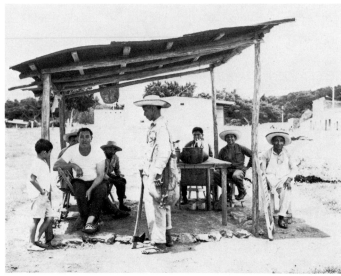

(left)
Cemetery, Vicksburg, Mississippi.

(above)
Men of the village, Bolonchenticul, Mexico.

(opposite)
The beach, New Hampshire.

Experiment with some of the many ways a photographer has of changing patterns.

Learn to visually separate parts from the whole. Look at the parts singularly for their own photographic potential and then seek other combinations if you wish. All photographers should develop the ability to isolate.

In creating a composition, one must often be conscious of more than one single group or object. Many groups of dissimilar objects can make up a pleasing whole. Within the single negative of such a group composition there may well exist the potential for other photographs.

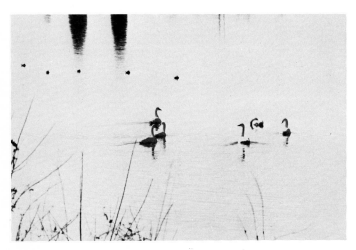

In this photograph several individual groups of objects are easily distinguished. There is one group of six swans or two groups of three, depending on one's perspective, one group of ducks sitting in a row in the background, a group of tree reflections in the upper part of the picture, a group of grasses in the lower, and a group of water ripples.

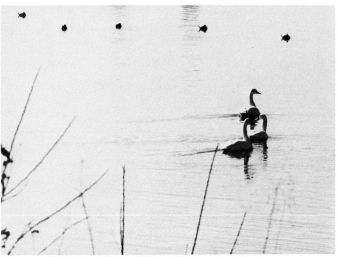

In this detail, a single group of swans, the row of sitting ducks, the water ripples, the grasses and the reflections make a fascinating overall pattern of groups. Note how important the large area of negative space is to the whole, and how the out-of-focus grasses in front add to the rare and oriental quality of the photograph.

(opposite)
A number of groups make up this complex, yet fascinating photograph of a Mexican market: fruits, shoes, lettering, sacks, and people.

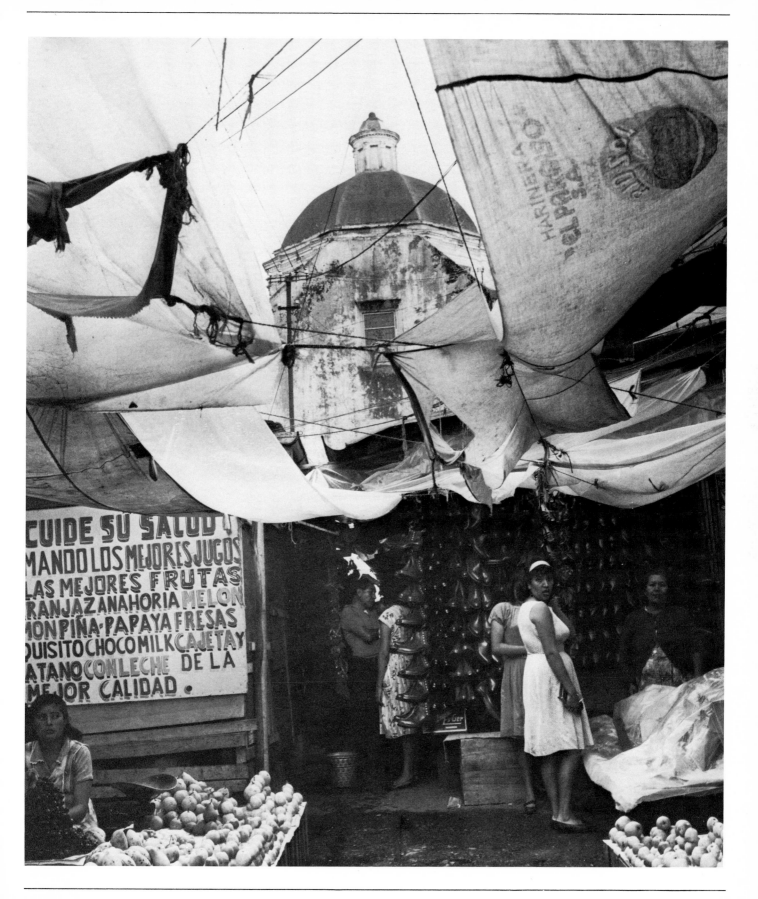

Try shooting quickly. Do not be afraid to use film to experiment.

Much has been written about the power of the candid shot, particularly in the realm of people, animal, and bird photography. Posed pictures often lack the kind of natural or spontaneous quality that evokes interest from the viewer. The approach which stresses the technically good picture emphasizes such things as always keeping content in focus, using the correct lens for subject, obtaining the correct light reading, and so on. It will sometimes mean missing good photographic potential. With all of these considerations in mind, it is easy to lose one's grasp on the importance of the content of a photograph. Often the photographer who has to stop repeatedly to change aperture, time setting, and lens will miss the timely shot altogether.

Undeniably, a certain amount of chance or luck plays a part in picture making. Being at the right place at the right time is very important. Often the wait may be lengthy before the right combination of elements appears in the viewfinder. Patience is sometimes critical to capturing a good picture. Frequently numbers of frames must be shot to ensure one satisfying print will be obtained, one that will hold the power of visual statement which the photographer is seeking.

Any photographer with a 35 mm camera should definitely consider investing in a bulk loader and buying film in 100-foot rolls to roll one's own cassettes. The process of rolling film is very simple and the cost of a frame is considerably less than when buying film by the individual roll. This cost reduction can make experimentation possible for those with limited economic resources.

The great medieval Italian poet Dante is deep in thought with a pigeon perched on his head.

An elderly English lady with dog turns around to catch the photographer in the act.

A Dutch gentleman having a chat through the low, open window.

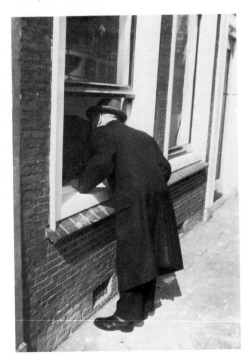

A parade is an event which lends itself to candid photography and is rich in photographic potential. Here is a series of five photographs from a single, 36-exposure roll all of which were taken within a few moments of one another. Each reflects a bit of the spirit of a small American city celebrating its Main Street parade. The expressions, gestures, and attitudes of the people are particularly revealing.

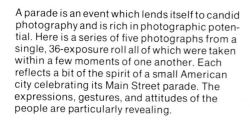

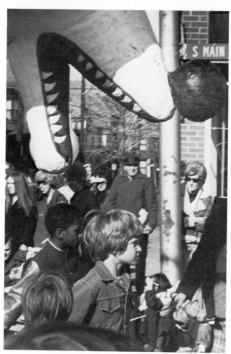

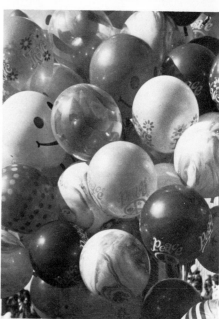

In attempting to capture the spirit, personality, or essence of a person, animal, or place, look carefully and, if necessary, wait. A gesture, a mannerism, or a small part of the whole can be extremely revealing.

Even dealing with a place or an area, the photographer will discover that a small part may reveal a great deal. Explore the significance of the parts.

This series of window studies were taken in a small American town. The photographs have captured the essence of the town in a way that no panorama type photograph could have done.

Windows are often so mysterious—full of secrets and tiny glimpses of privacy. Windows reveal something of their owners; perhaps their values, their aesthetic, their ways of living, or even their ages. In addition to objects in the windows, note the interplay of sun, shadows, and reflections.

This gracious young hostess who is describing colonial dress to visitors at Concord, Massachusetts reveals much of herself in her expression and gestures.

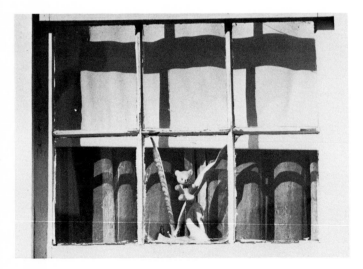

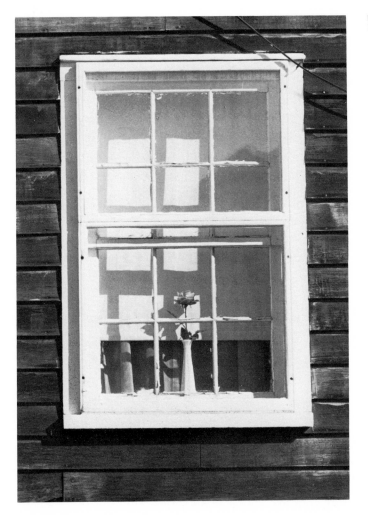

In addition to the interest generated by the objects in the window and within the room, there is the remarkable detail of the reflection in the window of the sky outside and the house across the street.

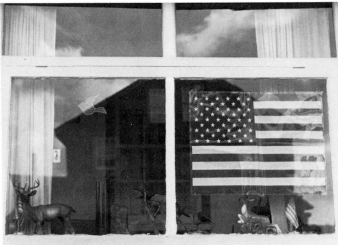

Try getting closer to your subject matter. Attempt close-up photography by using special lenses, extension tubes, a bellows unit, a microscope, or a telescope. Place emphasis on an ordinarily small object by making it appear larger than life.

All of the preceding suggestions should help you in examining your subject thoroughly. Some photographers feel that many amateurs do not get close enough to their subject, and that the way to assure a good picture is to move in. Whether this is universally true is doubtful. Certainly many photographs are made in which distance is essential to the realization of a certain effect. In many cases it is physically impossible to get any closer. However, where possible, the effort should be made. Close-up photography tends to magnify the sense of presence of the subject and its characteristics, sometimes even hauntingly so.

The photograph above was taken from a distance with a 35 mm camera and a 135 mm lens. The sharply focused textures, particularly those of hair, eyebrows, and lashes contrast in an interesting way with those that are out of focus. There is something haunting about this partial aspect of a face. For some reason there is a need to know toward what the eyes are directed.

This photograph of a very lovely insect which had settled temporarily on a sliding glass door was taken with a close-up lens while standing on a chair. The insect remained still during the exposure.

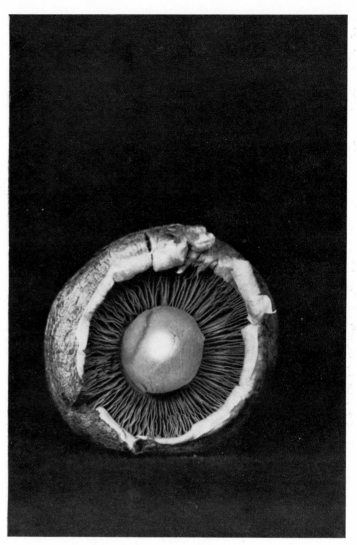

This life-size photograph of a mushroom was taken with a normal lens mounted to a bellows unit.

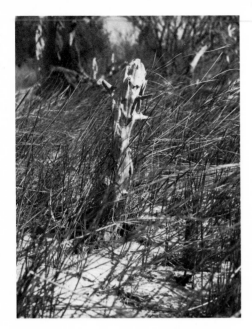

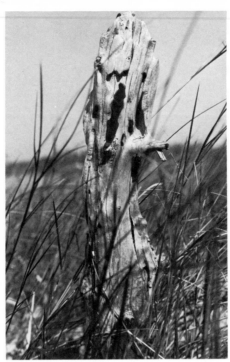

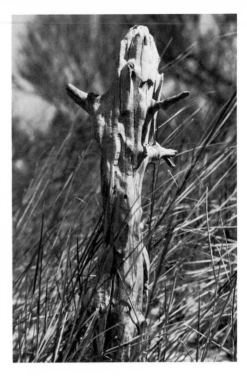

The author liked this scarecrow-like piece of weathered wood, about fifteen inches tall which is almost lost amid the tall sand grasses. Moving closer and mounting a close-up unit to a twin-lens reflex camera, the characteristics of the wood received greater emphasis.

In a close-up from behind the texture and shadow plays are accentuated. The gentle curve of the wood from this angle also interacts nicely with the rhythms of the in- and out-of-focus swaying grasses.

Closer up, there is an outstanding topographical play on the surface, which is punctuated by rich value contrasts. Also, the wood takes on an animated character, with an outward extension of the arms.

One can create interesting larger than life effects by using close-up photography. Smaller objects or parts can take on a different, and often fascinating, identity.

This close-up section of coral was taken with the use of a bellows unit. Because of the distribution and size of the holes and the principal texture, the coral has taken on the semblance of an animal—to this viewer, a bear.

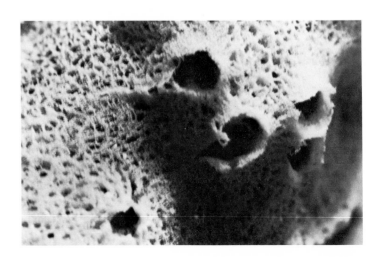

(right)
The potato sprout resembles a dinosaur walking on the crust of the earth.

(above)
These larger-than-lifesize pins take on an animated quality in this photograph.

Interesting size and spatial relationships between foreground and background fields can be created by taking a photograph close to a foreground object. The foreground object will then appear larger than background objects.

(above)
Photographing close to the large plant in the foreground made the plant appear larger than the stone chicken coop.

(right)
This photograph was taken by stooping down close to the railroad tie. From this perspective, the tie appears larger than the shack in the background. The shape relationship resulting from the placement of these two objects makes for a foreground-background play.

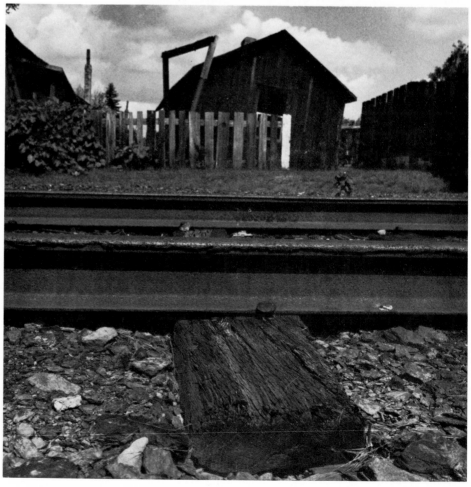

Develop an awareness of different types of light-ing and lighting conditions. Increase your sensitiv-ity to how lighting affects the photographic image by working with a variety of lighting situations.

Light reveals objects in the visual world. The photographer must work with light, both in picture taking and in darkroom developing and printing. The photographer must also work with lighting conditions when displaying the photograph.

Experiment with natural lighting—bright light, medium light, low light, shade, different combinations. Natural lighting is a fascinating study and often will create, or certainly help to create, the spirit of a picture.

Do not shy away from bright sun; many photographs are interesting because of it. The added presence of contrasting shade and shadow areas, as in these photographs, will usually strengthen the photograph.

Nineteenth-century false front, Mississippi.

Barber shop—noonday contrasts.

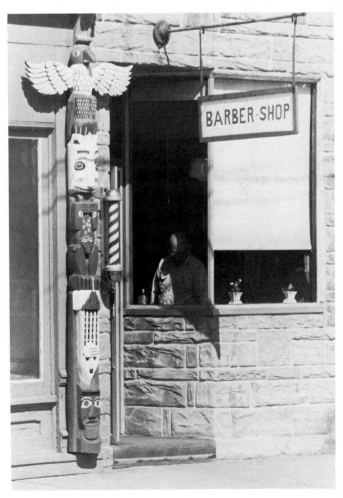

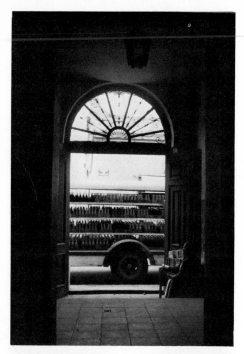

This photograph was taken from inside an apartment house in Mexico, looking out at a street with a parked truck filled with bottles of soda. The light-dark play between interior and exterior gives the photograph its interest and mood. Note the old woman selling magazines at the doorway, with light reflected on her front and her back hidden in darkness. The number of blacks and grays within the interior help create a sense of the sublime. These values contrast with the bright quality of the exterior.

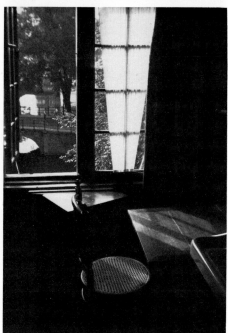

This is a photograph taken from the interior of a small Dutch hotel, looking down at a canal, bridge, house reflections, and trees. The contrasts among the light outside, the reflections of that light inside, and the solid blacks of the interior make this photograph particularly rich.

One can create some fascinating lighting contrasts by photographing from inside a building, capturing part of the interior, but directing the camera outward to take in a part of what is outside. Some dodging and burning-in may be necessary, but too much could destroy the interesting contrasts.

The power of light to reveal, as well as to create, the shadows and dimness which mask detail can also be experienced by photographing interiors from outside. Showing a portion of both exterior and interior can make fascinating light contrasts. As with photography of windows, photographs taken from the exterior looking in involve a sense of exposing at least a part of what is essentially private. In the two photographs with people, the glimpses at moments of private human experiences give the photographs some of their power.

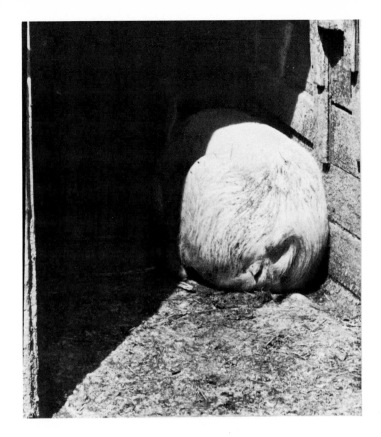

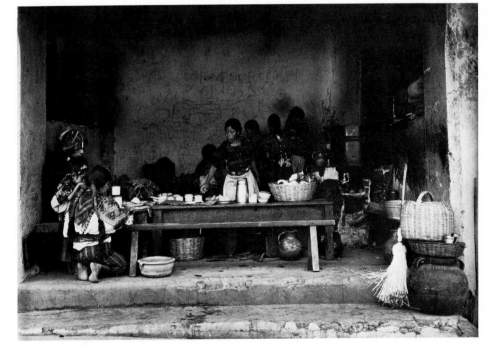

(above)
Ms. Pig

(above, right)
Milking.

(right)
In this Guatemalan home, at mealtime, the light becomes dimmer gradually, so that the four women behind are bathed in partial darkness. This darkness contrasts nicely with the reflected light on the rear wall and the brighter light falling on the mother in the center and the father and children at left.

Artificially lit interiors are often no problem in black and white photography with the use of a fast film. Indeed, types of artificial lighting have their own power to reveal and hide. Although a tripod is helpful in dimly lit interiors, particularly when maximum sharpness is desired, many interior photographs can be made when the camera is hand-held and a fast film is used.

In some instances windows photographed at night, when the darker values dominate, can be more mysterious and fascinating than when photographed during the day. This living room window with all its wonderful clutter has a very intimate quality.

Try photographing at night.

Night photography does not pose the problems people might anticipate. Indeed, night photography can be fun and provide the source for some outstanding imagery. What may be mundane or ordinary during daylight hours can take on a rare beauty in a night photograph. Special flash or flood lights are really not necessary in many cases and may destroy the effects of night lighting; for example, moonlight, light from street lamps and houses, neon lighting from signs or shop-windows, or light from automobiles.

In night photography, there is the problem of determining the appropriate exposure. An exposure meter, a fast film, a tripod, a cable release, and a lens hood or shade to keep stray light off the image are essential equipment in night photography. However, even with an exposure meter, it is often difficult to ascertain what aperture and shutter speed to use, particularly when there are several sources of light. Experimentation, to become acquainted with results of photographs made under similar circumstances, is often the best procedure. Calculators with suggestions for exposures in night lighting situations are available and may help as a guide. Also, do not be afraid to use film to experiment with different exposure times. Be aware of the importance of dark areas in night photography. Do not overexpose so much for detail in the darker areas that the rich night value contrasts are lost on the one hand, or take an exposure reading from the light source which will serve to expose only the lighted area, on the other hand. In the latter case, one can give additional exposure time to bring out the areas surrounding the light source. Either of these extremes may, in some cases, be necessary for a specified desired effect, but care should be taken in handling the technical aspects.

Moon-framed by telephone wires and spruce trees. In photographs in which the moon is included, one should adjust the exposure speed to not longer than $1/10$th of a second, unless one wishes to show the moon's movement relative to the earth.

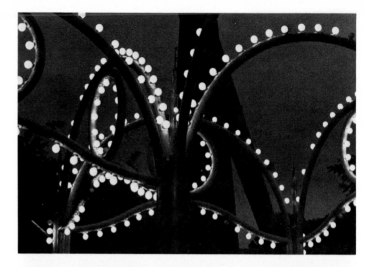

Artificial light sources in themselves can be quite exciting. The way they reflect light to surrounding areas, selectively illuminating certain parts, can be equally as interesting.

This series of photographs was taken in an amusement park, an excellent place to experiment with night lighting. To the delight of the photographer, it rained briefly, producing some fascinating reflections on the wet pavements. Reflective surfaces at night deserve exploration. Such surfaces also help strengthen the light.

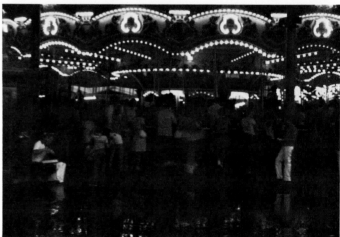

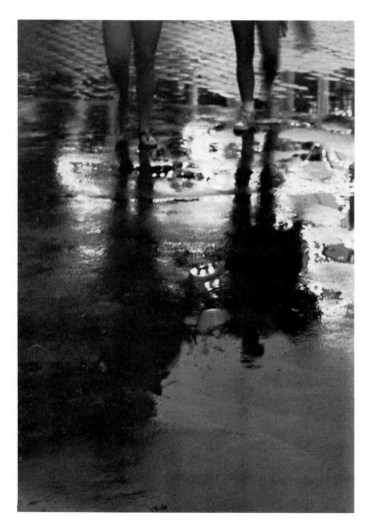

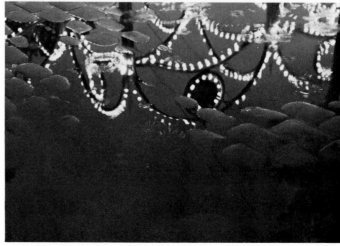

Develop an awareness of reflections and shadows.

Reflections and shadows can add interest and aesthetic dimension, and even make for good photography. They may also serve to destroy a potentially promising photograph. It is important that a photographer recognize both possibilities.

Reflections occur when some part of an area is mirrored or cast back by a reflective surface, such as glass, water, or metal. The degree of reflection and its clarity will depend on the characteristics of the reflective and reflected surfaces, as well as on the lighting conditions.

(below)
This delicate web of reflections from the overhanging branches is reminiscent of the patterns of some butterfly wings.

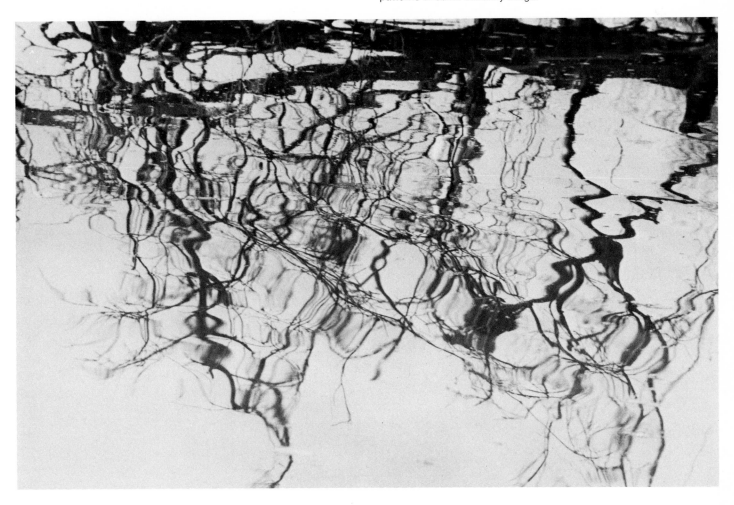

Glass windows frequently make for exciting plays of reflections. Sometimes surprises appear when the film is developed. Beware of reflecting your own image, unless that is your intent. The use of a polarizing filter will help to eliminate unwanted reflections.

(right)
Often fascinating are the reflections of objects which themselves do not appear. In this photograph the building across the street and the street itself with the truck appear only as reflections in the window, but the Bavarian gentleman with pipe appears twice.

(below)
Here is a play of reflections on two surfaces, metal and glass. Note the contrast in clarity between them which adds considerably to the interest and variety of the picture. There is also contrast in clarity between what is seen inside the car and what is seen outside.

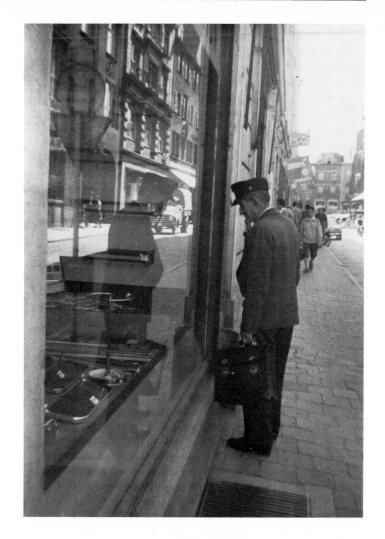

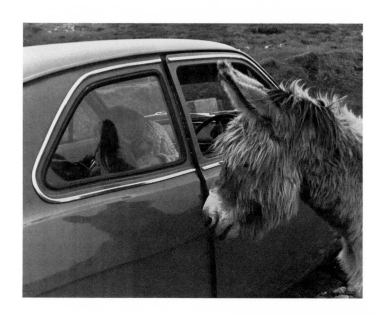

Not only can shadows stand on their own merit as subjects, but they can add significantly to the spirit of a photograph. Shadows can be fun to play with and may add a degree of humor. The longer shadows of early morning or early evening are particularly interesting. They can contribute a sense of mood and mystery.

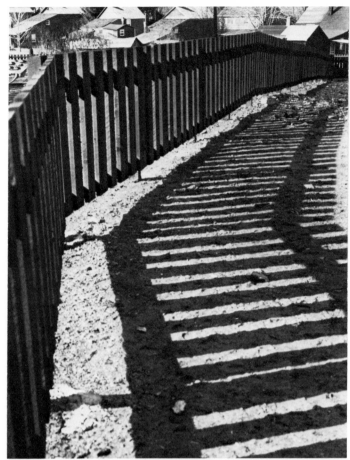

(below)
This photograph was made in fun. In it the real hand and flower appear with their shadows, but the shadow of the head has no such corresponding image.

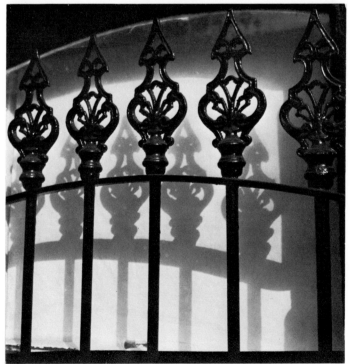

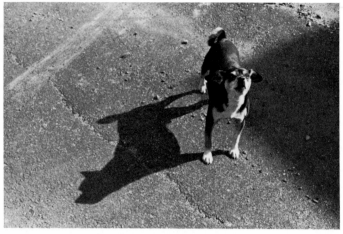 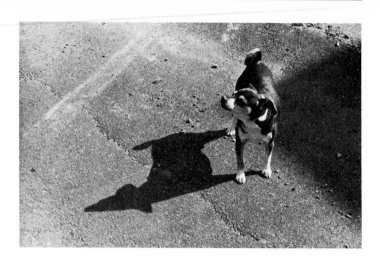

It is unfortunate that this barking dog was
unaware of the great shadows he was making!

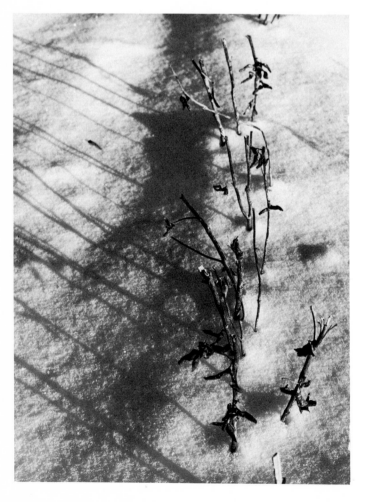

These are cut soybean stalks and their
shadows in the snow. The shadows add con-
siderably to the mood in the photograph,
which was taken in the early morning with
the sun at a low angle. In photographing
snow one must avoid having sunlight behind
the camera unless one wishes a flat white-
ness. The exposure time may have to be in-
creased when the camera is directed toward
the sun at a low angle.

Explore some of the aesthetic and expressive potential of movement in photography.

There are many ways in which movement can be shown or implied. The camera, lens focal length, aperture, shutter speed, inherent qualities of various films, and electronic flash unit can be used creatively to capture interesting and exciting images.

To stop motion so that the moving objects appear to be suspended in their movement calls for implementing one or a combination of the following steps of: selection of a relatively fast film, use of the fastest shutter speed possible under the circumstances, making the exposure at the dead point in the motion, shooting while moving the camera to keep pace with the movement of the subject, shooting from an angle that will minimize blur, and use of an electronic flash unit. The speed of the moving objects will determine how fast one must adjust the shutter speed to arrest the motion. Slowly moving objects will tolerate slower speeds; $1/125$th of a second will usually be sufficient to stop a slow runner. The photographer should learn what the relative speeds are for the particular choice of film, camera, lighting conditions, and subject matter. For maximum sharpness, the smallest possible aperture should be used.

These photographs illustrate an experience that occurred within about five minutes on an Irish country road. First, the road is blocked by sheep despite the efforts of a young shepherd on the bike with a whip. Some sheep are taking advantage of the lull by nibbling on the nearby bushes. While they blocked the passage of the photographer's car, their way was also partially blocked. The photographs below show the sheep moving along the side of the car after being chided and whipped by the young shepherd. Motion was stopped by the use of fast Tri-X film, a 50 mm lens at f 8 aperture, and a shutter speed of $1/125$th of a second.

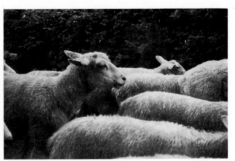

Arresting motion will often provide a candid shot without a blur, but with a sense of having caught a split-second position, gesture, expression, or relationship. The ability of the camera to record a fleeting moment makes it a very powerful creative instrument.

Sharp overall focus is not necessarily ideal. A background or object that is blurred or partially blurred can help convey a sense of speed.

Photographs in which the moving objects are blurred can be exciting. A blurred or out-of-focus image will often make an area or object appear to be moving even if it is not. The lack of clarity makes for a feeling of greater abstraction.

(above)
This duck was caught with out-stretched neck just as he was about to indulge in a drink of water.

(right)
This motion of this donkey has been stopped but without sacrificing the idea that he is in motion.

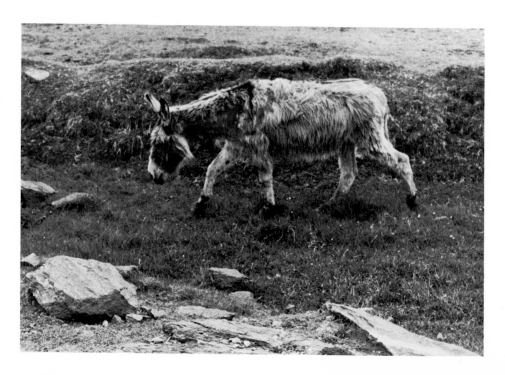

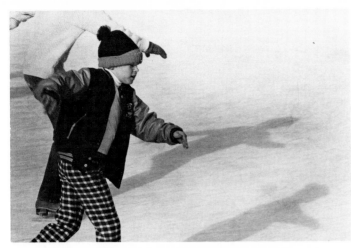

(left)
The motions of these skaters has been stopped by the camera, but with a great expanse of negative space to the right, there is no doubt that they are about to move into it.

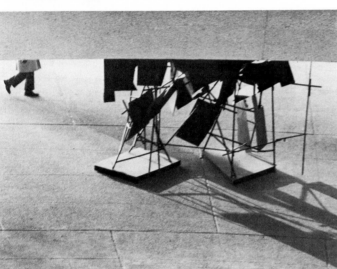

(below, left)
Taken from a second floor window in the Hirshhorn Museum in Washington, D.C., the stopped movement of the walking person nicely repeats similar movements and directions in the contemporary sculpture. The repetition of the dark and light values in both sculpture and in the section of the person also adds interest and contributes to unity.

(below)
"Panning" is exposing while moving the camera in the same direction and at the same relative speed as a moving object. The technique is used to heighten the sense of speed by keeping the moving object in relative focus while the background and other parts of the picture are streaked and blurred. The effects in the photograph at right were achieved in this way. The shutter speed was $1/125$th of a second, but one can get similar effects with speeds as slow as $1/30$th of a second.

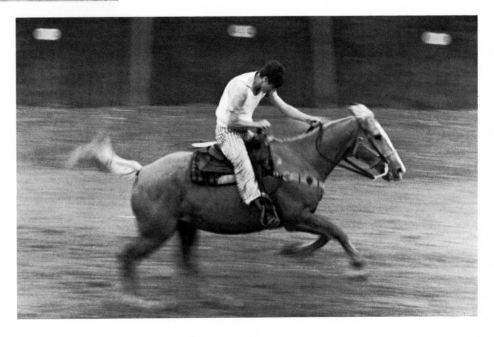

Do not be afraid to use devices or techniques which will create certain special effects for you. Beware that they do not become just tricks and ends in themselves rather than means to more effective imagery.

Certain graphic control processes, such as bas-relief, solarization, reticulation, and photograms (the latter requiring no camera), are intriguing and often result in powerful photographic imagery. Multiple-image photography can also be fascinating. Special effect lenses, such as the fisheye or soft focus, may prove helpful for certain types of photographs. Certain papers and other materials placed between the lens and the subject may likewise be advantageously employed and fun to work with. There are numerous ways to alter the natural image and you may wish to explore them. Perhaps you can invent a way of your own. Even mistakes may yield gratifying results in the form of distinctive imagery.

The following photographs are "unnatural" — all are mistakes. None was made intentionally as a trick image, but they were all pleasant surprises.

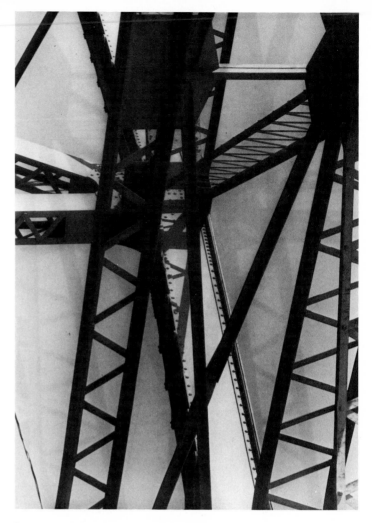

This photograph was printed first with the back side of the photographic paper up on the easel. Before putting the paper in the developer solution, the error was noticed and the paper put back on the easel again with right side up for yet another exposure. The echo or more distant effect in the background was caused by the back side exposure.

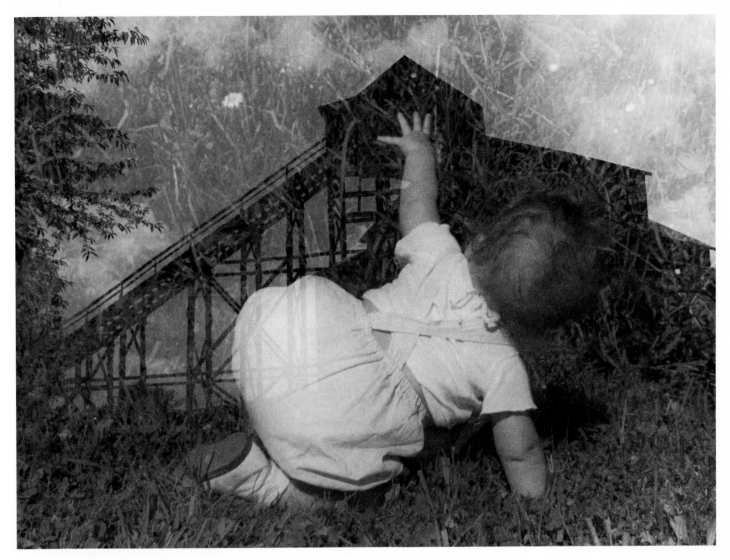

This is a photograph of the author's daughter at ten months made on Plus-X film which was inadvertently put away in the freezer after exposure. Five and one-half years later, the film was taken out and not knowing that it had been previously exposed, was re-exposed while visiting an old mining town (see photograph on pages 3 and 4). The picture of the coal breaker was superimposed on the child in the meadow so that she appears to be reaching for it. The result was a very pleasant surprise.

Avoid the feeling that you must read a number of books and articles and see numerous photographs of a subject before you can take camera in hand. Avoid becoming the "disciple" of any one photographer.

Instructive books and articles on any subject have their place and may aid in your discovery. However, some may also inhibit it. Photographers are, after all, subjective and they can be extremely arbitrary as to what a certain type of photograph should look like, what kind of lighting or lens should be used, and so on. (You may even find certain evidence of arbitrary judgments in this book!)

Do not emulate any one photographer to the extent that your photographs closely resemble his or hers.

Many amateurs become attracted to the visual effects, fame, or acclaim achieved by another photographer and thus are tempted to follow a similar path. Look at and enjoy the work of other photographers, but search for a way of making your own personal statement. Carefully and discriminately intersperse your reading and observation with personal exploration. Advice or criticism you may receive from other photographers and friends may or may not help you. Weigh it carefully in light of your own discoveries and ideas.

This double-image effect was made while printing the photograph on page 26. The paper moved on the easel halfway through the printing process, thus creating groups of twin swans, some in apparent movement and overlapping others. There is a nice rhythmic quality about the photograph.

This is a simple case of unintentional double-exposure. Something went wrong with the camera in the winding, creating a somewhat surreal image with the Mexican boy. Similar effects of more than one image are produced intentionally by multiple exposure or by sandwiching two or more negatives during the printing process.

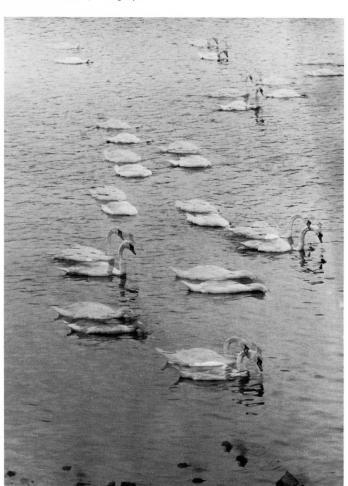

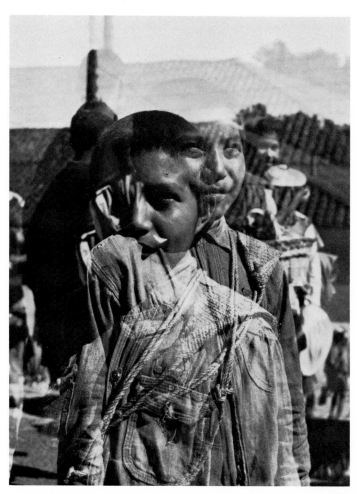